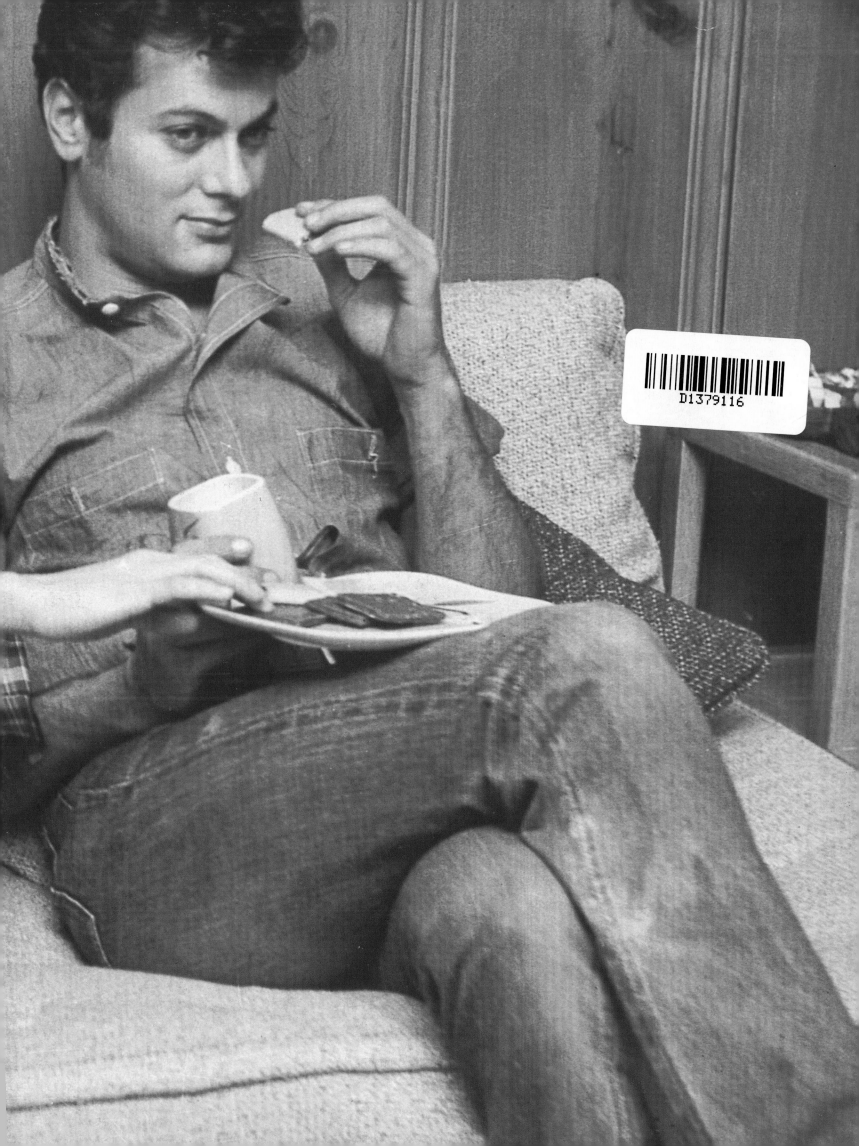

THE BLUE JEAN

THE BLUE

Alice Harris

PHOTOGRAPHY EDITOR DIANA EDKINS

DESIGN BY JOEL AVIROM

TEXT BY BOB MORRIS AND

BEN WIDDICOMBE

EDITED BY JOSEPH MONTEBELLO

pH

powerHouse Books
NEW YORK, NY

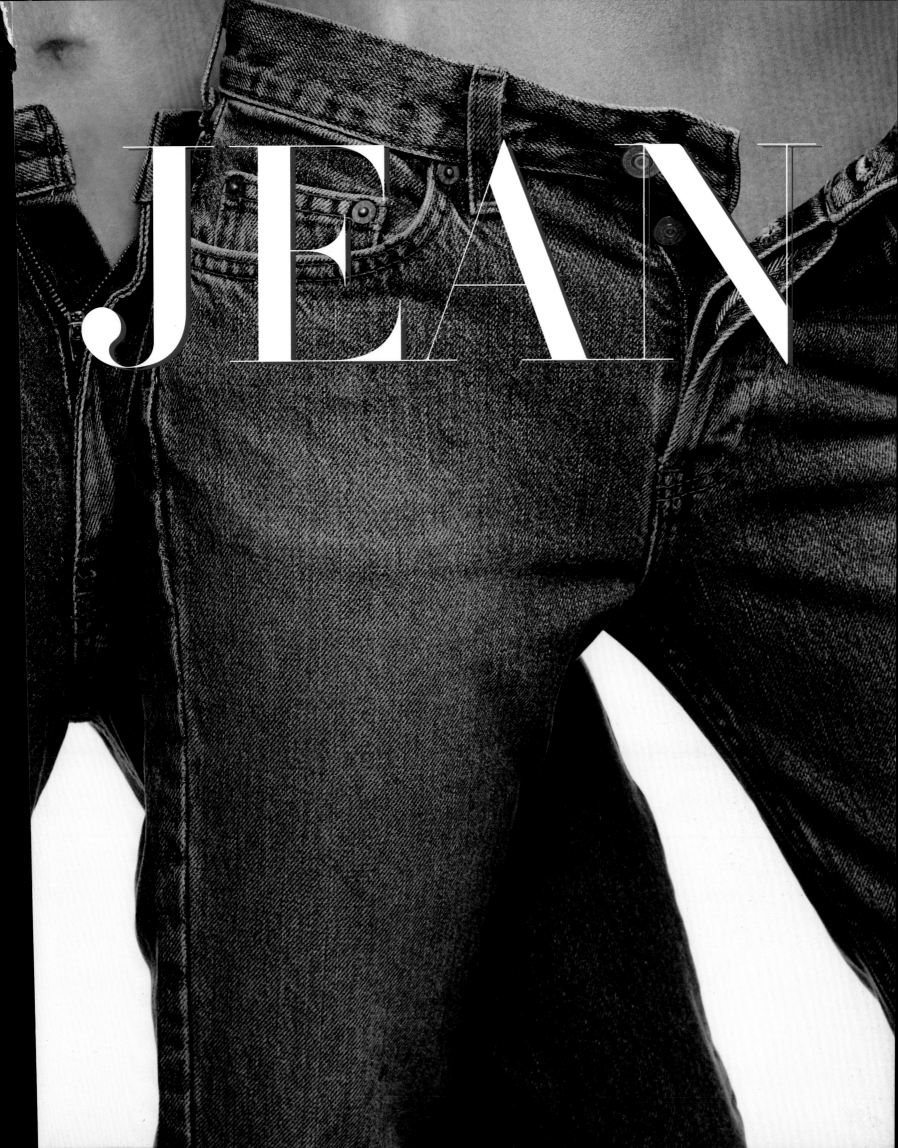

FRONT ENDPAPER: Janet Leigh and Tony Curtis, 1950s, Neal Peters Collection.
BACK ENDPAPER: Luna Park, Milan, 1961. Photograph by Mario Cattaneo.
PAGE 1: Rachel Williams, 1994. Photograph by David LaChapelle.
PAGE 2–3, 4: Photographs by Garth Aikens for NJ America.
 Stylist: Seanita Parmer; Assistant Stylist: Curtis Davis for Adam Group
PAGE 6–7: Matt Dillon. Photograph by Bob Deutsch.

THE BLUE JEAN

Published in the United States by powerHouse Books,
a division of powerHouse Cultural Entertainment, Inc.
180 Varick Street, Suite 1302, New York, NY 10014-4606
telephone 212 604 9074, fax 212 366 5247
e-mail: thebluejean@powerHouseBooks.com
web site: www.powerHouseBooks.com

First edition, 2002

Library of Congress Cataloging-in-Publication Data:
Harris, Alice.
 The blue jean / by Alice Harris, texts by Bob Morris.
 p. cm.
 ISBN 1-57687-150-9
 1. Jeans (Clothing)--History. 2. Jeans (Clothing)--Pictorial works. I. Morris, Bob. II.
Title.

GT2085 .H37 2002
646.4'3--dc21

2002068439

Hardcover ISBN 1-57687-150-9

Separations, printing, and binding by Artegrafica, Verona

A complete catalog of powerHouse Books and Limited Editions is available upon request;
please call, write, or step into web site.

10 9 8 7 6 5 4 3 2 1

Printed and bound in Italy

Book design by Joel Avirom
Design assistants: Meghan Day Healey and Jason Snyder

I DEDICATE THIS BOOK TO MY HUSBAND STANLEY;
HE HAS BLESSED MY LIFE WITH HIS LOVE!

FOR MY DAUGHTER SAMANTHA AND MY SON BENJAMIN:
I LOVE YOU!

A PRE-SHRUNK PRE-
RIVETING DEVELOPME
DON'T FENCE THEM I
WRONG FOR SCHOOL,
A NATION REBELS AN
THE BLUE-ING OF AM
DENIM, DIAMONDS, A
VERY LOOSELY TRANS
21ST CENTURY MODER

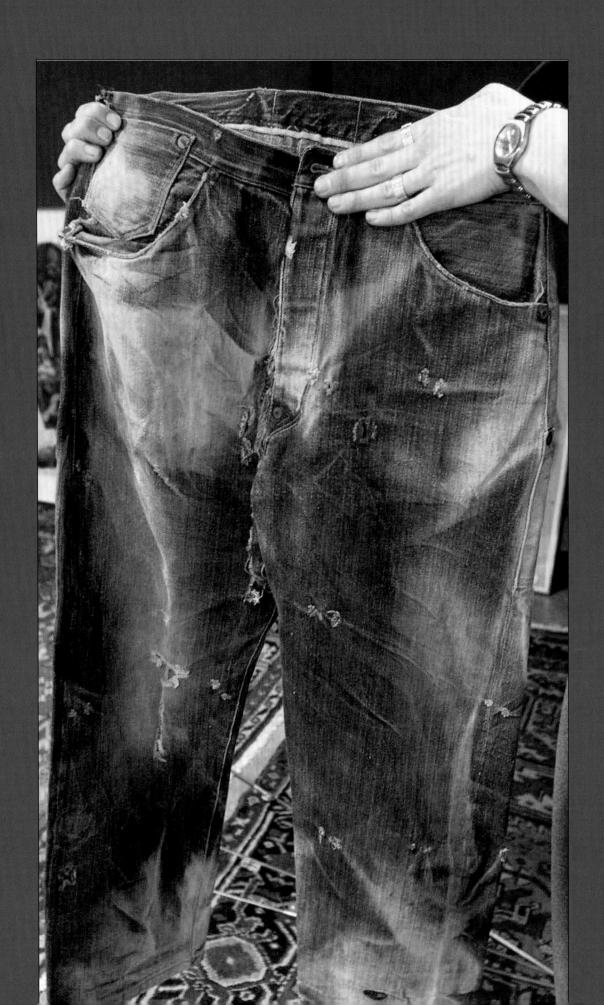

T

Old friends—Levi Strauss & Co. jeans, discovered in a Nevada mining town, are presented for auction in May, 2001. Photograph by Lloyd Francis, Jr.

■

he distance from a gold rush-era Nevada mining town to a twenty-first century Internet auction house near San Francisco is a few hundred miles and about half as many years. A pair of 1880s Levi's blue jeans recently made the journey with only a few nicks and bruises to tell the tale.

Experts say this remarkable pair of jeans—or "denim waist overalls," as their original owner called them—was produced between 1880 and 1885, and cost $1.25 when brand new. Unearthed from a pile of miners' junk in 1998, Levi Strauss & Co. bought the garment back at auction three years later for $46,532. What is extraordinary about the sale is not that the artifact, created almost thirty years before the first Model-T Ford, lived the life of a miner, or that it outlasted twenty-three American presidencies and still survived almost totally intact. What makes the story remarkable is that this humble piece of denim remains instantly recognizable—as workpants, leisurewear, even as high fashion—to the world in which it reemerged 120 years later.

That's not to say that a pair of blue jeans cut in the 1880s didn't come into being without a fair bit of history already woven into its twill. Even the origin of the name "denim" is surprisingly contentious. Although conventional wisdom holds that the word is an Anglicized version of "serge de Nimes," a fabric typical to the French mill town of Nimes, the fact remains that serge is a wool blend often mixed with silk, while denim has always been cotton. Pascal Gorguet-Ballesteros, curator of a 1994 exhibition at the Musée de la Mode et du Costume in Paris, which documented the 250-year history of jeans, denies point blank that denim has its origins in France. "This is all just a patriotic myth," she says. "I am sure that denim is not French." In fact, there was a fabric called "denim" in England in the 1600s, and it's possible that merchants hit upon the French-sounding name as a way to exoticize their particular brand of twill. But there was also a wool blend sold in France in the seventeenth century known as "nim." As for the word "jeans," it came from the cotton workpants worn by sailors from the port of Genoa, Italy, who were themselves known as "Genes."

Whatever its origin, denim has always been important to the cotton industry, and cotton was vital to the economic development of America. Sprawling plantations created a new class of landed gentry in the South, while textile milling became the country's first major industry in the North. The Levi's waist overalls discovered in Nevada were produced in San Francisco with denim from the Amoskeag Mill in Manchester, New Hampshire, which was the biggest textile producer in the world by the time its looms shut down in 1936. The mighty Amoskeag facility was built in 1838, just fifty-one years after the establishment of the country's first mill in Beverly, Massachusetts.

The introduction of textile milling technology to America—which had been banned in the colonies by King George III—was significant enough to warrant a visit by President George Washington, barely six months after his inauguration. A 1789 edition of the *Salem Mercury* records his inspection: "He was shown, in the lower story, a jenny of eighty-four spindles upon which some of the manufacturers were spinning warp; and three or four others were spinning weft; and about a dozen looms upon which they were weaving cotton denim, thickset, corduroys, [and] velveret."

Two centuries before Jimmy Carter immortalized his image as America's farmer-president by being photographed in jeans, Washington put himself on record as the first chief executive impressed by denim. In his diary entry for the day, he wrote: "In short, the whole seemed perfect, and the cotton stuffs which they turn out, excellent of their kind."

America's love affair with denim had begun.

A miner on his farm near Penfield, Pennsylvania, August 1940. Photograph by Jack Delano for the Farm Security Administration (FSA).

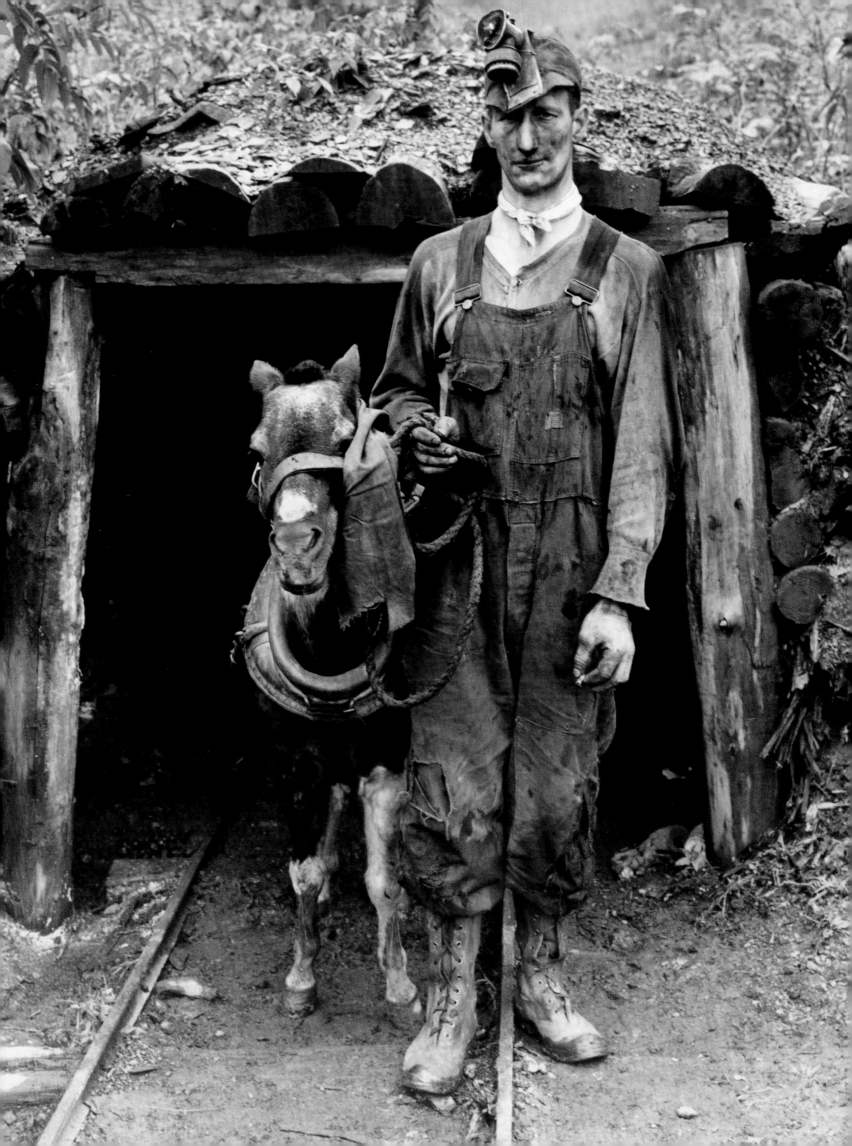

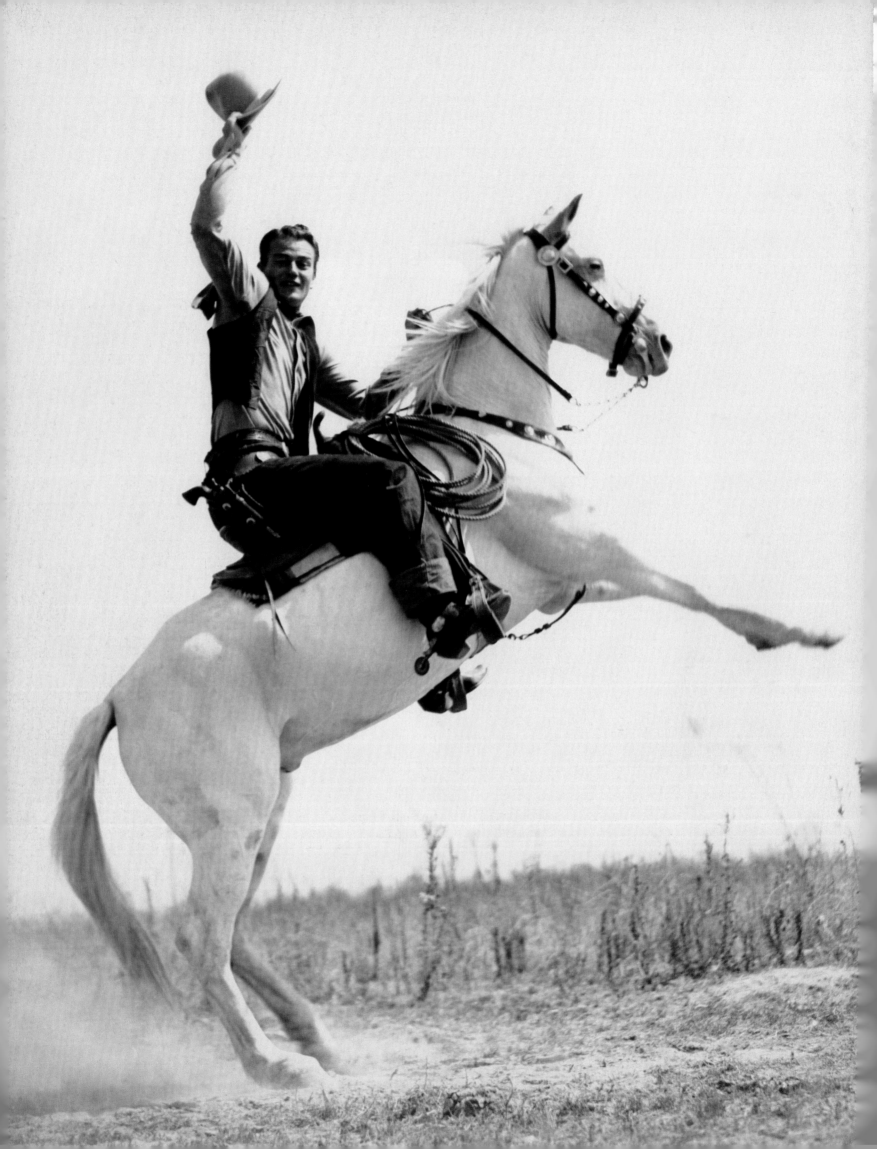

B

John Wayne on a horse,
of course, 1920s.
■

y the mid-1800s, sturdy denim twill had already established itself as a reliable cloth for

workwear. It was a fabric for people who came home with their hands dirty, and bib

overalls—an outsized garment with pockets on the chest as well as hips, designed to

be worn over day clothes—could be found hanging in railwaymen's shacks and behind

barn doors across the country.

In 1847, just twelve years after an inquiring French aristocrat

named Alexis de Tocqueville published his sensational account of life in the new

republic, another young European made the journey to America—this one, to stay.

Levi Strauss was eighteen years old when he left Bavaria for New York, and twenty-

four when he became an American citizen. That same year, 1853, he sailed for San

Francisco to establish a West Coast branch of his brothers' dry goods business.

From his wholesale warehouse on California Street, the newly-made American

sold bedding, underwear, raincoats, collars, and cuffs to the families who were settling

the coasts and valleys of the new territory. At the time, duck canvas, which was lighter

than the canvas on covered wagons, was used for pants. But denim quickly eclipsed

canvas in popularity. It didn't chafe, was hard to rip, and the tough twill of its weave

was still light enough to prevent a working man's muscles from sweating too much.

It was a tailor in Reno, Nevada, who came up with the idea that would differen-

tiate the workpants Levi Strauss was selling from all the others. In 1872, Jacob Davis

sent a letter to the San Francisco merchant proposing copper rivets be attached to

stress points in the garment at the pockets and on the fly, to prevent ripping (Davis,

independently, couldn't afford the $68 patent fee). One year later, in partnership with

Davis, Strauss received U.S. patent 139,121 for his riveted blue denim waist overalls.

Levi Strauss was not the only dry goods merchant to notice that a lucrative

sideline in workwear might make its own separate business. On the East Coast, the

brothers Moses and Caesar Cone were traveling in the South taking orders for their

father's Baltimore grocery when they saw the opportunity in textiles. In 1891, they

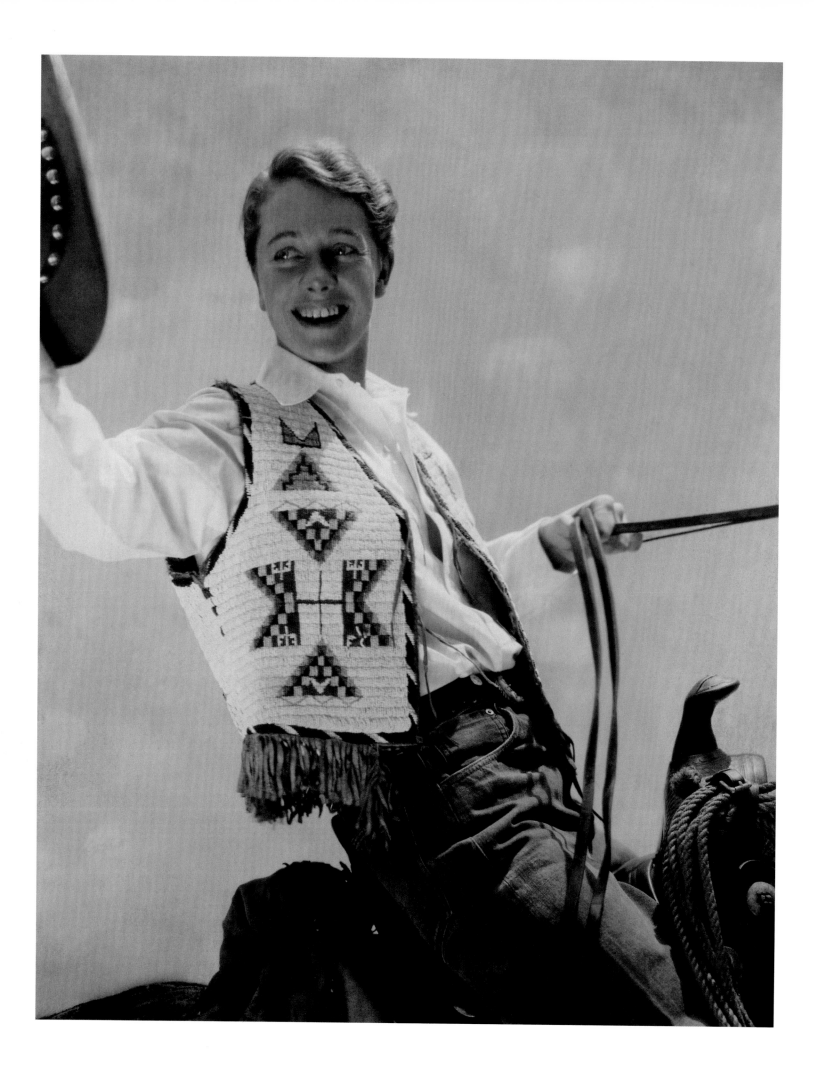

founded the Cone Export and Commission Company, and soon had a mill in Greensboro, North Carolina. In 1904, the Hudson Overall Company (now known as Wrangler) was formed, and in 1911, the H.D. Lee Mercantile Company of Salina, Kansas, began producing its own denim workwear. These four companies would dominate the denim industry, in America and abroad, throughout the twentieth century.

Levi Strauss & Co.'s patent on riveted pockets expired in 1891, and they quickly became the industry standard. Zippered flies, the next major development, were first introduced by Lee on their denim "Cowboy Pants" in 1926. ("To fully appreciate this development, speak with a man standing in an Iowa cornfield in late December, his gloved hands desperately fumbling at his buttoned fly," the company observes on its website.) Soon Babe Ruth was endorsing a new garment called "Whizits," after the sound made by its "amazing hookless fastener," and the product was a hit.

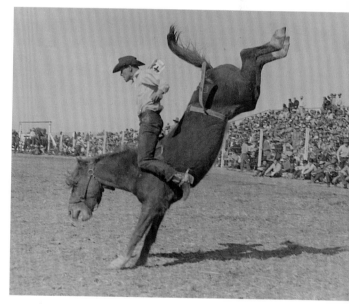

The Alaskan gold rush of '98, meanwhile, had also sparked a boom in the demand for sturdy workwear, and America's burgeoning industrial sector proved denim was as practical for those who worked indoors as out. Popular images, from Walker Evans' powerful studies of rural families to the anonymous, iconic 1932 photograph "Lunch on the Skyscraper," showing a line of construction workers having their midday meal on a girder precariously suspended over Manhattan, cemented denim in the American consciousness as the fabric of manual labor.

Little did anyone suspect that in the 1930s, another West Coast industry was about to change all that. Once Hollywood discovered the cowboy flick, denim would never be the same again.

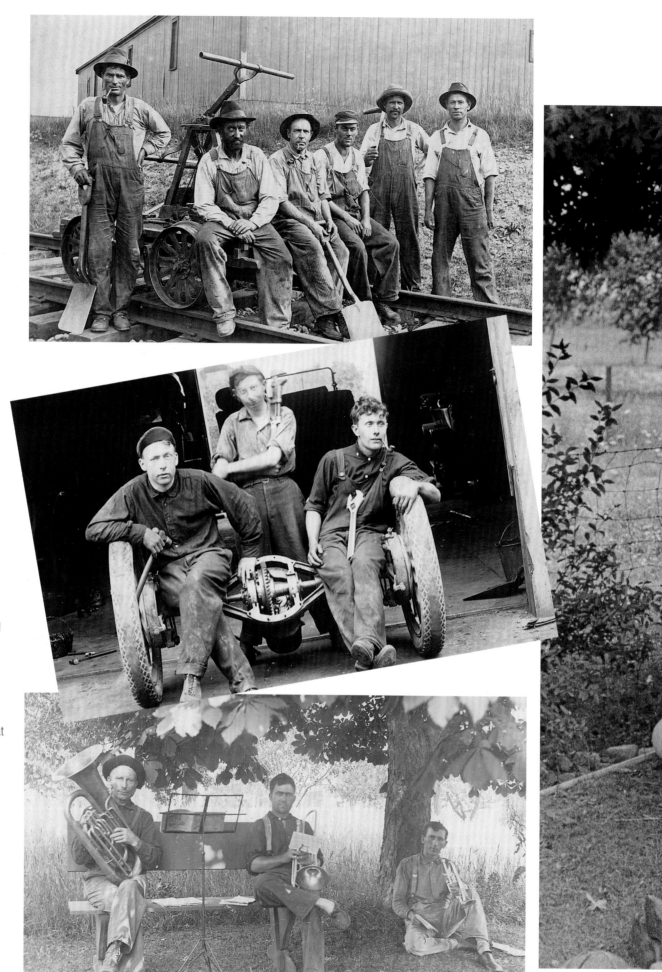

RIGHT
Working on the railroad
and elsewhere; post-
cards from the 1920s.
■
OPPOSITE
Farmhand discussions
before dinnertime, wheat
harvest, central Ohio,
August 1938.
Photograph by Ben
Shahn for the FSA.
■

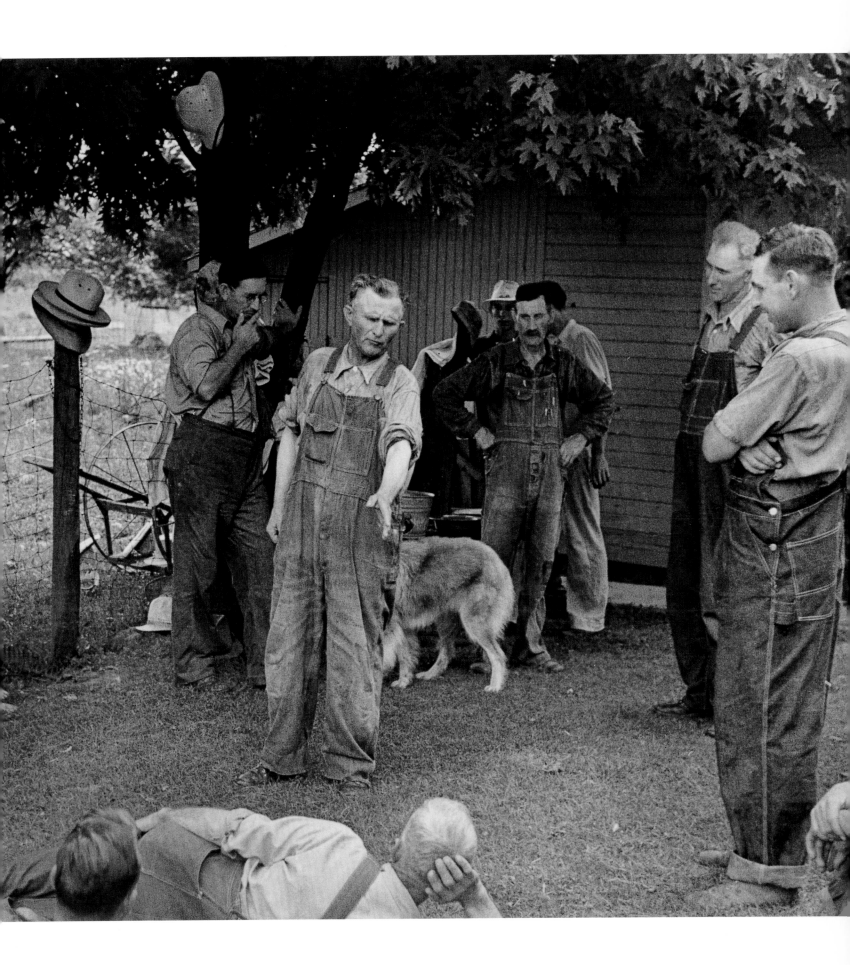

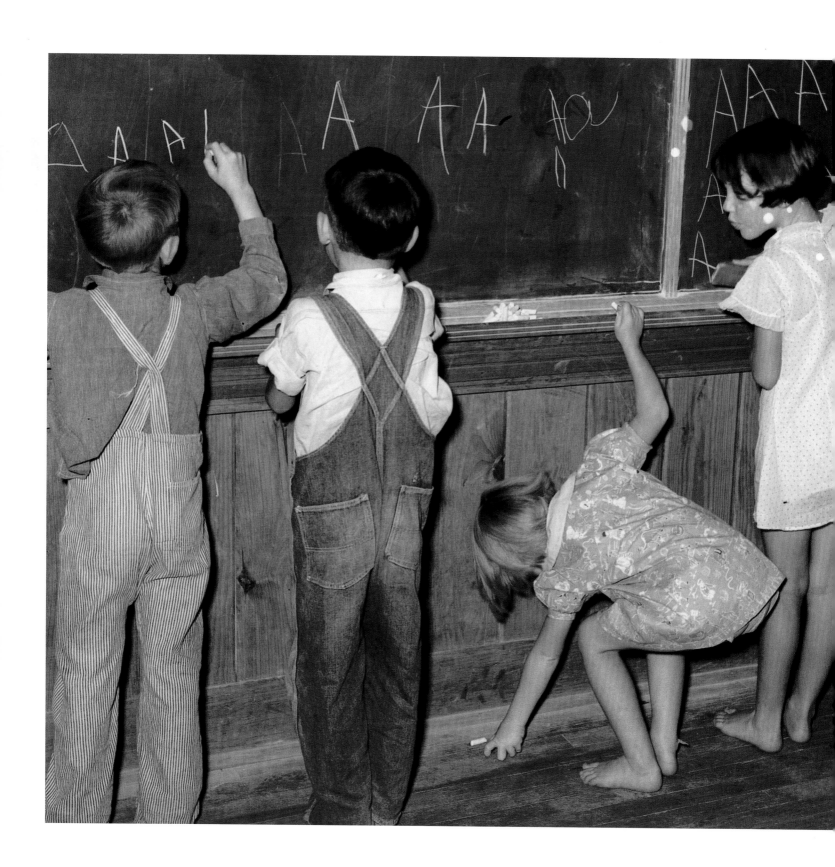

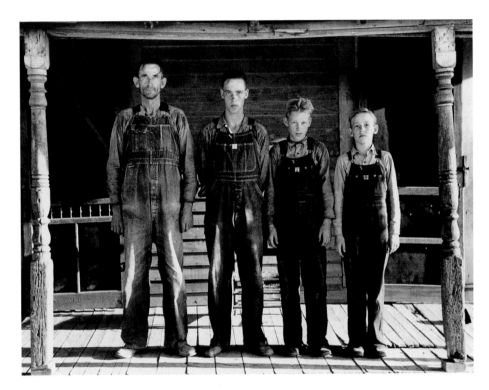

LEFT
Blackboard blues, Arkansas, October 1938.
Photograph by Russell Lee for the FSA.

■

ABOVE
FSA client with his three sons,
Caruthersville, Missouri, August 1938.
Photograph by Russell Lee for the FSA.

■

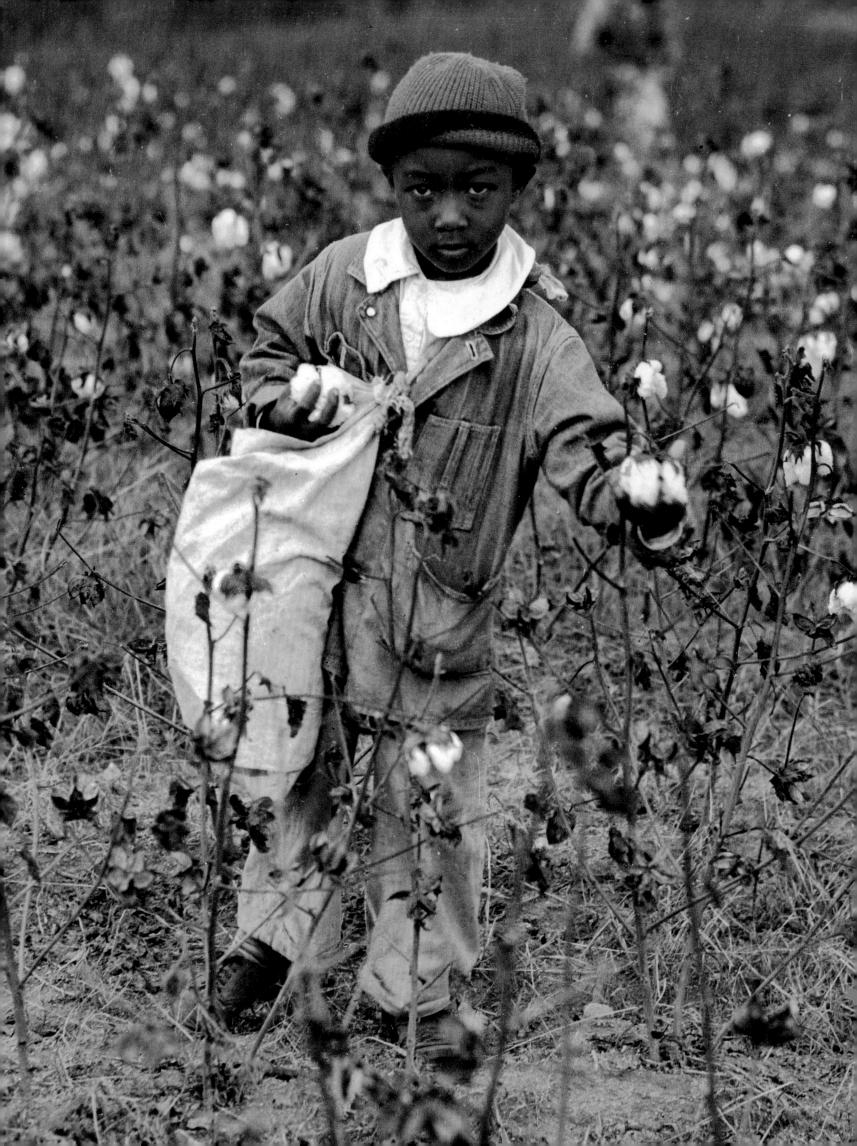

OPPOSITE
Picking cotton, ca. 1935.
Photograph by Sheldon Hine.
■
RIGHT
Daydreaming; postcard from
the 1930s.
■

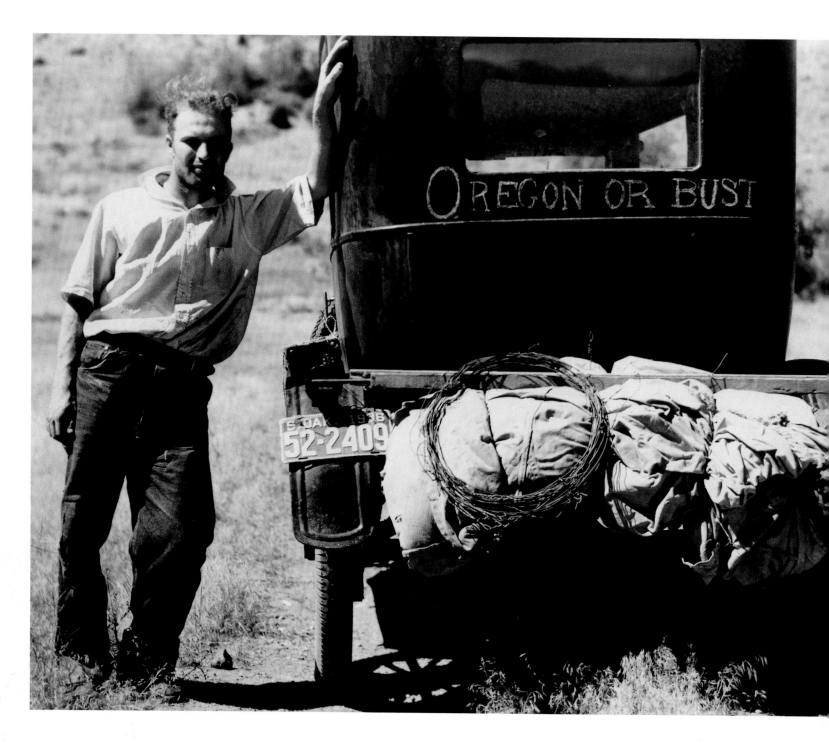

Vernon Evans, a migrant from South Dakota
on his way to Oregon, 1936. Photograph by
Arthur Rothstein for the FSA.

∎

Henry Fonda in the *The Grapes of Wrath*.

∎

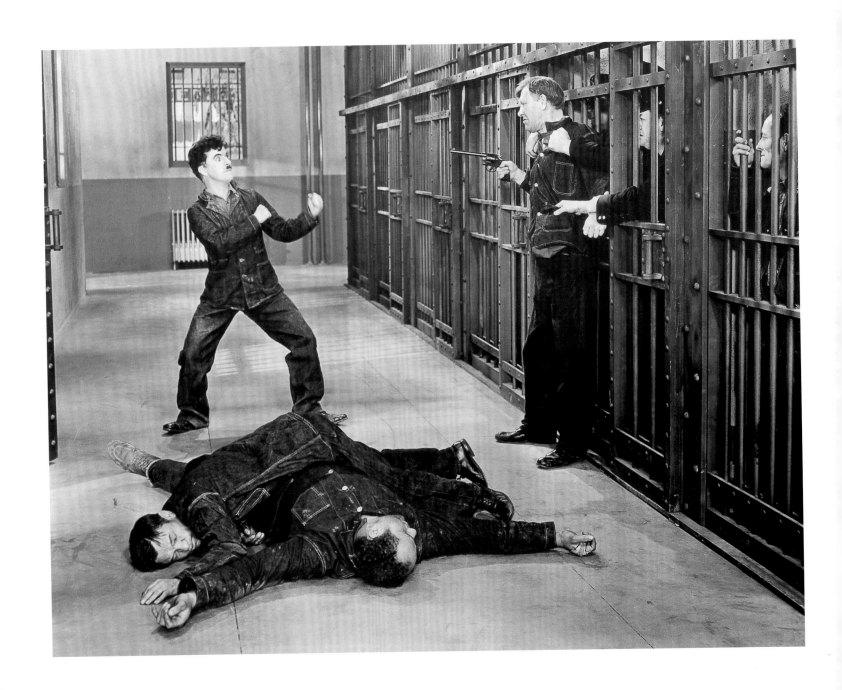

ABOVE
Charlie Chaplin in *Modern Times*, 1936.
■

OPPOSITE
Real modern times. Worker at the edge of a
platform constructing the Empire State
Building, 1931. Photograph by Lewis Hine.
■

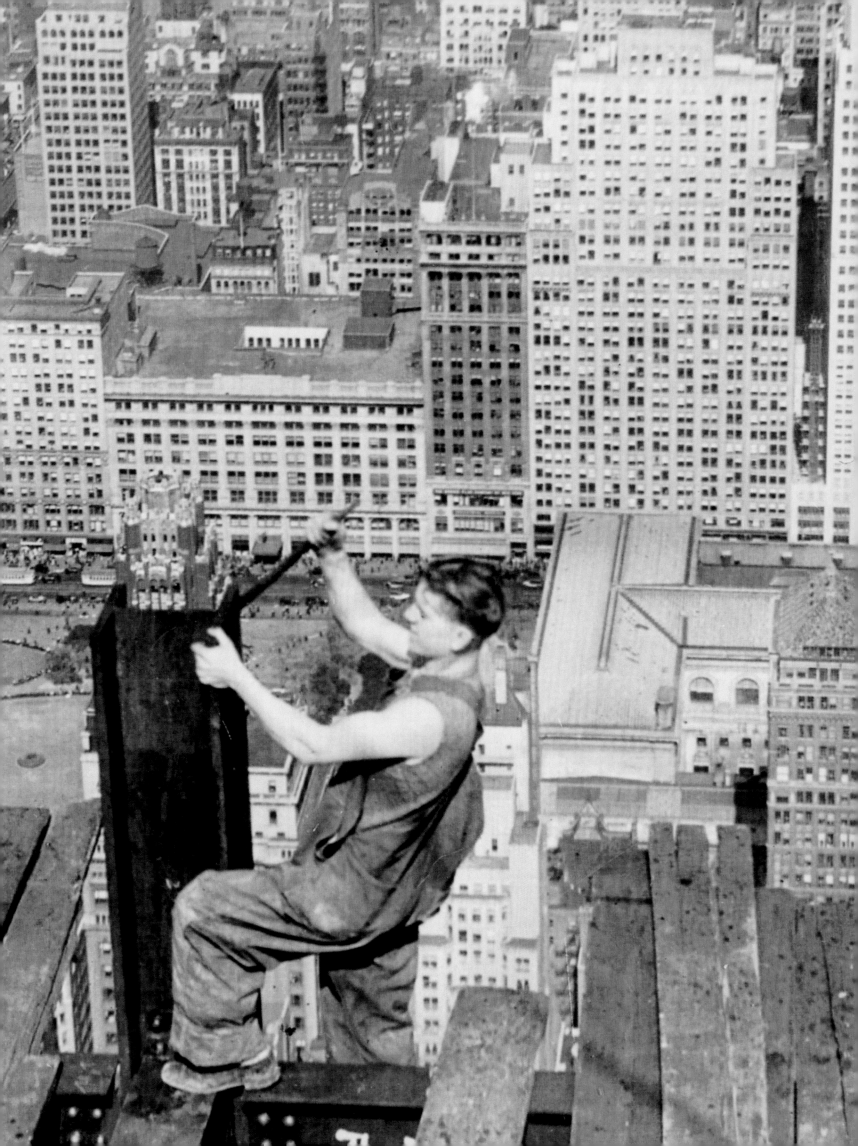

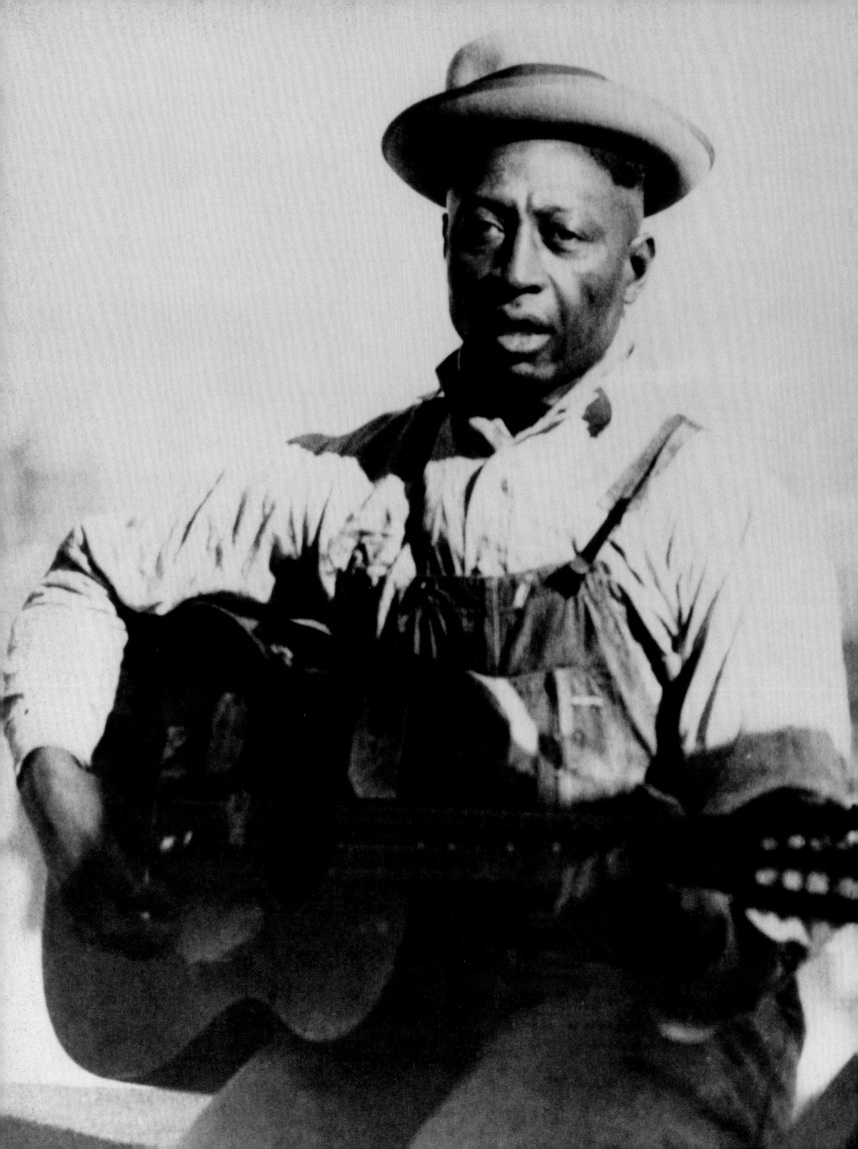

Leadbelly, 1940s.

Amerca was changing so fast during the 1930s that you could leave your house in the morning dressed for work, and come home at night wearing the latest fashion craze— all without changing your clothes.

The unlikely catalyst for this fashion revolution was the cowboy. What Henry Ford had done for the production line, Hollywood filmmakers like John Ford were doing for entertainment. Ford and his fellow directors of cowboy flicks were filling the cinemas of the country with romanticized, action-packed sagas of the wild, wild West. Whether it was Gene Autry striking up a tune by the campfire, or John Wayne clearing a saloon full of snake-eyed varmints with a few swings of his mighty arm, masculinity was forever redefined in blue jeans. The movies glamorized denim, but other social factors cemented its popularity. Americans in the 1930s were more mobile than at any other time in their history. Motorcars were becoming affordable, and the nation was crisscrossed with rail track. While trailer homes were becoming popular among the working classes, the dude ranch craze allowed wealthy Easterners to spend a week or more living the western idyll they observed on screen—with someone else watering down the horses, of course. Levi Strauss adopted the cowboy as its corporate icon, and introduced "Lady Levi's," their first jeans for women, in 1935. They followed it up with "Tropical Togs," a women's sportswear line that featured denim halter-tops, pants, and tennis outfits.

In the 1939 film version of Clare Boothe Luce's satire *The Women*, a bevy of Hollywood stars portray Manhattan socialites vacationing at a ranch in Nevada in order to take advantage of that state's quick divorce laws. Norma Shearer, Rosalind Russell, and Joan Fontaine show off their jeans as natty separates, every bit as appropriate to their class, style, and sense of place as a gown at the opera. Not even the hatchet-faced ranch hostess Marjorie Main (who, as her signature character Ma Kettle, could age a side of beef with a single scowl) could deflate the sheer glamour of it all. For the first time in their history, jeans had become leisurewear.

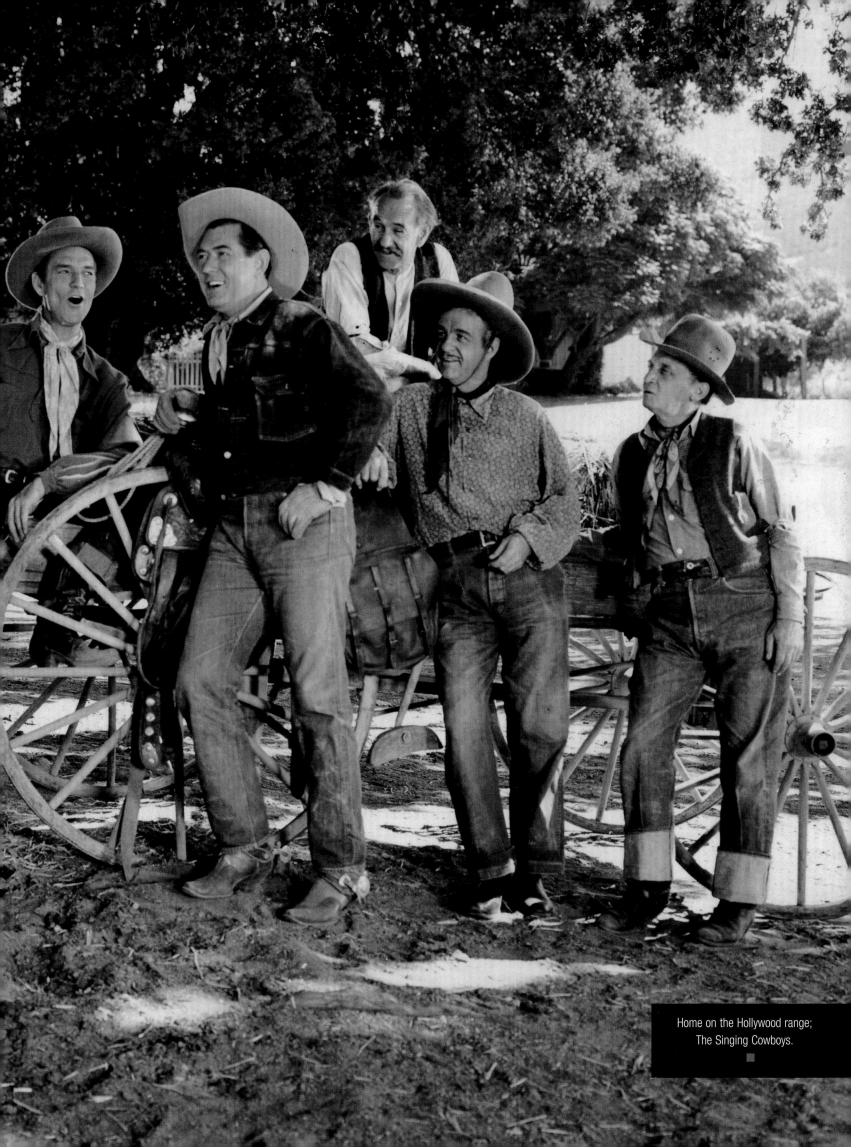

Home on the Hollywood range;
The Singing Cowboys.

So widespread was the fascination with this fabric that in 1939 the syndicated oddity column "Believe It or Not!" by Ripley devoted an entire page to testing the claims of Lee Jeans' Jelt Denim brand: "The buttons hold their shape after being ironed with a five-ton steamroller! The denim survives a twenty-six-mile crawl across untreated concrete! One man can stand in the pockets of overalls worn by another—and the stitching stays secure!"

Unfortunately, America was about to be jolted out of its increasingly playful relationship with denim. Soon enough the material would return to its primary function as workwear, but this time on women. Rosie the Riveter—born in an era before steroids—embodied a generation of American women called to manual labor for the war effort. Norman Rockwell depicted her for the May 29, 1943 *Saturday Evening Post* cover with red socks, denim bib overalls turned up once at the cuffs, and a halo. Suddenly, dresses weren't the only proper uniform for women.

Wartime meant some minor changes for jeans—Levi Strauss & Co. scrapped suspender buttons and cut down on rivets to save copper. Ironically, one of the subtler outcomes of the war would prove to be most significant to the expansion of denim's popularity. Suddenly, American working men were all over the world, from Sydney and Tokyo to London and Berlin. Wherever they traveled, their jeans went with them. Even in countries that had imported American cowboy movies before the war, few foreign citizens had ever seen these strange garments in person, and they become instant objects of desire. Unwittingly, American G.I.s had created a global market for jeans.

Rosie the Riveter, *Saturday Evening Post*,
May 29, 1943. Painting by Norman Rockwell.
■

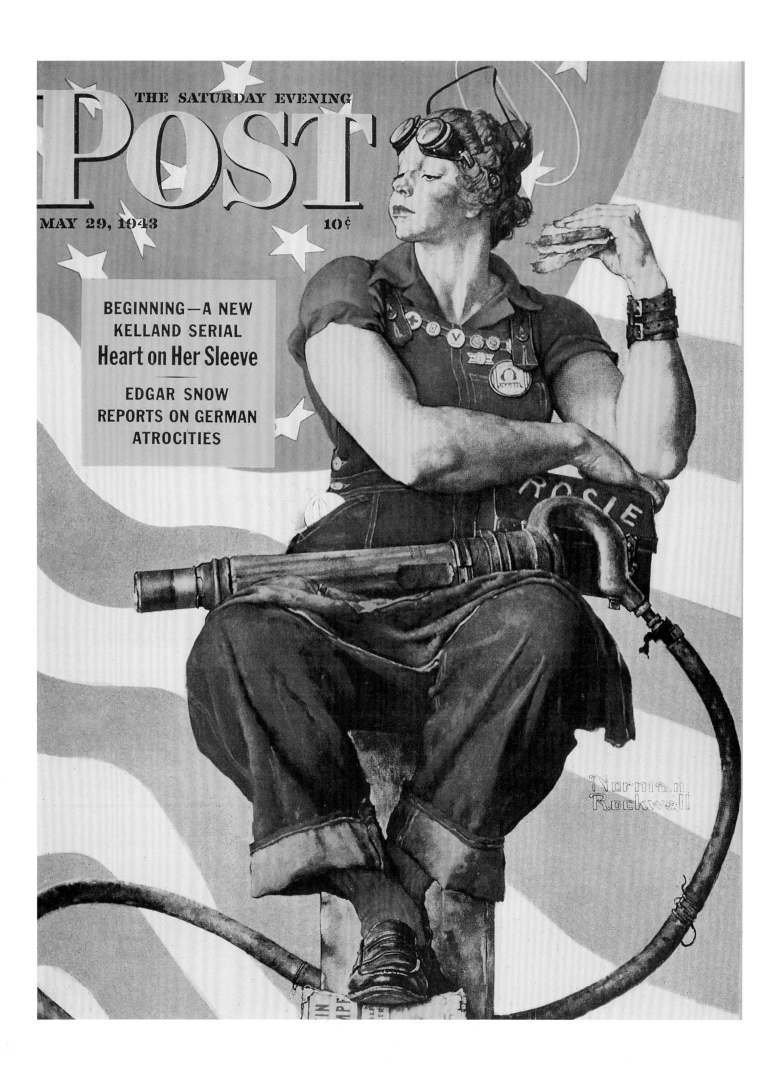

Not a lumberjack but he's okay;
Photograph of his son Brett by
Edward Weston, 1943.

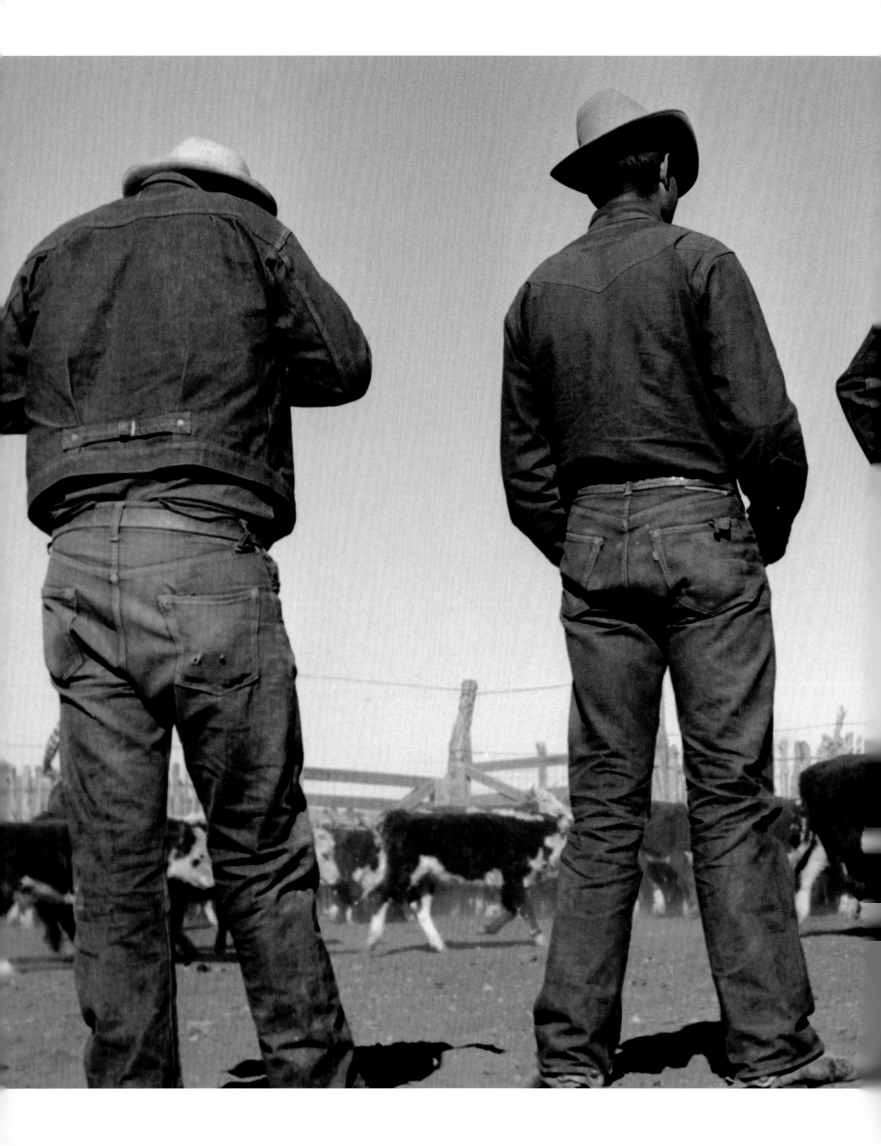

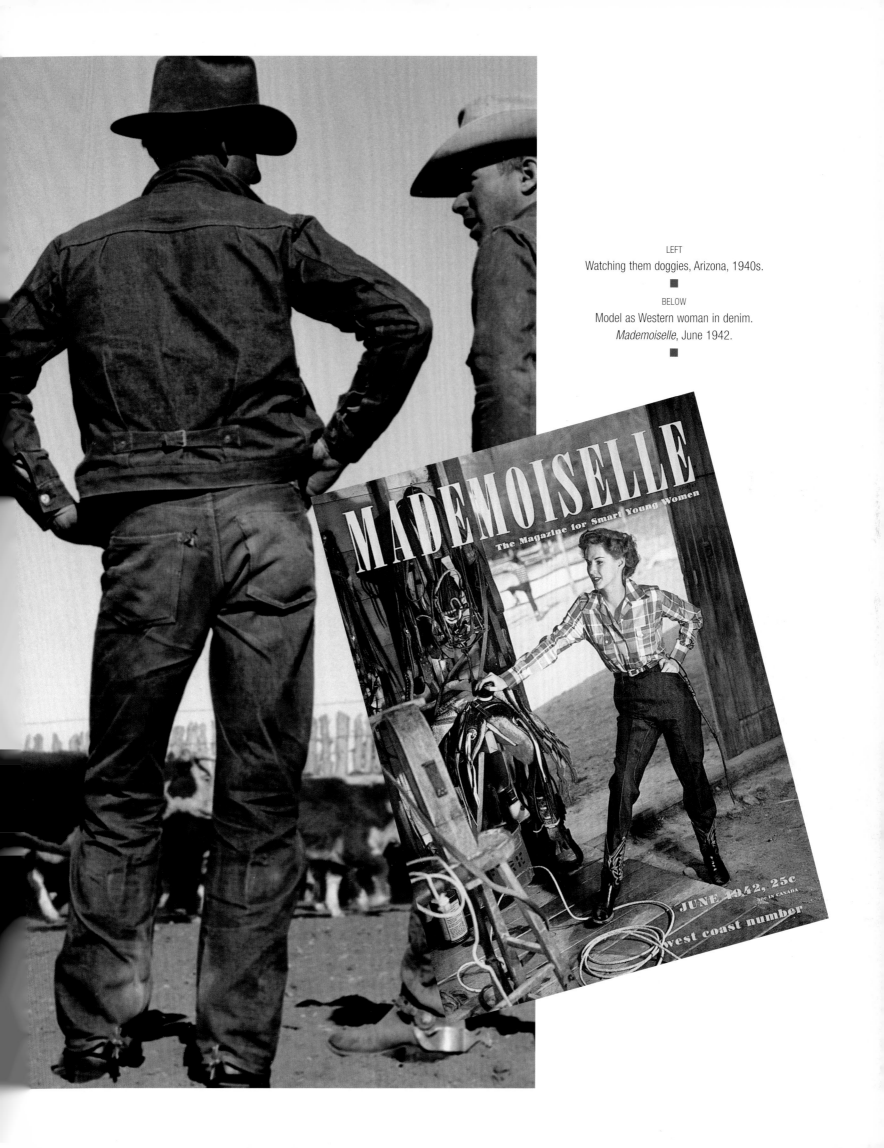

LEFT
Watching them doggies, Arizona, 1940s.
■
BELOW
Model as Western woman in denim.
Mademoiselle, June 1942.
■

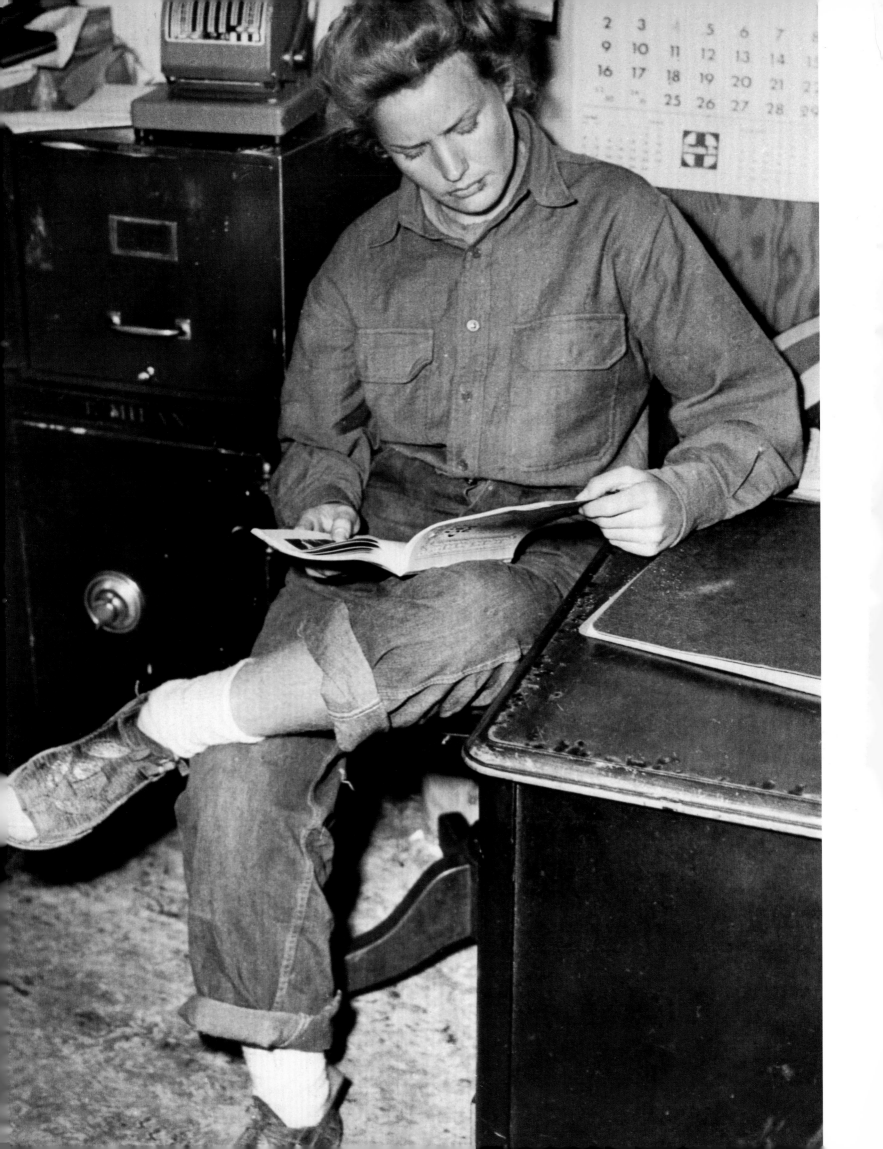

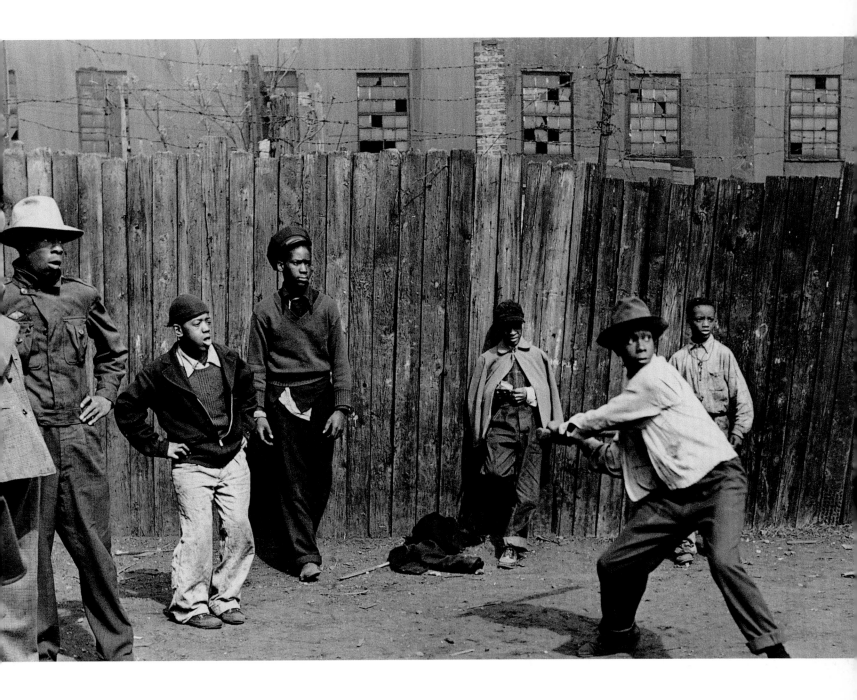

OPPOSITE
Good pants for a bad girl;
Frances Farmer in jail, 1943.

■

ABOVE
Sandlot Baseball, Chicago, May 1948.
Photograph by Wayne Miller.

■

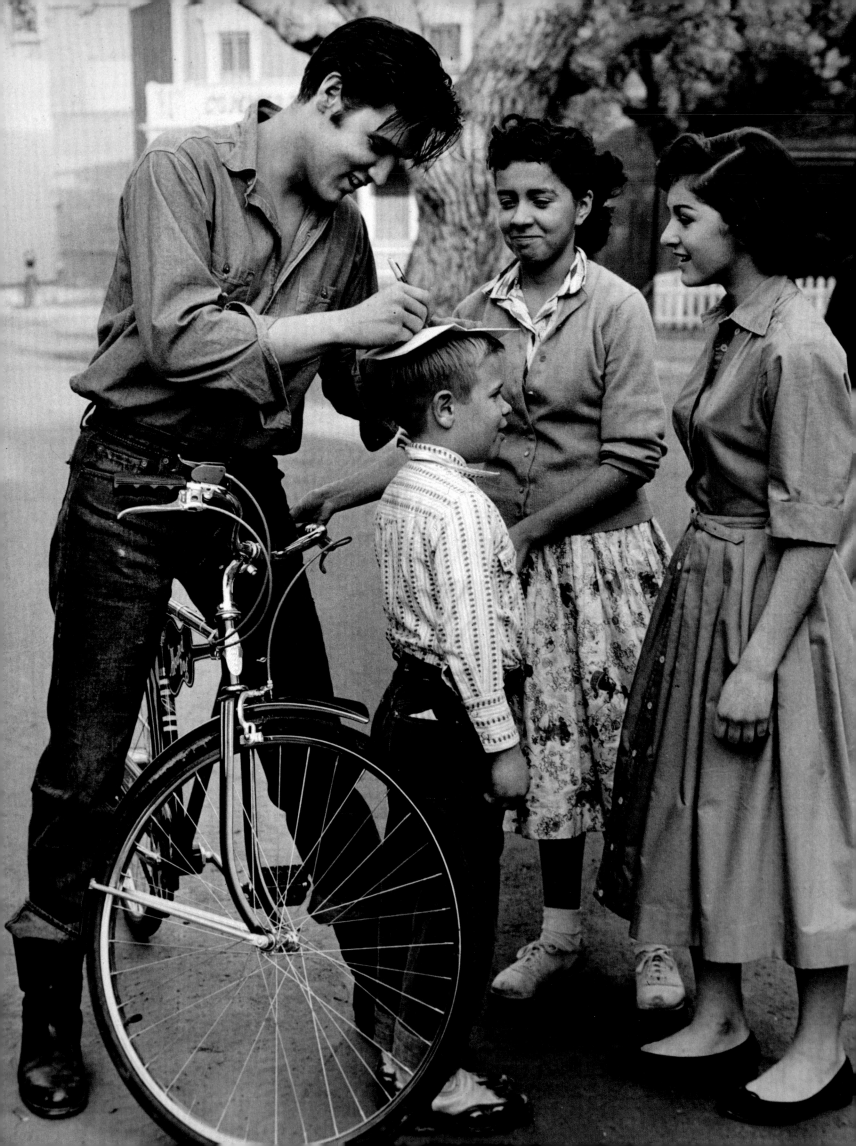

R

Ahead of his time;
Elvis Presley, 1957.

osie the Riveter was fine for a time of national crisis, but back home after the war American men did not encourage their ladies to make dinner dressed like they were about to pound the last spike into the Union Pacific Railroad. Once more, jeans became the provenance of men, and the gals, well, they were encouraged to try a little something in gingham, if not the fancy new look of big dresses from Dior.

Regardless of this gender monopolization (women's jeans would not become a major trend until the late 1960s), the return of the male work-force meant a revitalized market for denim, both for men, and increasingly, for children. Despite the increase in the visibility and popularity of jeans in the 1930s, Levi Strauss & Co. did not sell their products nationally until the late 1940s. An early campaign marketing jeans for teenagers, under the slogan "Right for School," elicited a mixed response from upright Easterners, not all of whom were receptive to slouchy western ways. One letter received at Levi's San Francisco head-quarters from an outraged Hillsdale, New Jersey correspondent told the company that encouraging denim in schools would contribute to "juvenile delinquency."

Once again, it was Hollywood to the rescue. While movies like *The Wild One* (1954) and *Rebel Without a Cause* (1955) did nothing to allay the fears of the people of Hillsdale about the corrupting qualities of jeans, they electrified American youth depicting the sensual, form-fitting quality of this working-class garment. Even better, their parents hated them.

In the bobby-socks and poodle-skirt vernacular of the era, blue jeans spoke of sex and danger. It was no mistake that when the 1950s came to be rehashed by the nostalgia series *Happy Days*, Richie Cunningham was in khakis while the Fonz wore denim. The decade's sexiest stars cut their look in blue jeans. Marlon Brando and James Dean sent shivers down teenage spines of both sexes while Marilyn Monroe single-handedly sent the Kinsey Scale lurching to the left as a saloon singer marooned

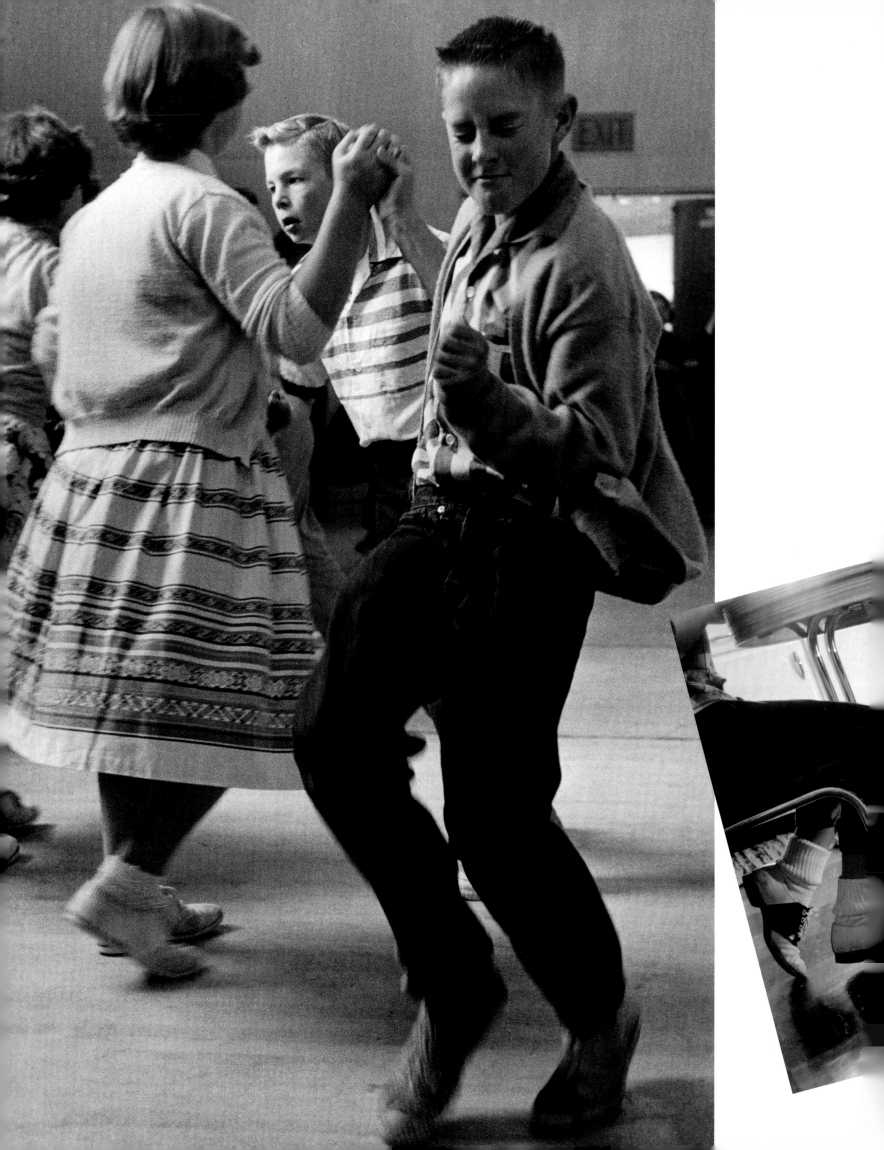

in the woods in a camisole and blue jeans in *River of No Return* (1954). She tipped the scale again in 1961 as a jeans-wearing ranch girl causing trouble between Clark Gable, Montgomery Clift, and Eli Wallach in *The Misfits*.

Elvis Presley donned denim in 1957 for his film *Jailhouse Rock*, where even a manslaughter rap couldn't keep his character from dripping sex on the screen. "How dare you think such tactics would work with me?" demands an outraged Judy Tyler, struggling free from a twenty-two-year-old jeans-clad Elvis, who has just planted one square on her lips. "They ain't tactics, honey," he mutters, his mouth curling into a half a smile; "it's just the beast in me." At that moment there was no question where the beast was, and it was denim that was holding it in.

Kinsey's macho-male "zeros" weren't the only ones paying attention to blue jeans in the '50s: on a scale where zero was exclusively heterosexual and six was completely homo, fours and up were occasionally leafing through magazines like *Physique Pictorial*, so-called "physical culture" monthlies featuring photo shoots of shirtless outdoorsy types working on their bodies. In 1957, Touko Laaksonen—the prolific gay artist who would be remembered by history as Tom of Finland—contributed his first illustration for a *Physique Pictorial* cover: a lumberjack riding a log downriver. He was blond, shirtless, and wearing jeans cuffed midway up his calves—and a dark-haired one just like him was following on a log behind.

41

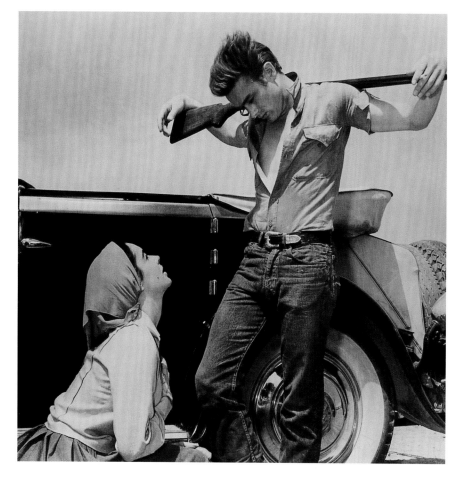

Themes of denim and leather would dominate the artist's work until his death in 1991, contributing to the unassailable status that tight blue jeans have held since the inception of modern gay culture.

In 1959, American denim laid seeds in another sleeping market when Levi's was invited to exhibit at the "American Fashion Industries" show in Moscow, encouraging interest in a Western commodity that would come to dominate the black markets of the Cold War Eastern Bloc. At home, the consumer market for blue jeans shifted from working men to fashion-conscious teenagers for the first time. The middlebrow national retail chain J.C. Penney even went so far as to market the garments to women. But the country's postwar prosperity also brought an unpredicted downside to the sales of blue jeans: despite denim's on-screen glamour, consumers who now could afford dressier fabrics generally bought them. Demand dipped so much that Cone's original mill in Greensboro shifted its production from denim to khaki.

History, though, was on the side of jeans. The U.S. baby boom, which had been building for a decade, peaked in 1955 at twenty-five births per 1,000 heads of household—meaning an awful lot of teenagers were coming down the pike. And if production faltered toward the end of the 1950s, nothing would prepare jeans manufacturers for the denim-mania that was about to break in the following decade.

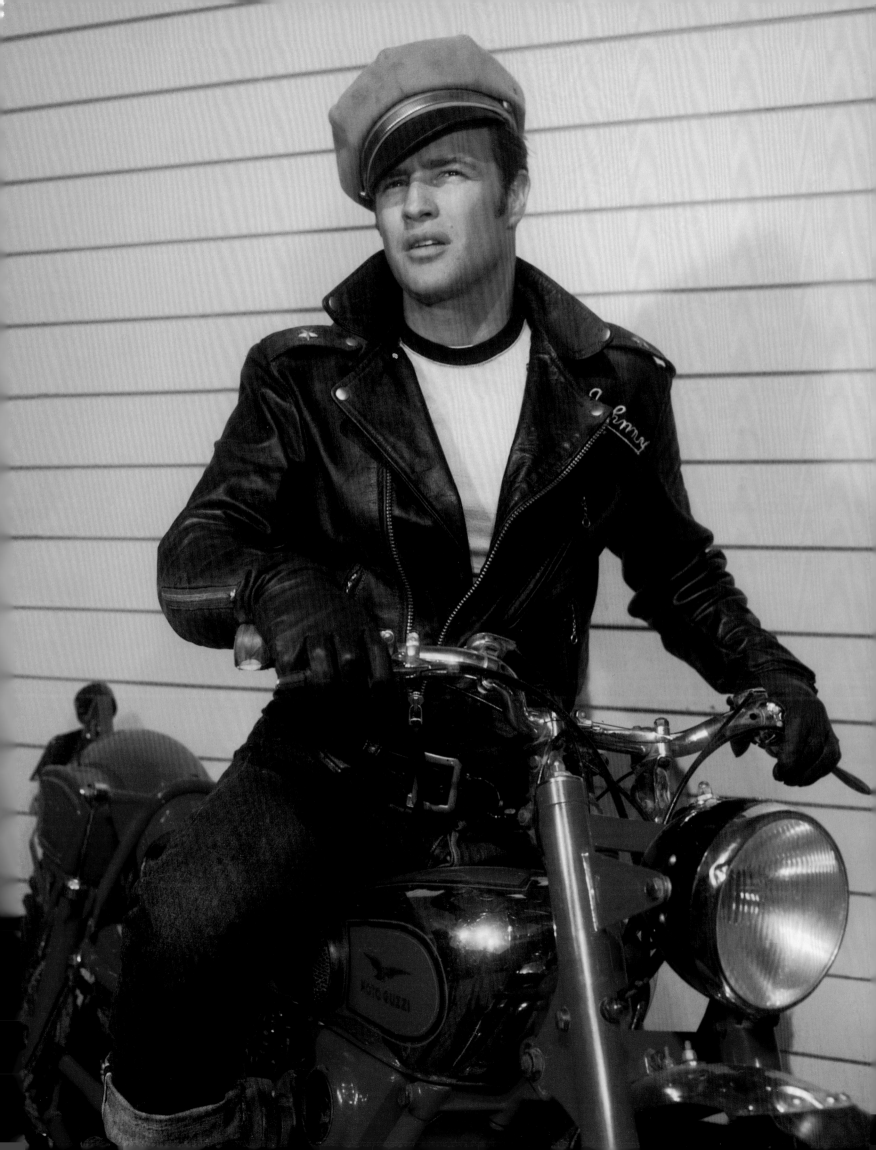

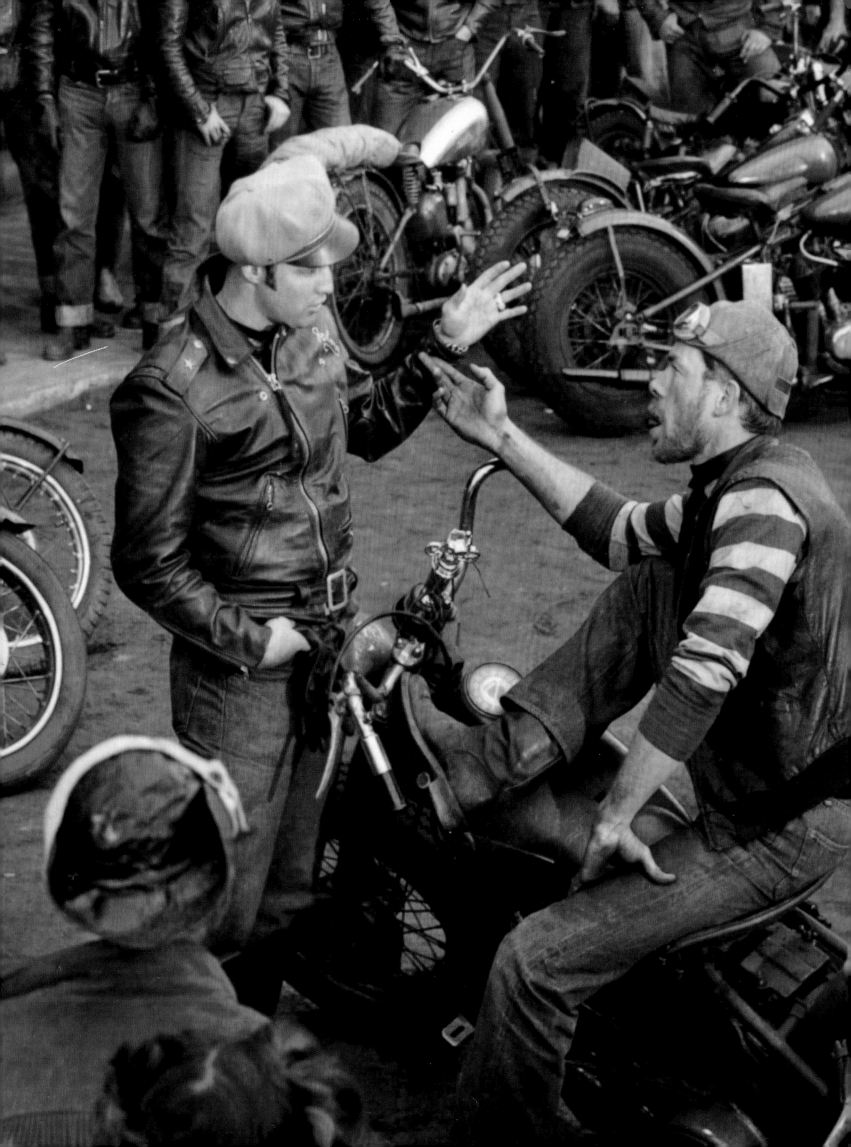

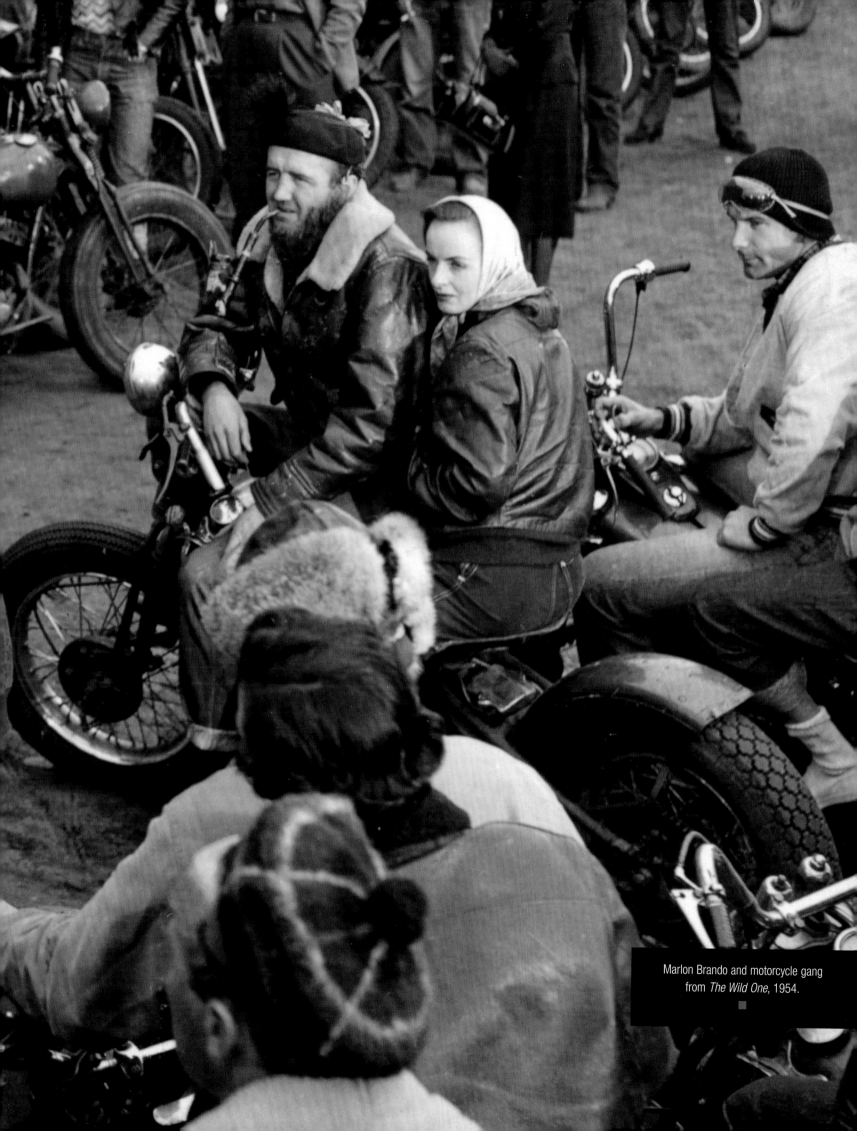

Marlon Brando and motorcycle gang from *The Wild One*, 1954.

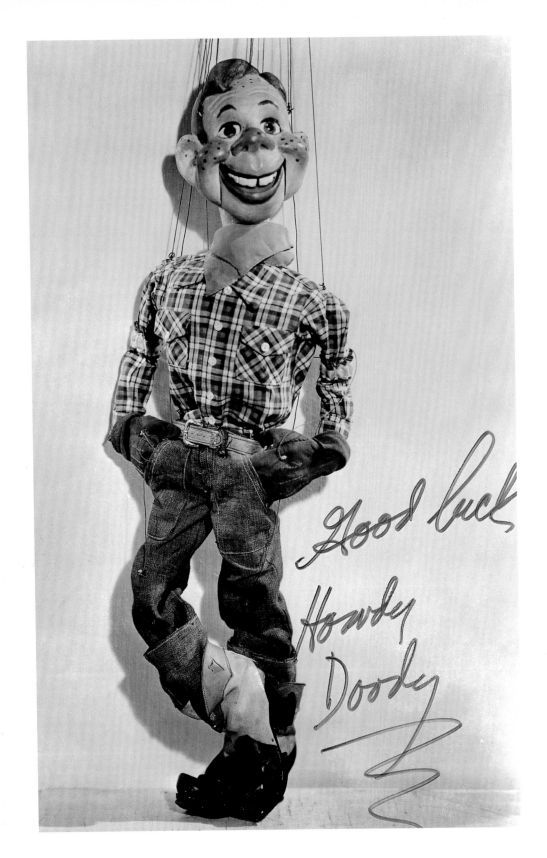

Good luck
Howdy
Doody

Wholesome—and then some: Howdy Doody, Sandra Dee, and Ozzie and Harriet making jeans acceptable.

■

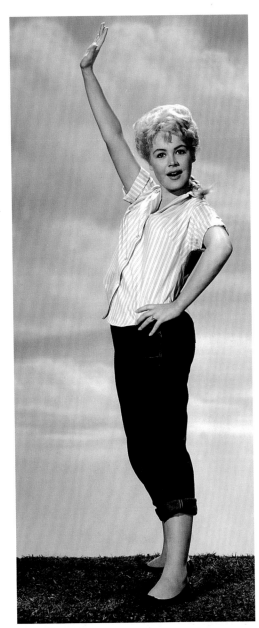

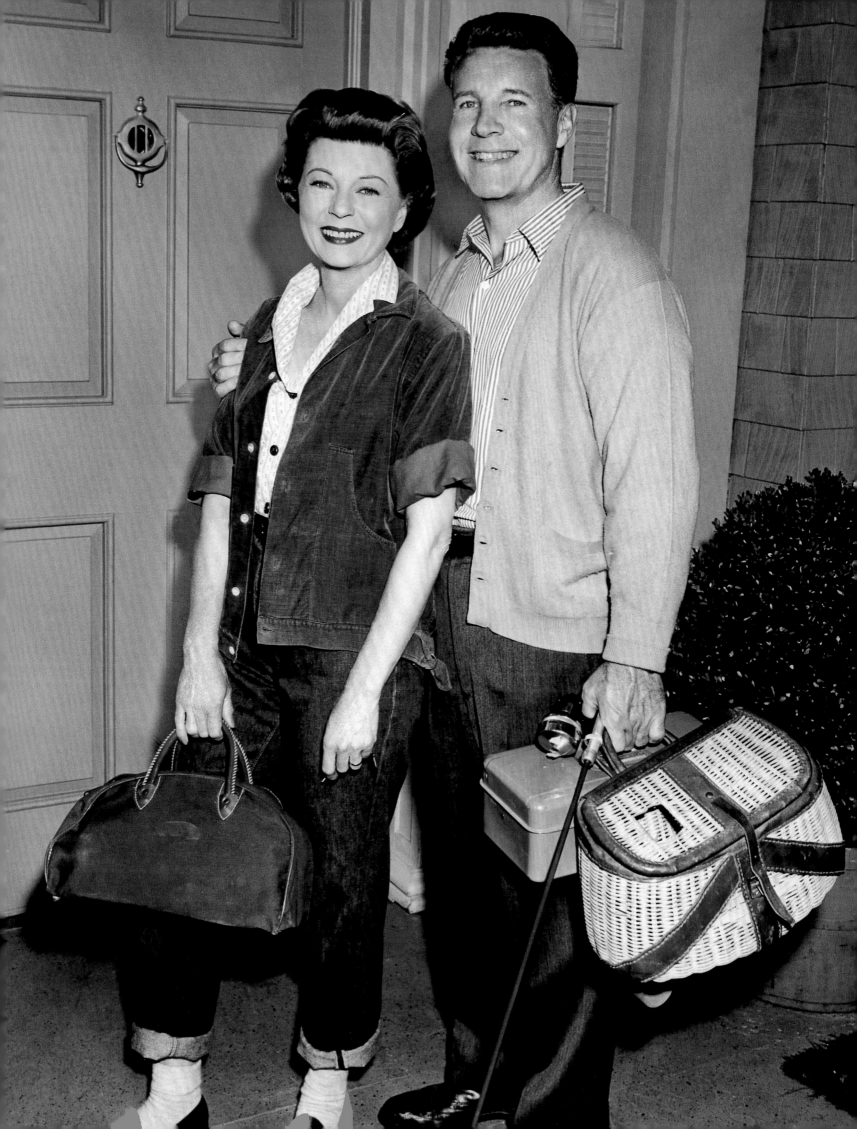

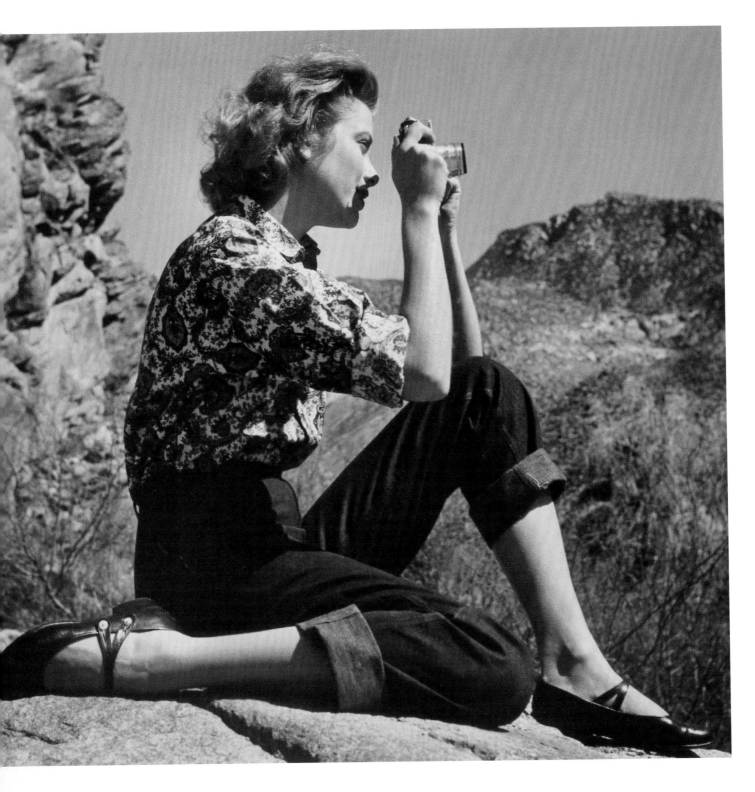

ABOVE
Grace Kelly, 1954.

■

OPPOSITE
Gene Kelly in *Thousands Cheer*, 1943.

■

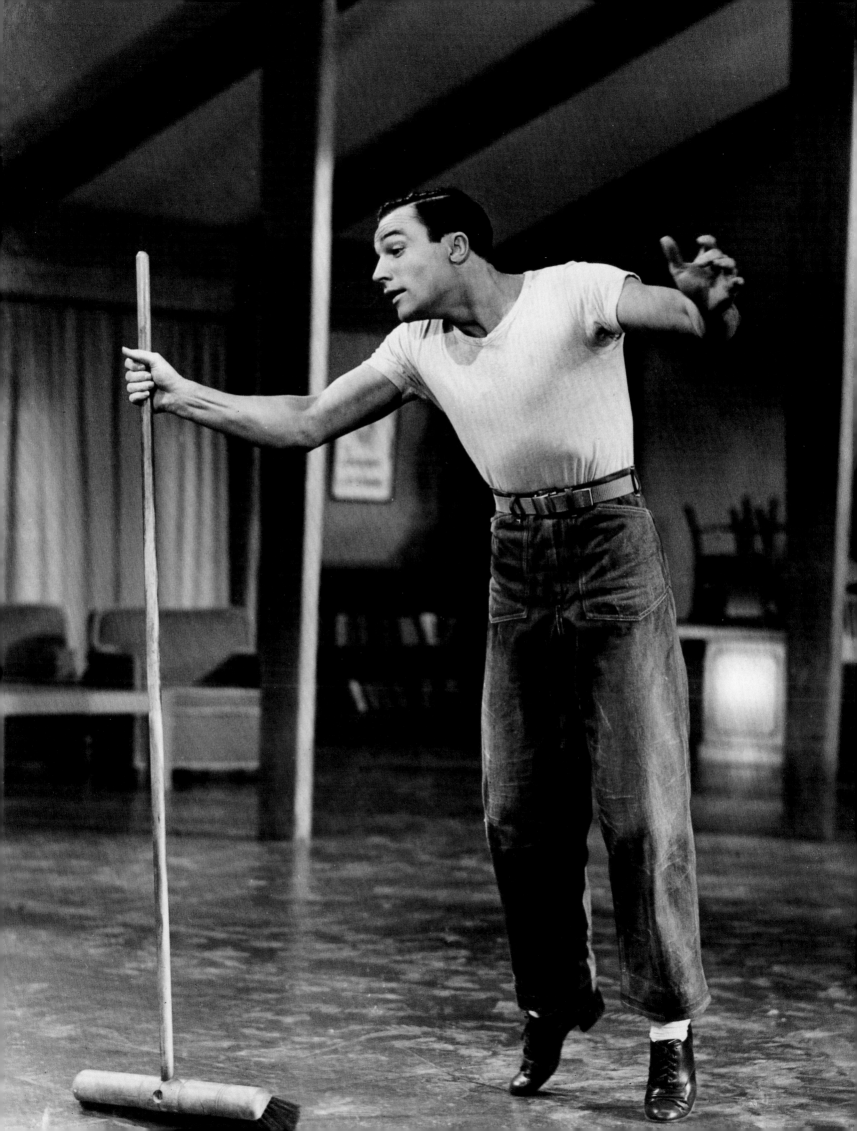

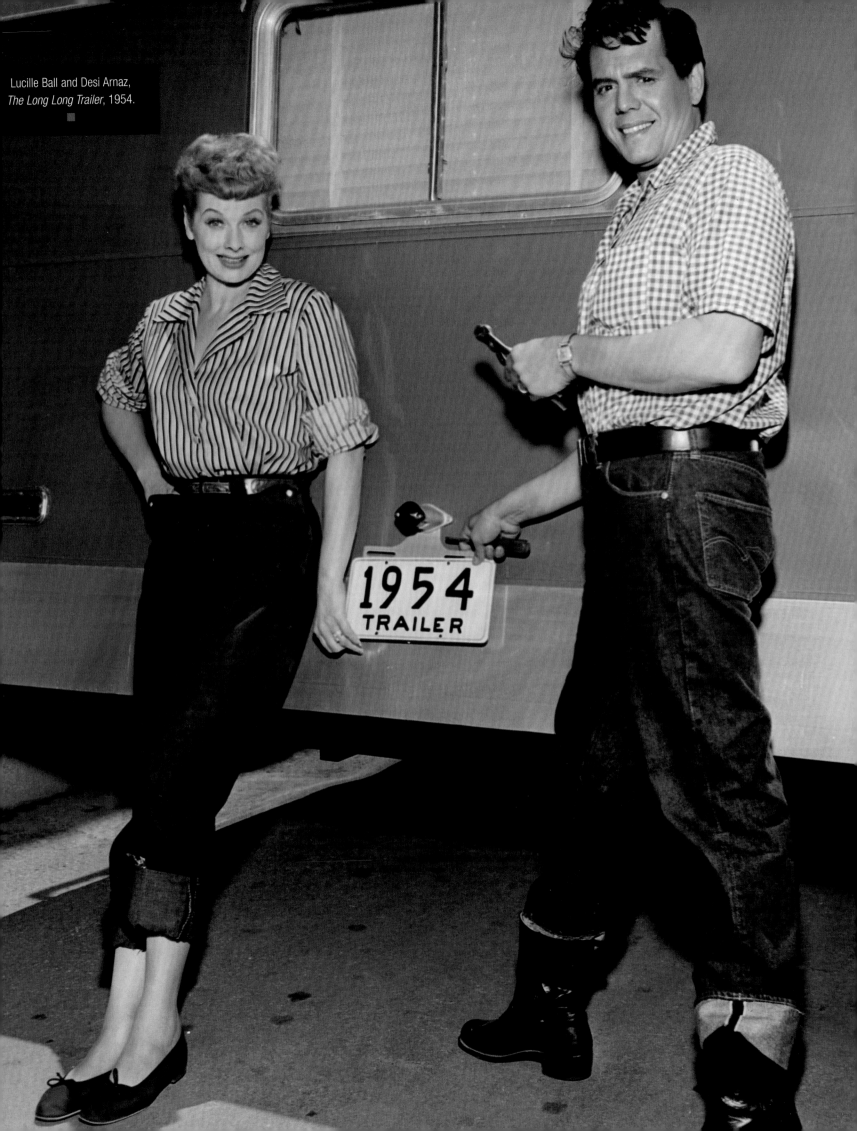

Lucille Ball and Desi Arnaz,
The Long Long Trailer, 1954.

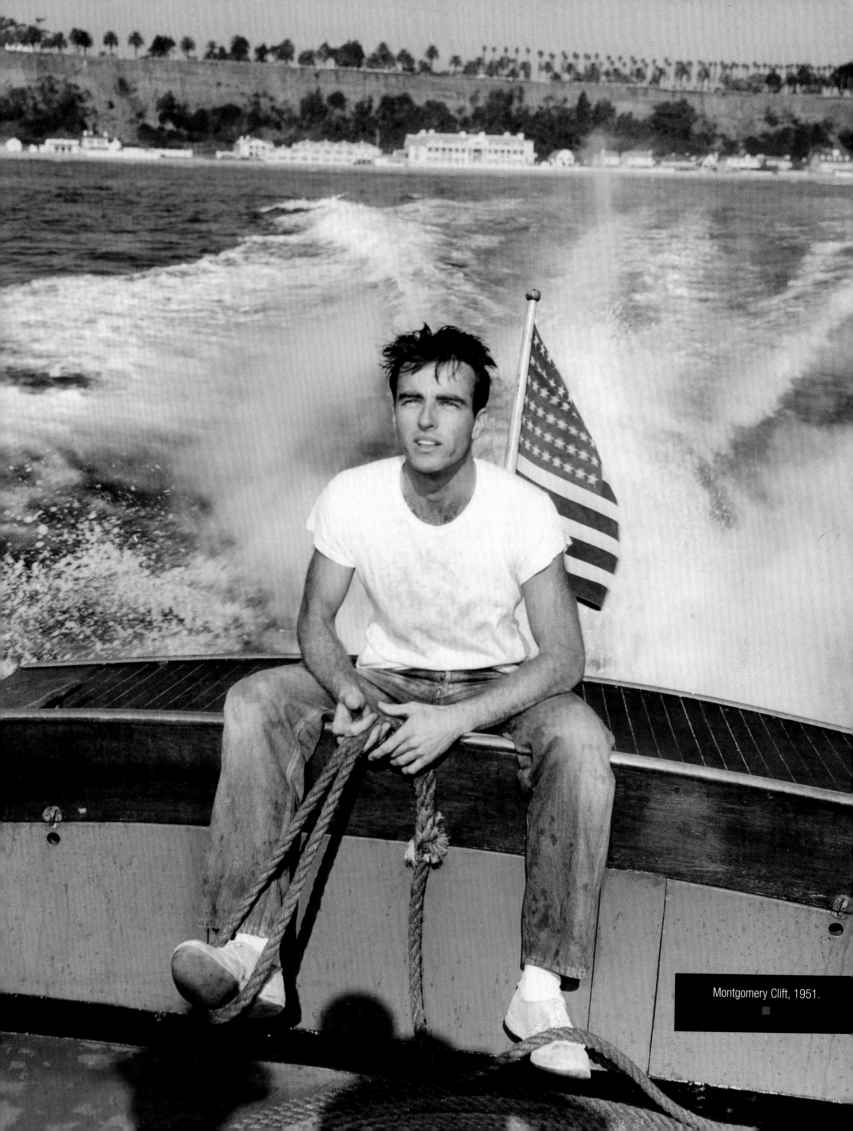

Montgomery Clift, 1951.

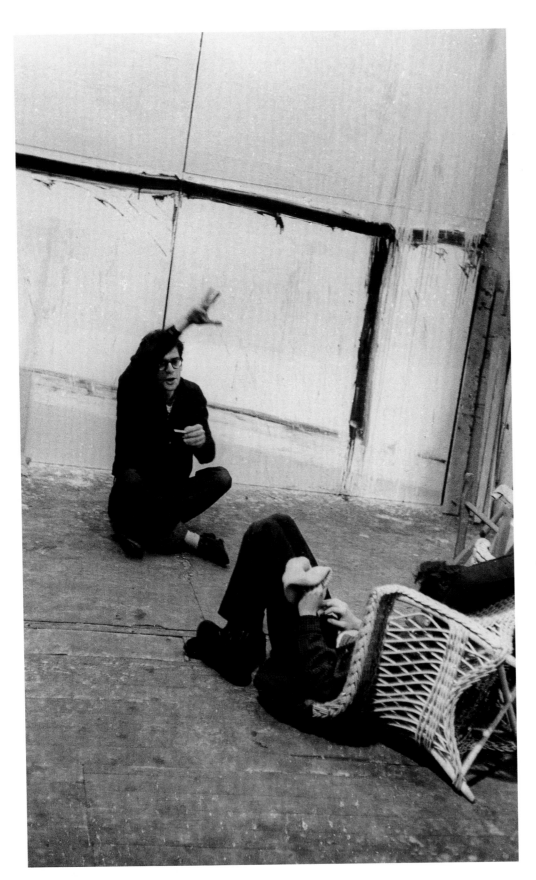

LEFT
Allen Ginsberg and Gregory Corso,
Pull My Daisy, 1959. Photograph by
John Cohen.

■

OPPOSITE
Jackson Pollock, 1951. Photograph
by Hans Namuth.

■

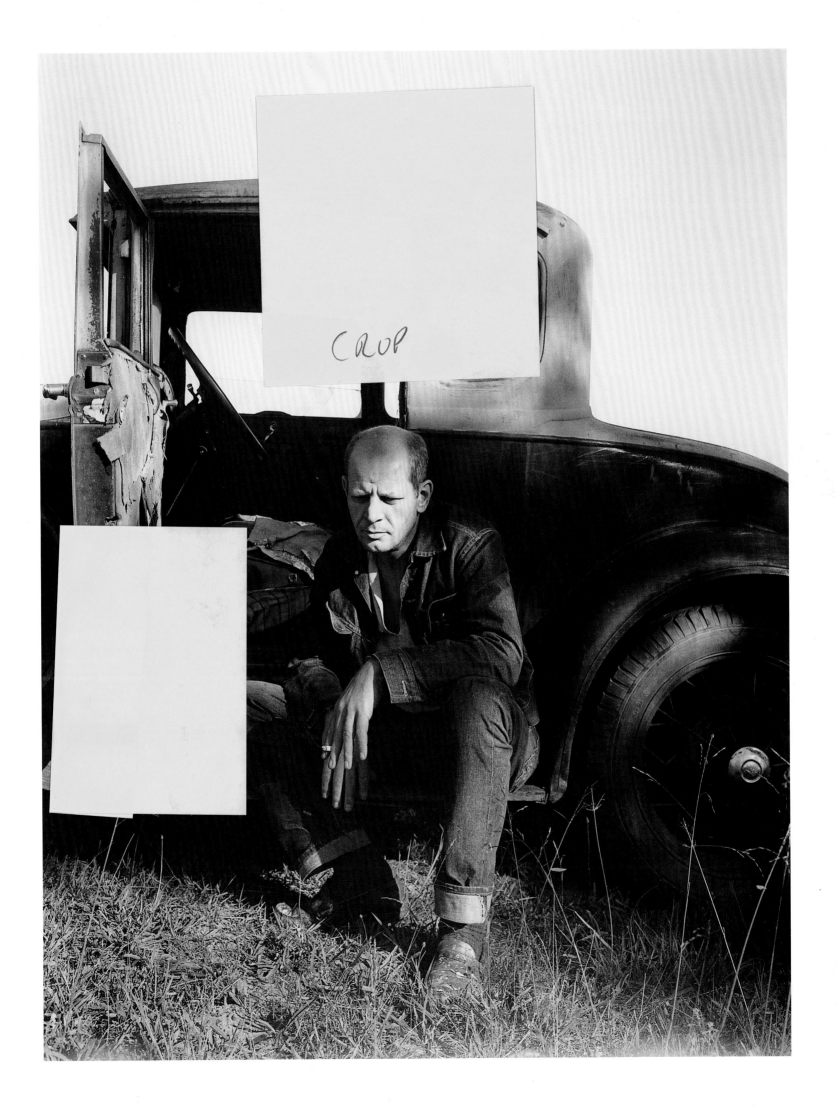

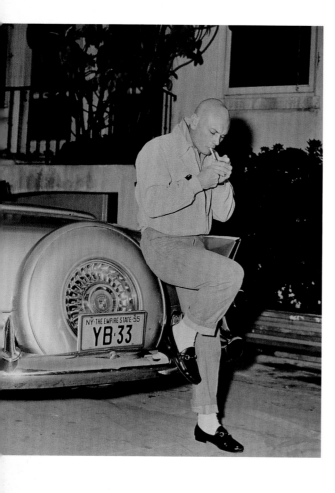

ABOVE
The bald and the beautiful; Yul Brynner, 1955.
∎

RIGHT
Boys under the hood, Wichita, Kansas, 1957.
Photograph by A.Y. Owen.
∎

I f the 1950s were the decade that made jeans radical, in the 1960s they became a uniform. In the peculiarly conformist way that young people choose to rebel, blue denim became standard-issue fatigues in the generational warfare that developed as baby boomers shot into their teens and young adulthood.

A NATION REBELS & UNISEX SELLS

Marilyn Monroe,
The Misfits, 1961.
Photograph by
Eve Arnold.

■

An ironclad law of pop culture is that the dangerous becomes the glamorous. Sometimes it's literal, as in the latter-day "heroin chic," or the trend amongst multi-millionaire hip-hop moguls to carry guns. But more often the dangerous becomes the glamorous symbolically, like a kid with a mullet and an AC/DC tee-shirt in the 1970s, or in the 1960s, a pair of dirty blue jeans.

It did not take denim long, once it emerged as the street style of American youth, to end up on the stages and album covers of the era's rising rock gods. As rock 'n' roll shed the skinny ties and matching jackets of its early pass at American Bandstand respectability, a new breed of spindly, sexualized young men stalked the stage, often wearing blue jeans and little else. "Jeans," Marshall McLuhan observed in a *Newsweek* interview, "represent a rip-off and a rage against the establishment."

Even in the early years of the decade, before the youth revolution of the mid- and late-1960s, denim had adopted a cultural significance beyond its function. In 1964, a pair of Levi's became part of the permanent collection of the Smithsonian Institution in Washington, D.C. And abroad, jeans were continuing to gain in popularity as a quintessentially American fashion statement. Between 1963 and 1965, Japan gave birth to three indigenous denim labels: BF Jeans, Canton, and Maruo Hihuko (now sold as Big John). Japanese consumers had prized jeans as a fashion item for almost twenty years. But with no retail outlets for the American product, they had become used to the worn feeling of used denim picked up in thrift stores. "The need to replicate the feel of a used pair of jeans led Japanese manufacturers to develop completely new finishes, including stone washing and chemical washing," observed fashion bible *Women's Wear Daily* in a May 2000 jeans retrospective. As much as European designer jeans would influence American consumers in the 1970s, this was an early indication of how foreign ingenuity would contribute to the culture of American denim.

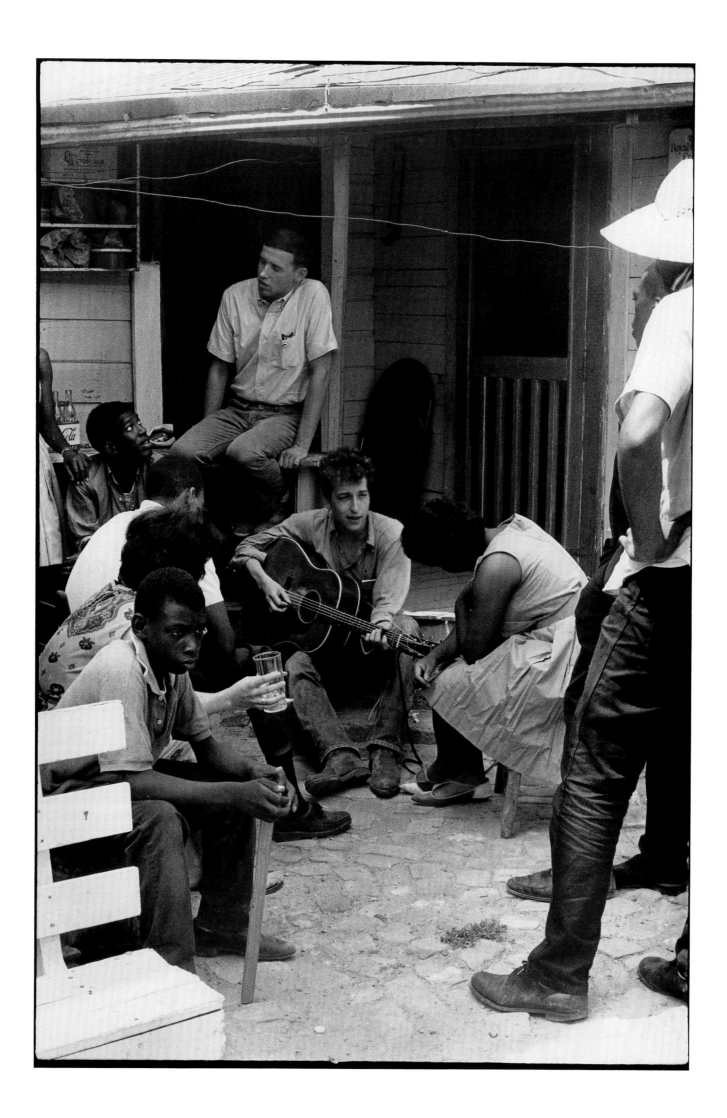

Of course, if American fashion is about anything, it's about sportswear and marketing—and in the United States denim was becoming increasingly associated with popular culture. Levi's recruited musical groups like Jefferson Airplane and Paul Revere and the Raiders to record radio spots for their jeans in 1967. In January 1968, *Vogue* photographed the aristocratic Austrian model Verushka in a fourteen-page spread on denim skirts. In the same month, a story on French artist Niki de Saint Phalle noted that she "works in white jeans—on which she jots memos and notes." Denim manufacturers saw rising sales, particularly among their women's products.

With the growing popularity of jeans for women—not as novelty resort wear for a dude ranch, but as a practical outfit for daily life—America had its first unisex garment. There were still plenty of places in the 1960s where pants of any kind were a radical statement for women. But the willingness of a new generation to slip on a pair of jeans to wear on the streets was not simply about fashion. It was among the first stirrings of the nascent feminist movement that would soon be challenging almost every assumption about the role of women in America.

Bob Dylan plays behind the office of the Student Nonviolent Coordinating Committee (SNCC), Mississippi, July 1962. Photograph by Danny Lyon.

■

And it wasn't just feminists. In the south, African-Americans pioneered a non-violent form of civil disobedience that would become the model for all American protest movements, from the expanding civil rights cause to critics of the Vietnam War. Even the dapper Rev. Martin Luther King, Jr. was photographed wearing a stiff new pair of blue jeans. Jeans were worn on the weekend of June 27, 1969 when protestors against police harassment at the Stonewall Inn in New York launched the modern gay rights movement. Anyone who took to the streets in those years discovered that blue jeans were the ideal fatigues in which to do battle with the establishment.

But jeans were also the official uniform for those interested in making love, not war. From San Francisco to the West Village, young people were beginning to personalize their favorite worn-in jeans with patches and slogans. By the time of the Woodstock Music and Art Fair in August, 1969 the only socially acceptable alternative to wearing jeans was to wear nothing at all.

Little did the laid-back Woodstock generation realize, as they relaxed in their frayed blue jeans with their bare backs against the grass and a daisy stalk between their toes, that jeans were about to go very...glam.

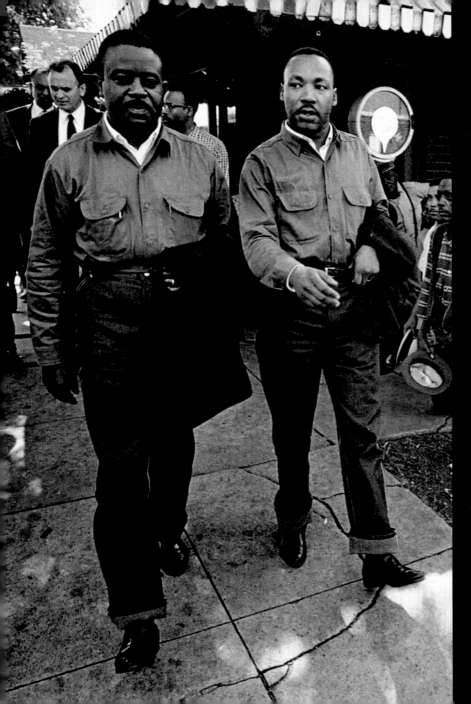

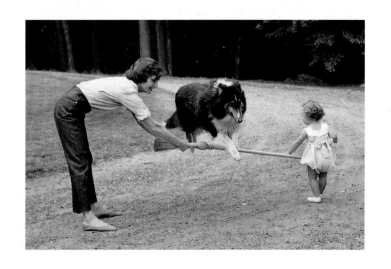

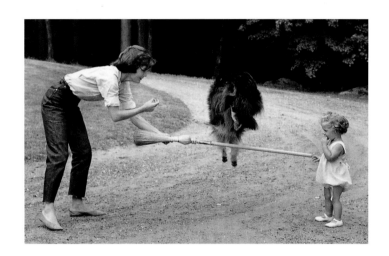

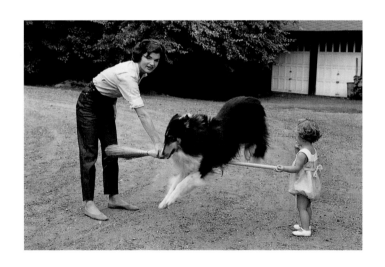

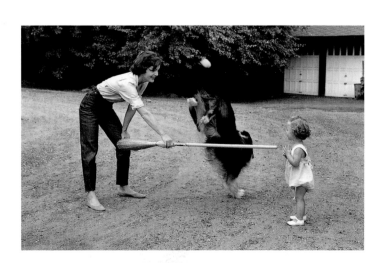

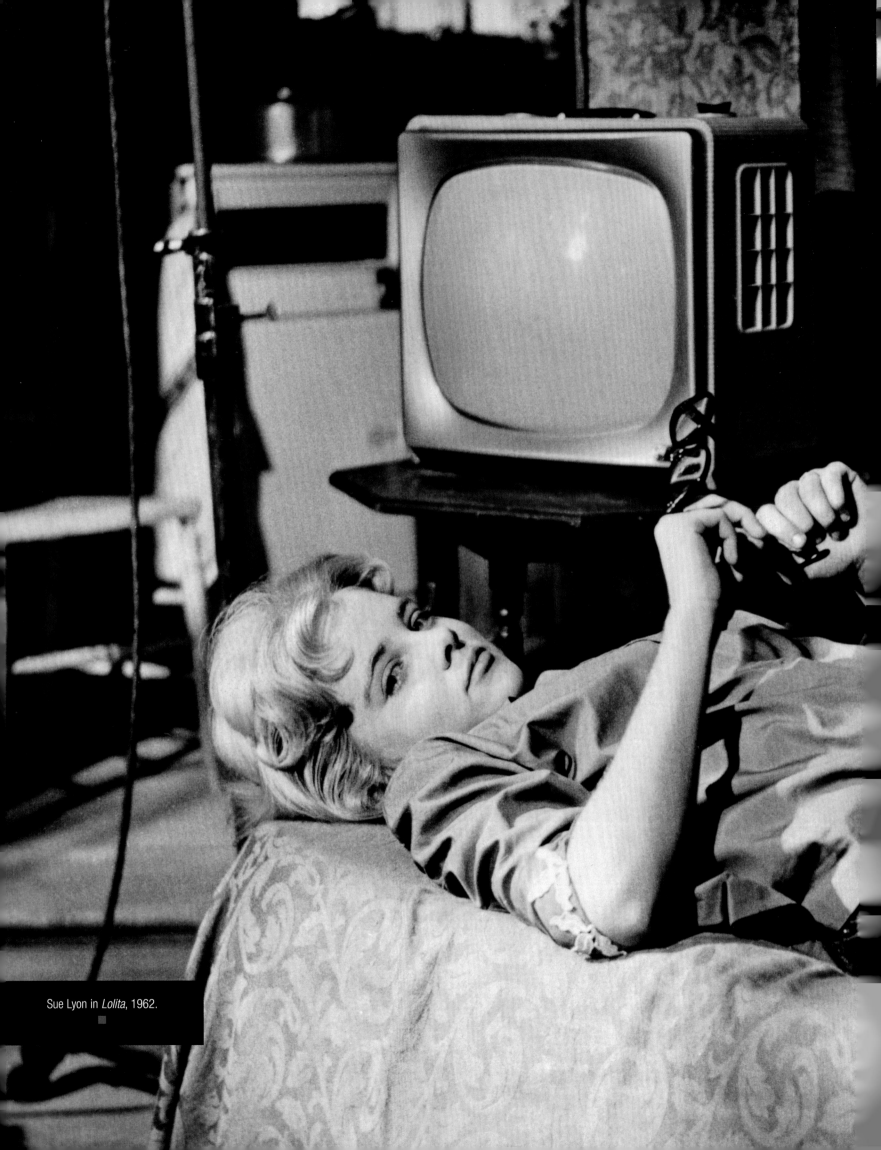

Sue Lyon in *Lolita*, 1962.

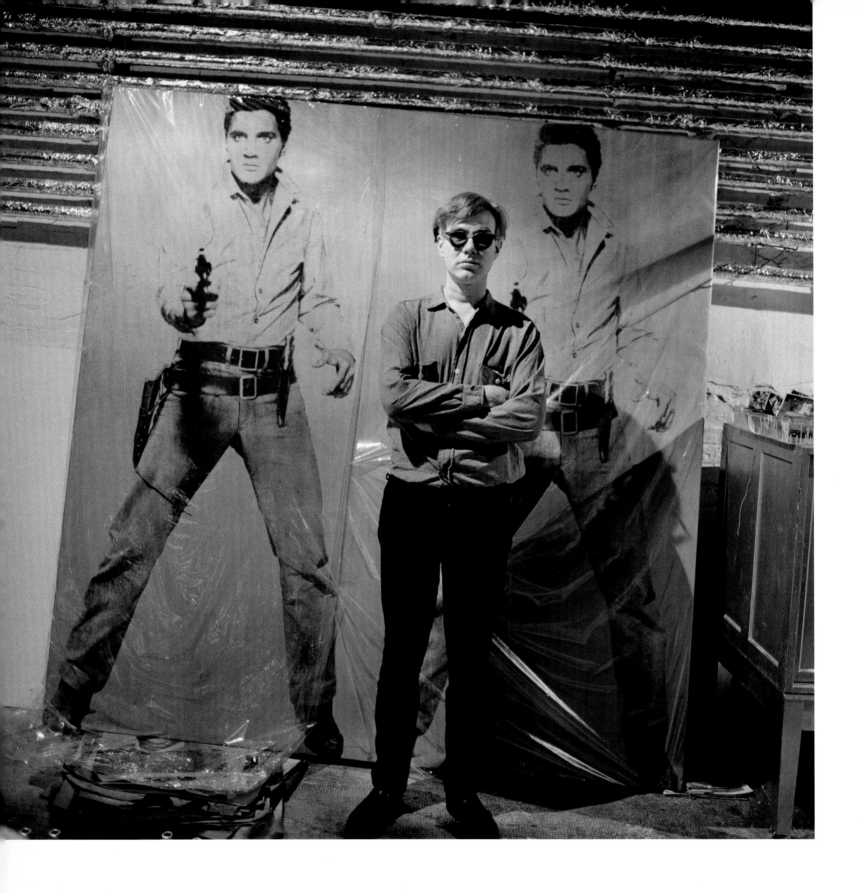

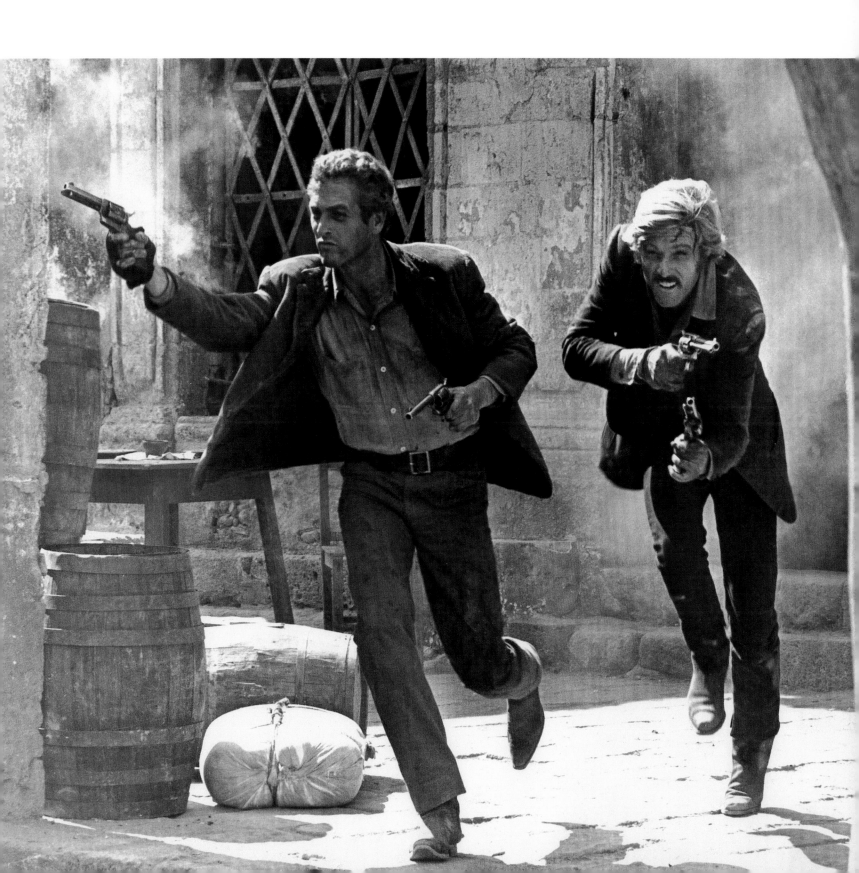

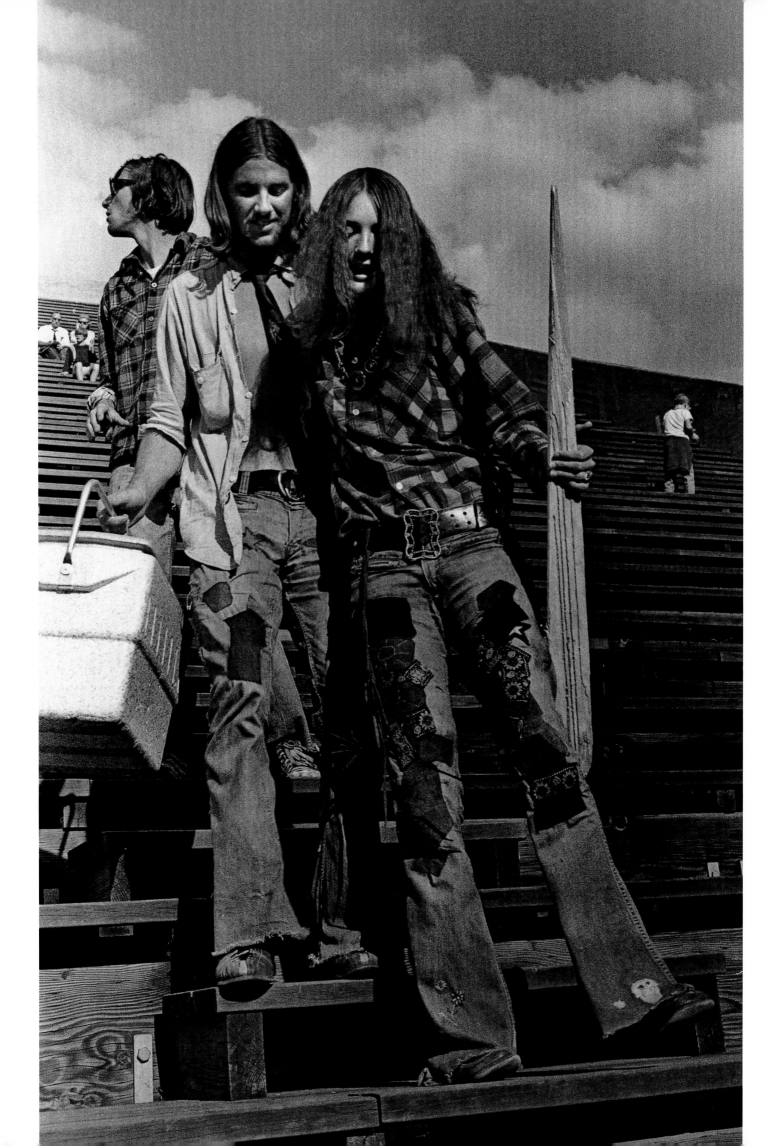

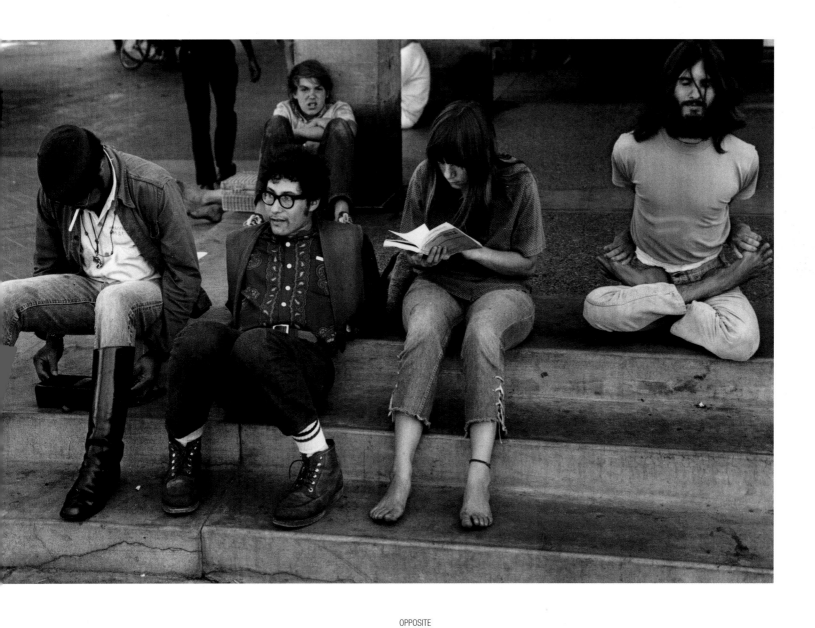

OPPOSITE
Youth, 1960s.
Photograph by Larry Fink.

■

ABOVE
Berkeley campus, 1968.
Photograph by Dennis Stock.

■

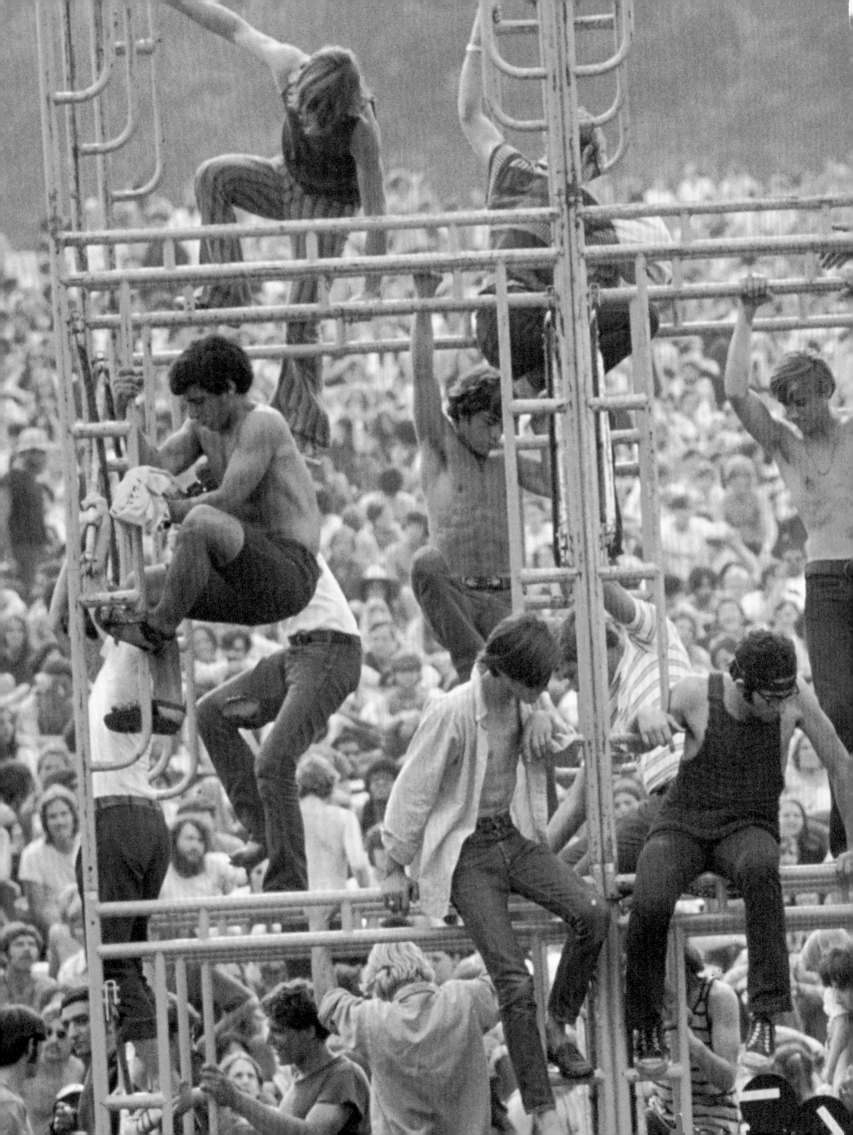

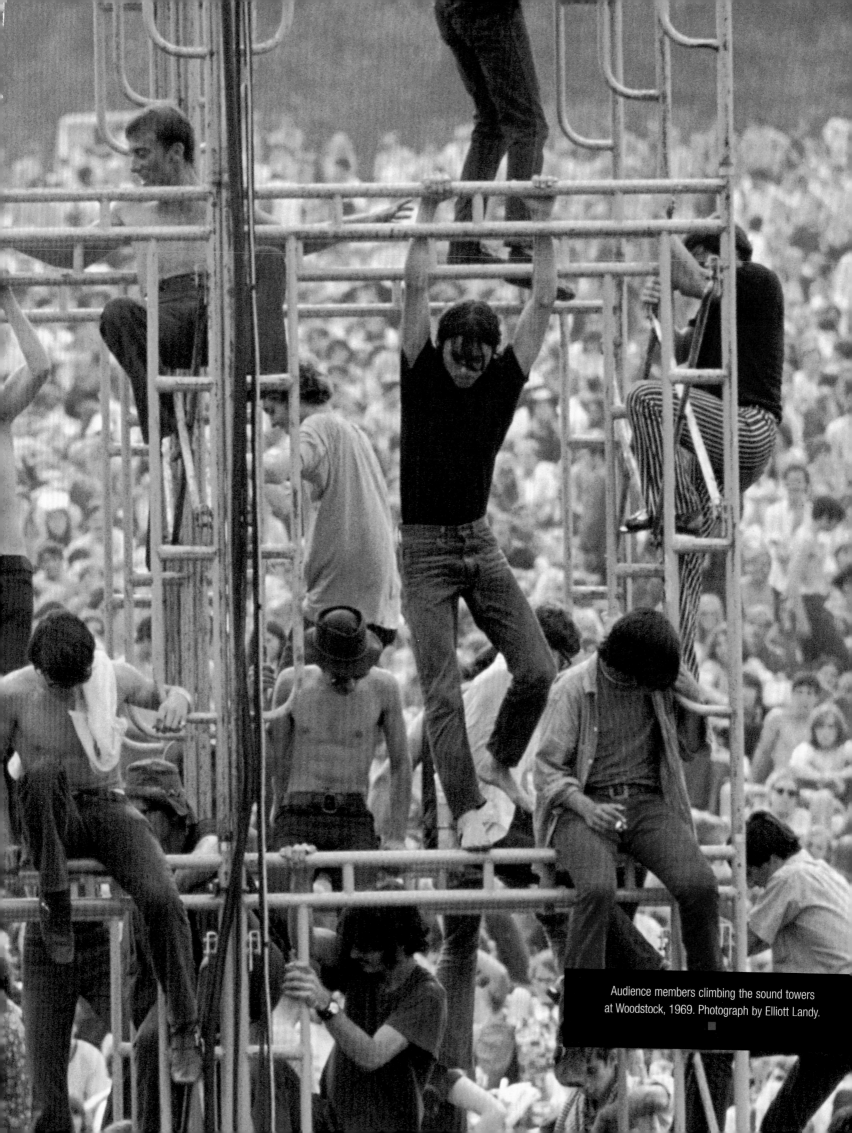

Audience members climbing the sound towers at Woodstock, 1969. Photograph by Elliott Landy.

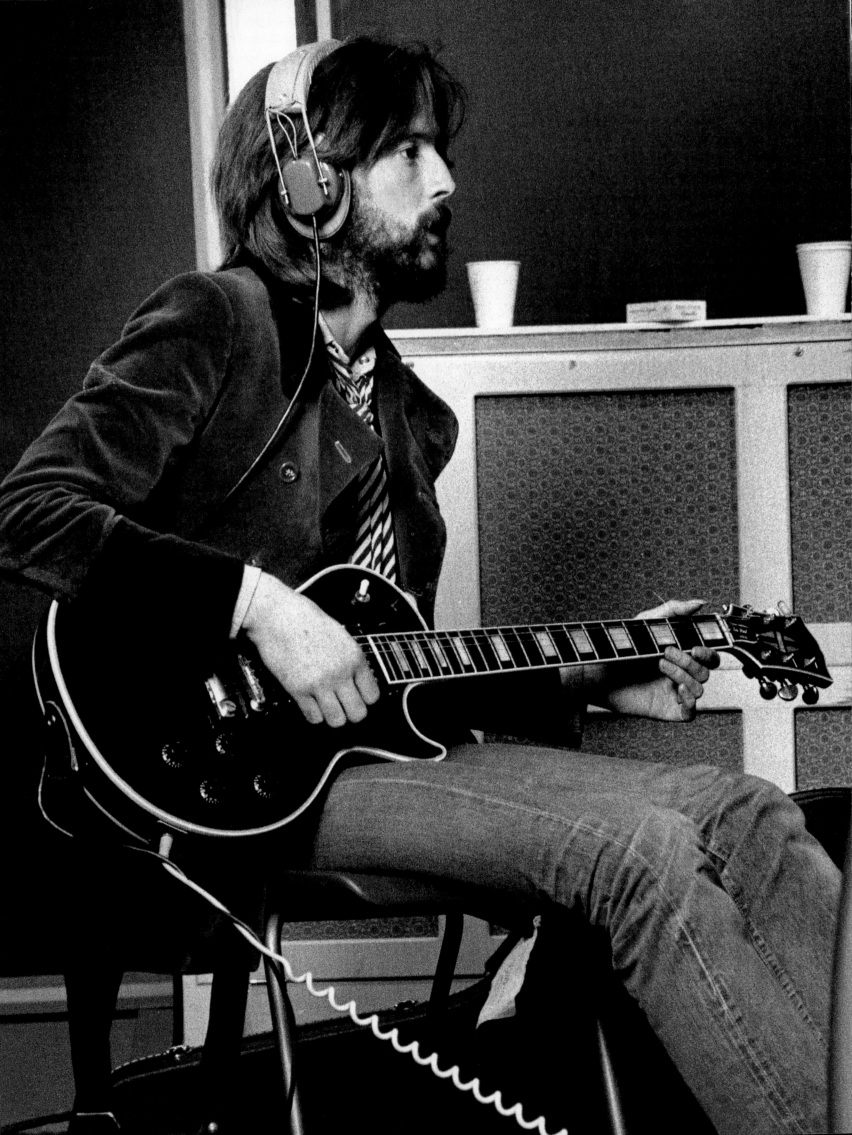

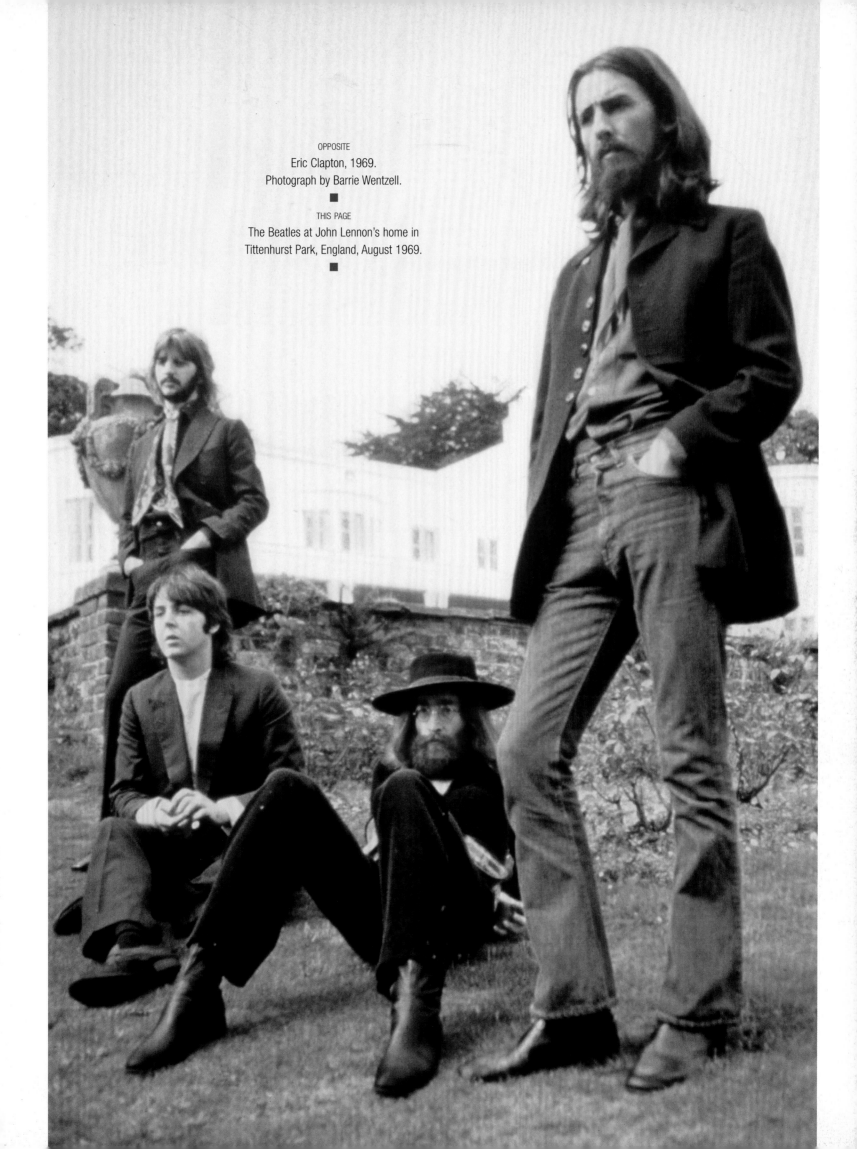

OPPOSITE
Eric Clapton, 1969.
Photograph by Barrie Wentzell.
■
THIS PAGE
The Beatles at John Lennon's home in
Tittenhurst Park, England, August 1969.
■

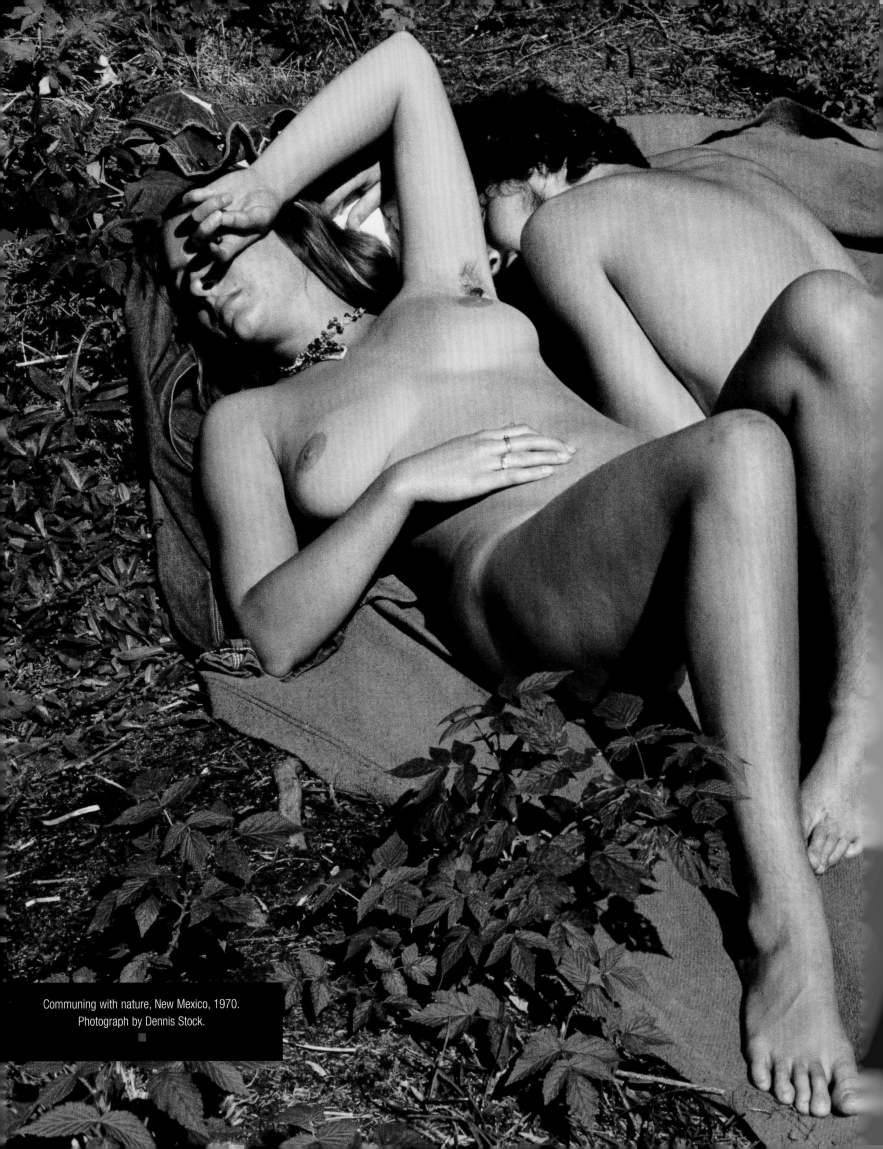

Communing with nature, New Mexico, 1970.
Photograph by Dennis Stock.

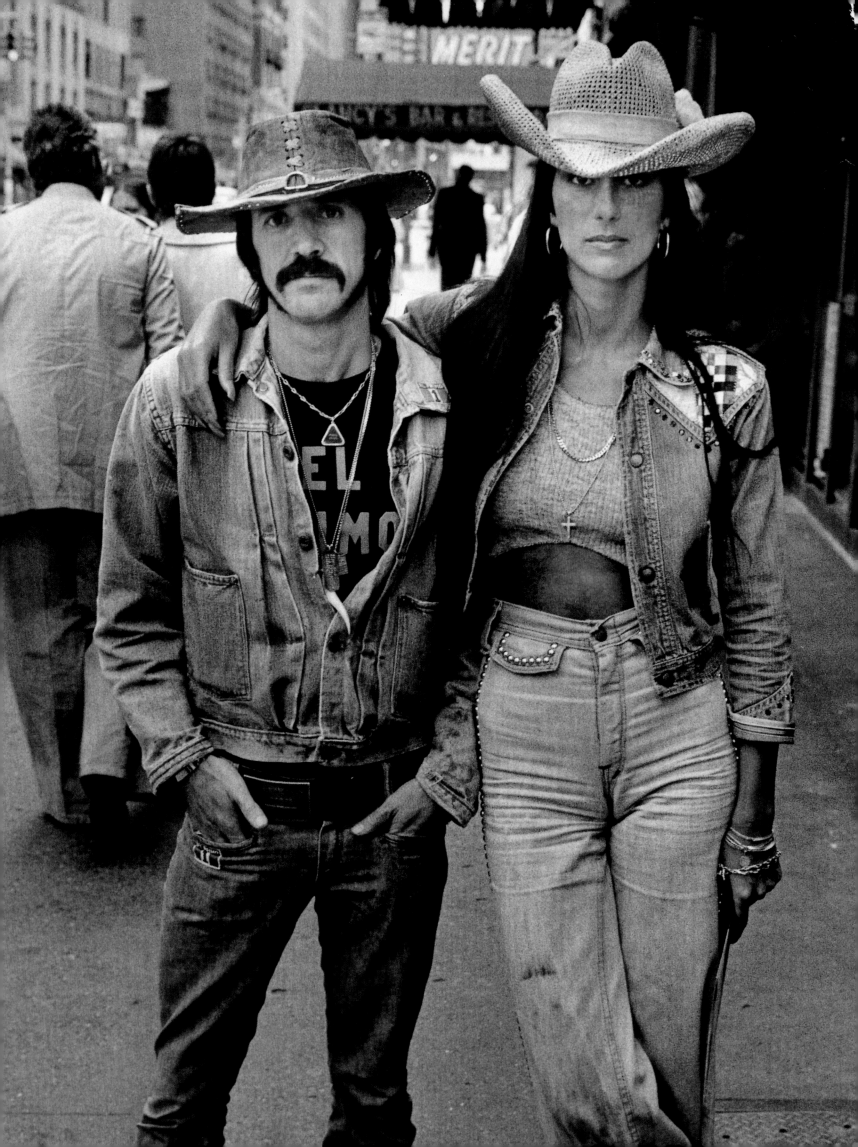

THE BLUE-ING OF AMERICA

I got blue, babe;
Sonny and Cher, 1973.
Photograph by
Bob Gruen.
■

In the transitional '70s, which started earnestly and ended glamorously, you weren't any-one if you weren't in blue jeans. They started the decade on the Rolling Stones, hung out at the Factory with Andy Warhol, put the wings on Charlie's Angels, witnessed the goings-on of Margaret Trudeau at Studio 54, and ended the era with a sexy teenage diva declaring her allegiance to Calvin. Like Forrest Gump, jeans were everywhere. Even New York's haute-fashion designer Bill Blass declared: "Levi's are the best single item of apparel ever designed."

As jeans took to the uptown streets, their cultural credibility opened the way for denim to be taken seriously as a high-fashion fabric. It appeared on the cover of *Vogue* for the first time in January 1971, as the collar of a calf-length dress worn by French actress Catherine Jourdan. For those wanting a more mainstream take on cool, Lee invented in 1972 the leisure suit ("Leesure Suit"), based on a five-pocket knit jean with a matching jacket. "Jeans Art" fairs for personalizing blue jeans became a fad on college campuses across the country—starting with "Smart Ass Art" at Wesleyan University in 1973.

Since the Summer of Love, of course, the youth culture was being eroticized as never before. Even the somber Charles Reich, whose 1971 bestseller *The Greening of America* warned about the dangers of the "corporate state," took notice. "Jeans make one conscious of the body, not as something separate from the face but as part of the whole individual," he wrote. "[They] are a declaration of sensuality, not sensuality for display as in Madison Avenue style, but sensuality as part of the natural in man…[and] are a deliberate rejection of the neon colors and artificial plastic-coated look of the affluent society."

But even if you overlooked *The Greening of America*, you could hardly have missed it on the Rolling Stones album of the same year, *Sticky Fingers.* Photographed by Andy Warhol, the cover featured a real zipper stuck over a belt-to-thigh close-up of a man's aroused, jeans-clad crotch. Although generally assumed to be Mick Jagger, the model was in fact the Warhol film star, Joe Dallesandro.

Warhol himself once remarked: "I want to die with my blue jeans on." In *Holy Terror*, his memoir of their friendship, writer Bob Colacello recalls accompanying Warhol to Washington in May, 1975 when the artist attended a White House dinner." Sure enough, an hour and a half after he had locked himself in the bathroom, Andy emerged," Colacello writes. "His wig was well-combed, his cover cream was well-applied, and he looked rather elegant in his white tie and tails. 'The pants are too itchy,' he said, 'so I left my blue jeans on underneath. That's okay, isn't it?'"

Later, Warhol returned to his hotel room, full of gossip. He said, "Susan Ford came in after dinner with five boyfriends in blue jeans. And she's really a beauty and I told her I had blue jeans under my pants and she didn't believe me, so I just unbuttoned one button to show her. Do you think she'll tell her father I was being funny or something?"

The White House wasn't the only place Andy Warhol enjoyed privileged access. It was the age of disco, and back in fashionable New York the disco of discos was Studio 54. Much has been written about the democracy of the dance floor at 54, where black tie and blue jeans shook their groove thing side by side. But two participants in this classless milieu would come to make the most profound contribution to the way denim was understood in the last quarter of the twentieth century—Gloria Vanderbilt and Calvin Klein.

"She's taken her good family name and put it on the asses of America," remarked the *Saturday Night Live* comedienne Gilda Radner about the unprecedented success of Vanderbilt's up-market jeans line. After launching a diverse range of products from linen to eyewear under her distinctive swan logo, Vanderbilt began producing women's jeans in the late 1970s. They were available in a rainbow of colors, from lavender to black, and were made in a new "stretch denim" that more easily followed the movement of the body. The innovations were a big hit.

Knee-deep in peanuts; Jimmy Carter, Plains, Georgia, September 1976.

■

Not far behind her monogrammed back pocket was Calvin Klein. "Jeans are about sex," he famously remarked, justifying the incendiary advertising strategy that would stake

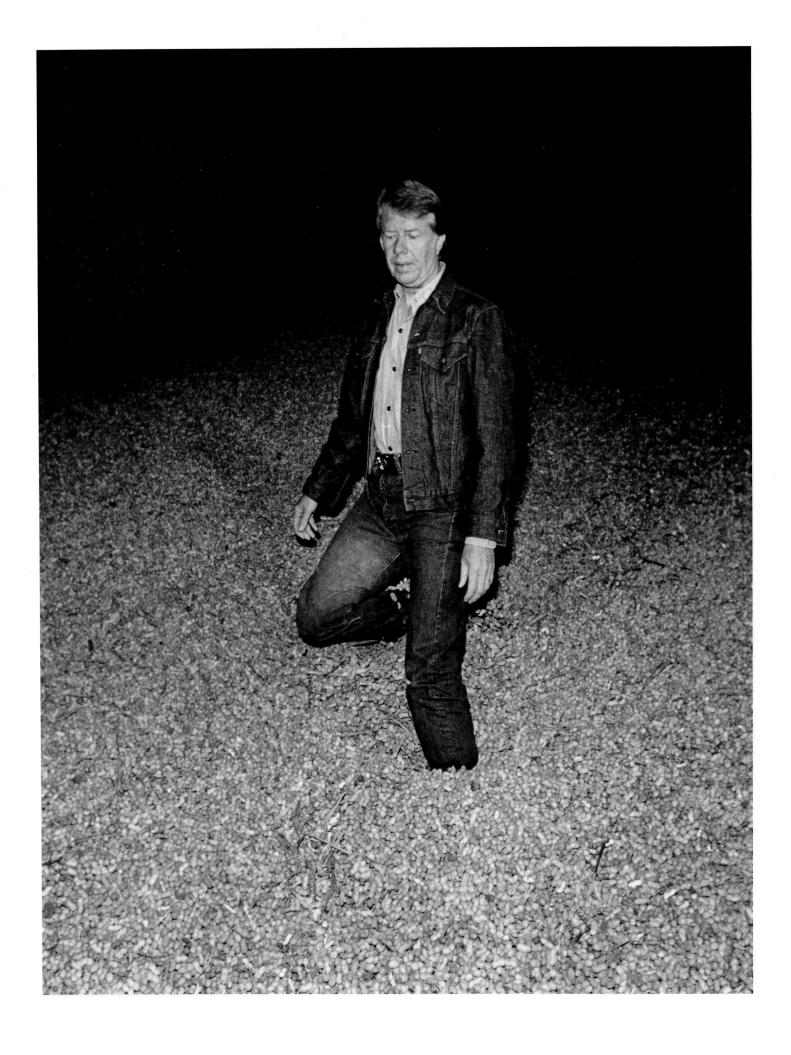

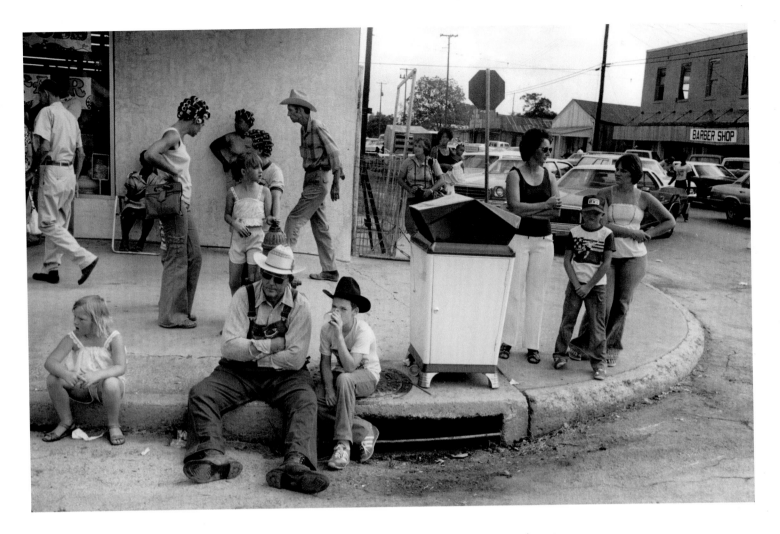

his own claim to the designer jeans gold rush. In a 1980 campaign that still reverberates in the national consciousness, the fifteen-year-old sex bomb Brooke Shields told the country: "Nothing comes between me and my Calvins." There was outrage in the streets, and sales went through the roof.

In 1977, U.S. domestic denim production peaked at 748.9 million square yards, several times the figure of ten years before. Jeans, it seemed, had worn their way into every sector of society one could imagine. By the end of the decade, they were the one garment that could bestow credibility on everyone from Jimmy Carter to Debbie Harry. In 1980, former *Vogue* editor Diana Vreeland told the *New York Times*: "Blue jeans are the most beautiful things since the gondola."

The voyage wasn't over yet.

ABOVE
Lulling, Texas, 1977. Photograph by Garry Winogrand.
■

OPPOSITE
Cybill Shepherd, *The Last Picture Show*, 1971.
■

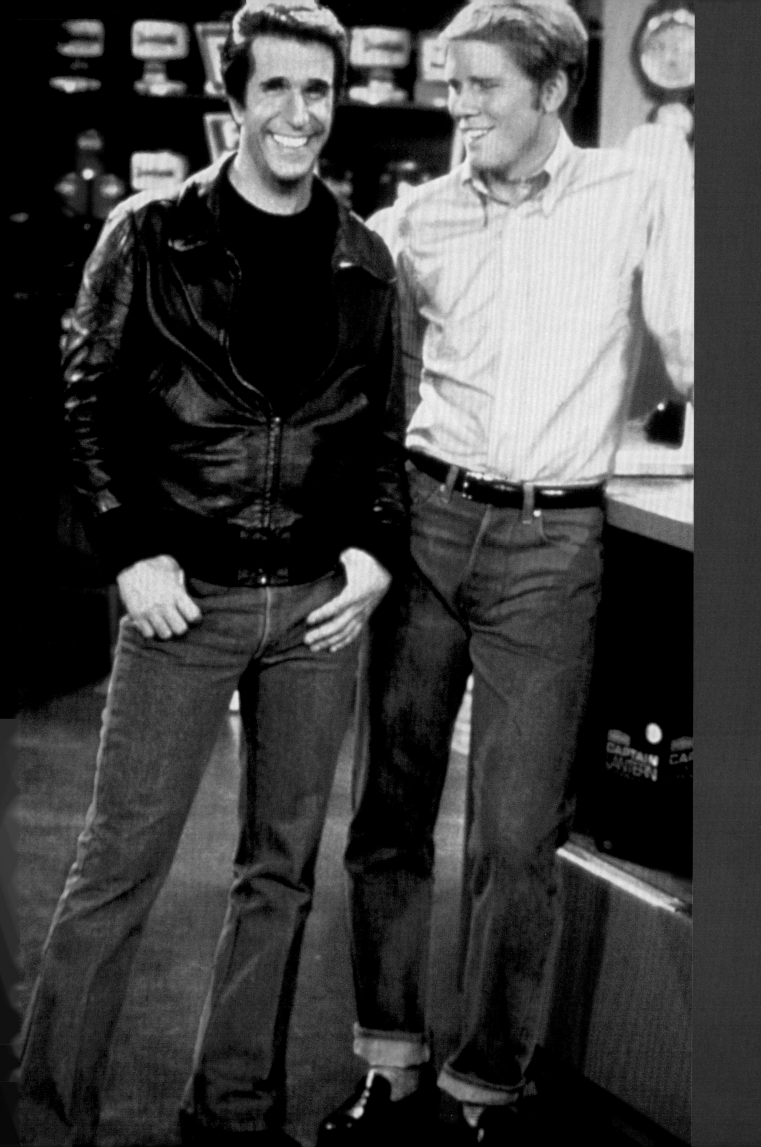

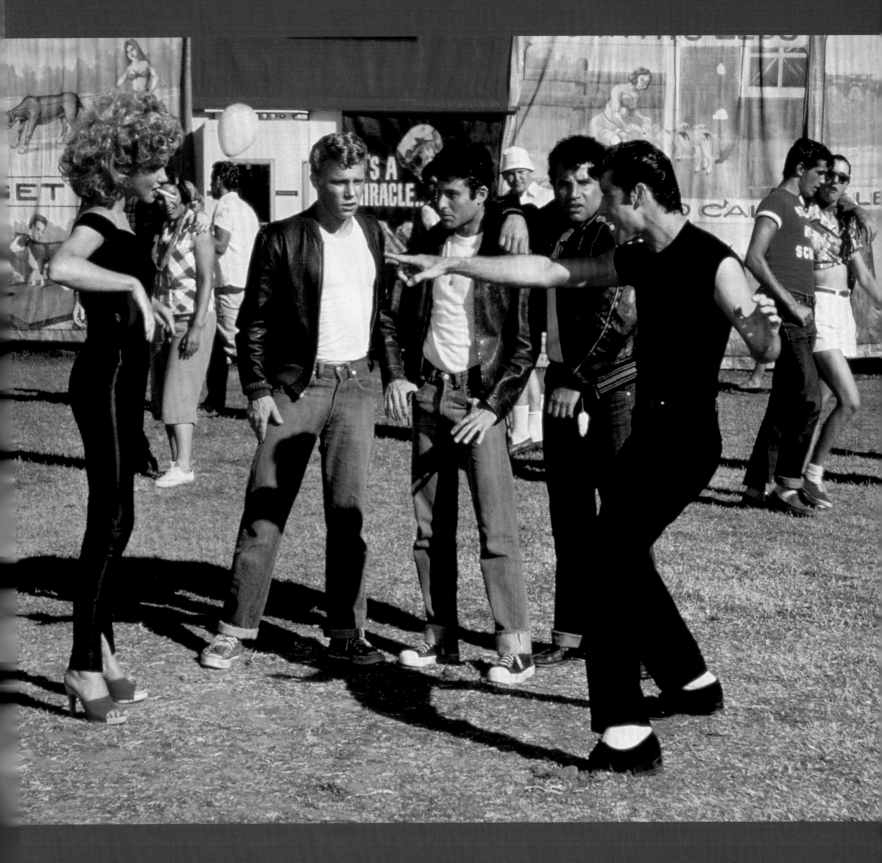

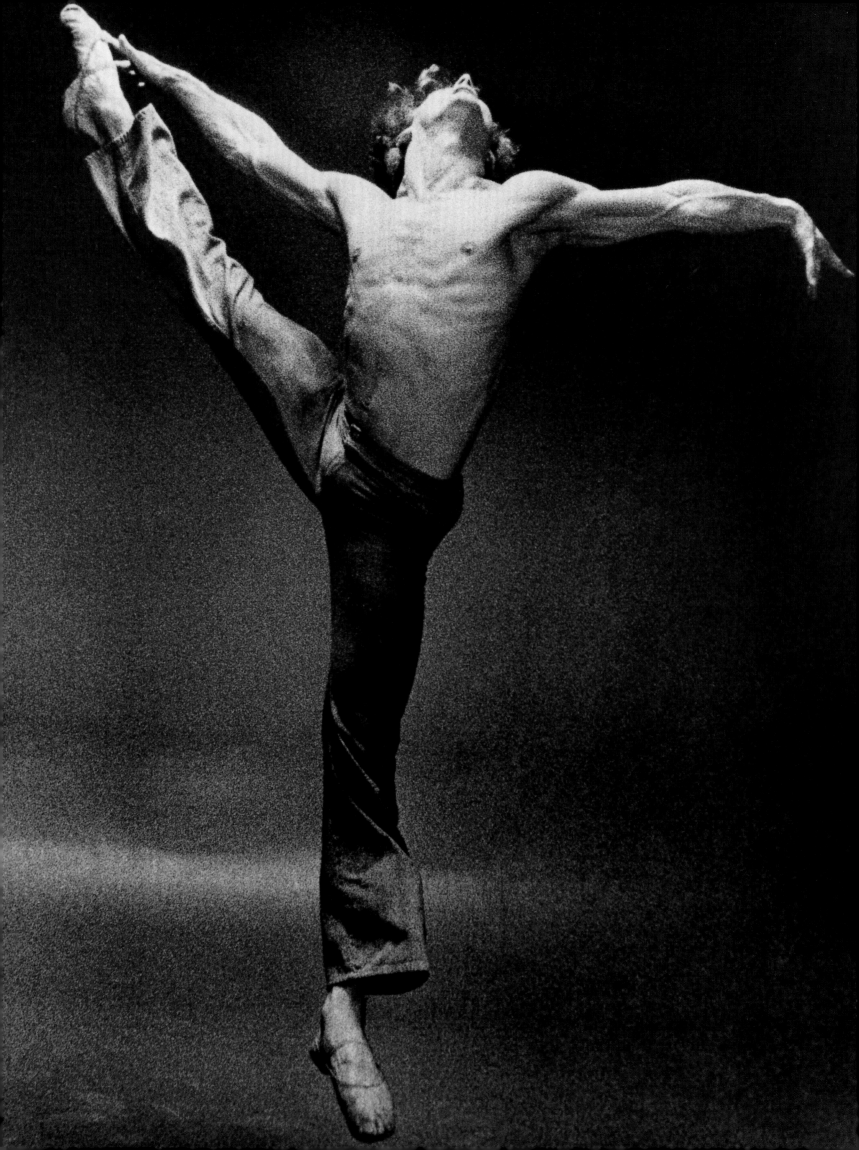

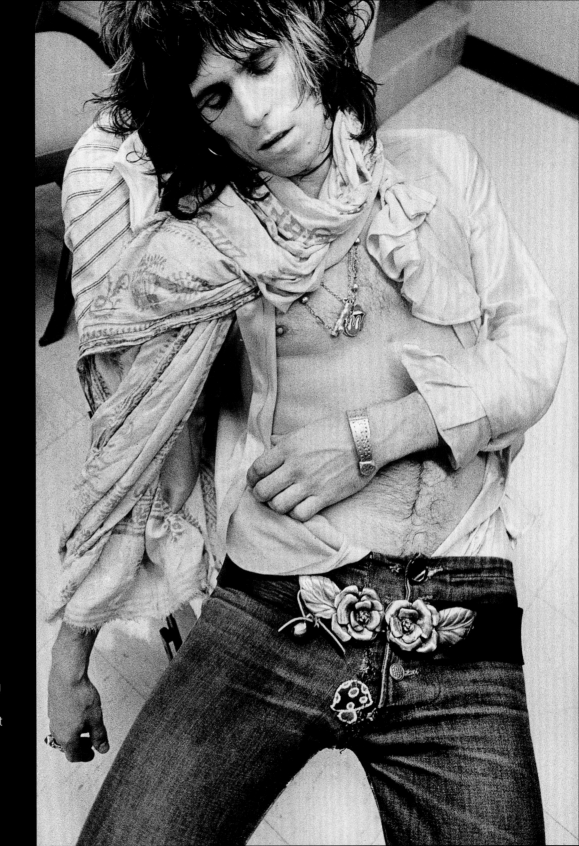

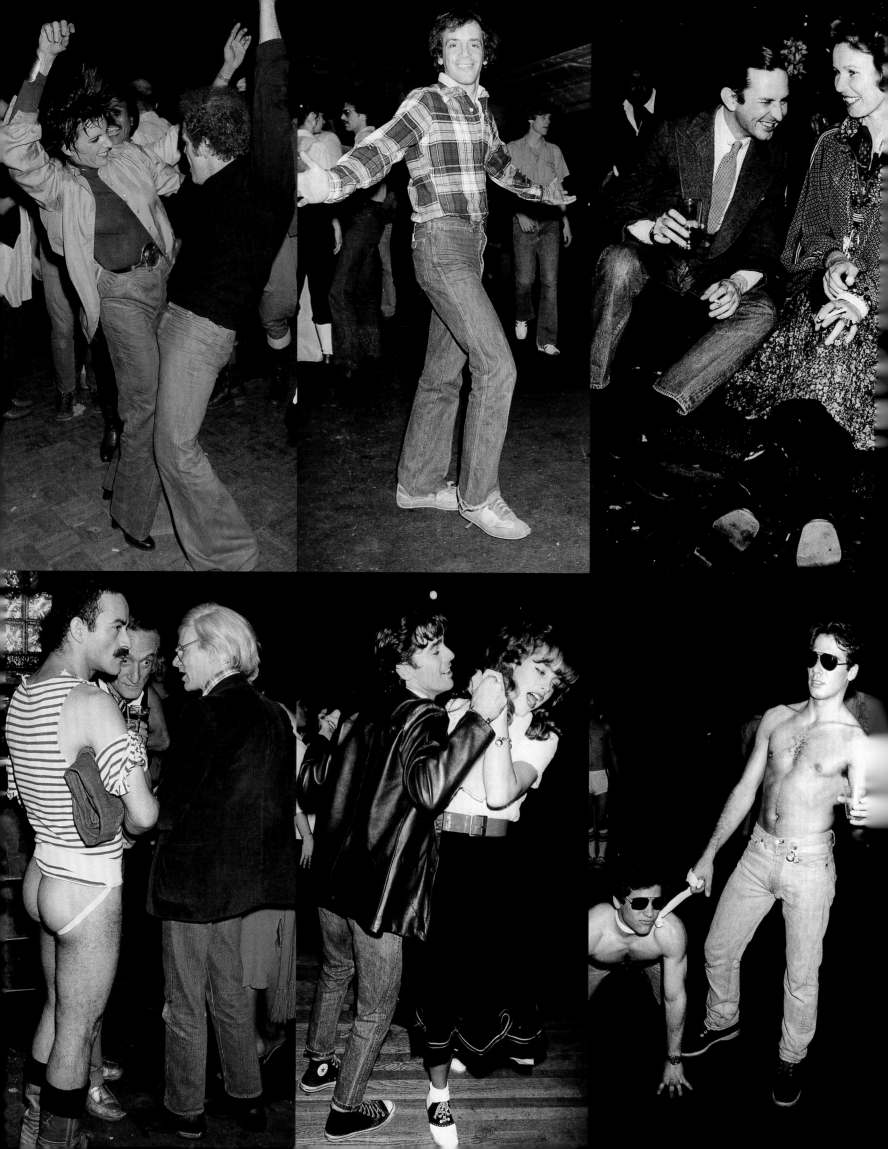

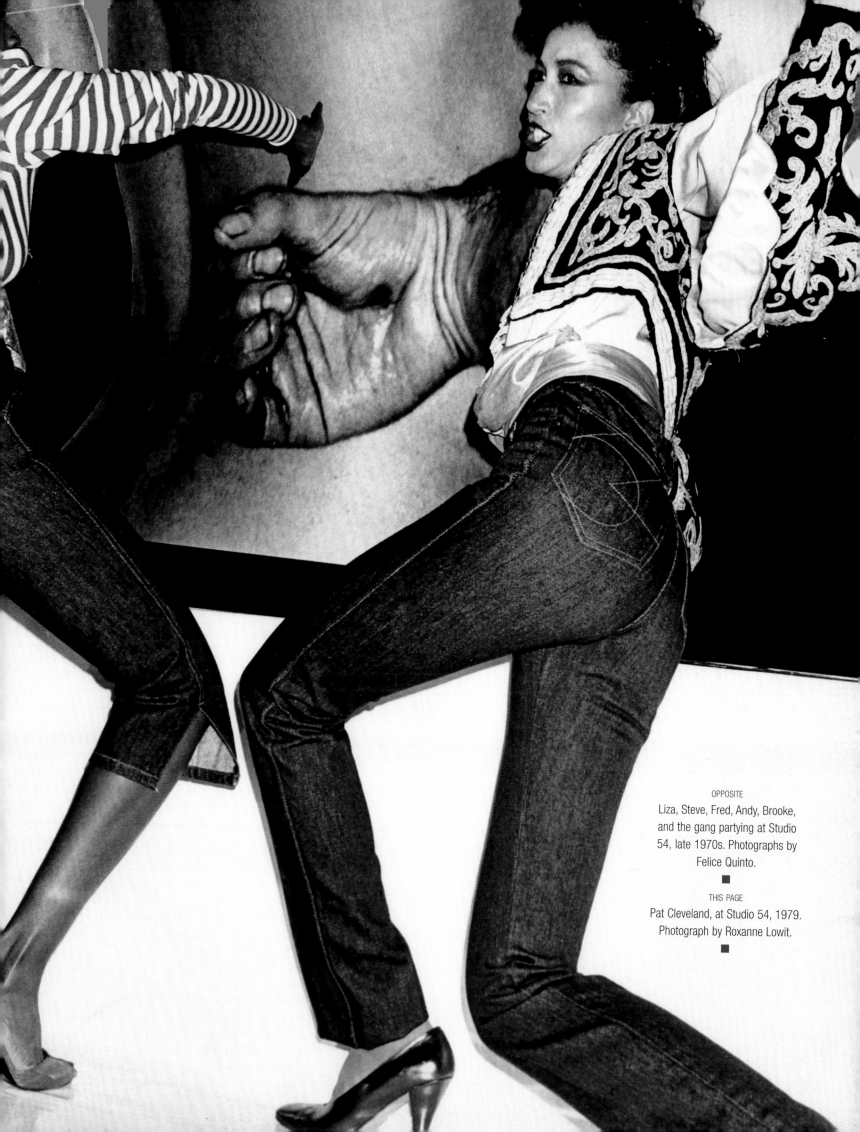

OPPOSITE
Oscar and Françoise de la Renta, 1978.
Photograph by Alexander Liberman.

■

ABOVE
Nan Kempner in Yves Saint Laurent with
Louis Vuitton luggage, *Vogue*, June 1974.
Photograph by Francesco Scavullo.

■

RIGHT
Inès de la Fressange. Photograph by
Christian Simonpietri.

■

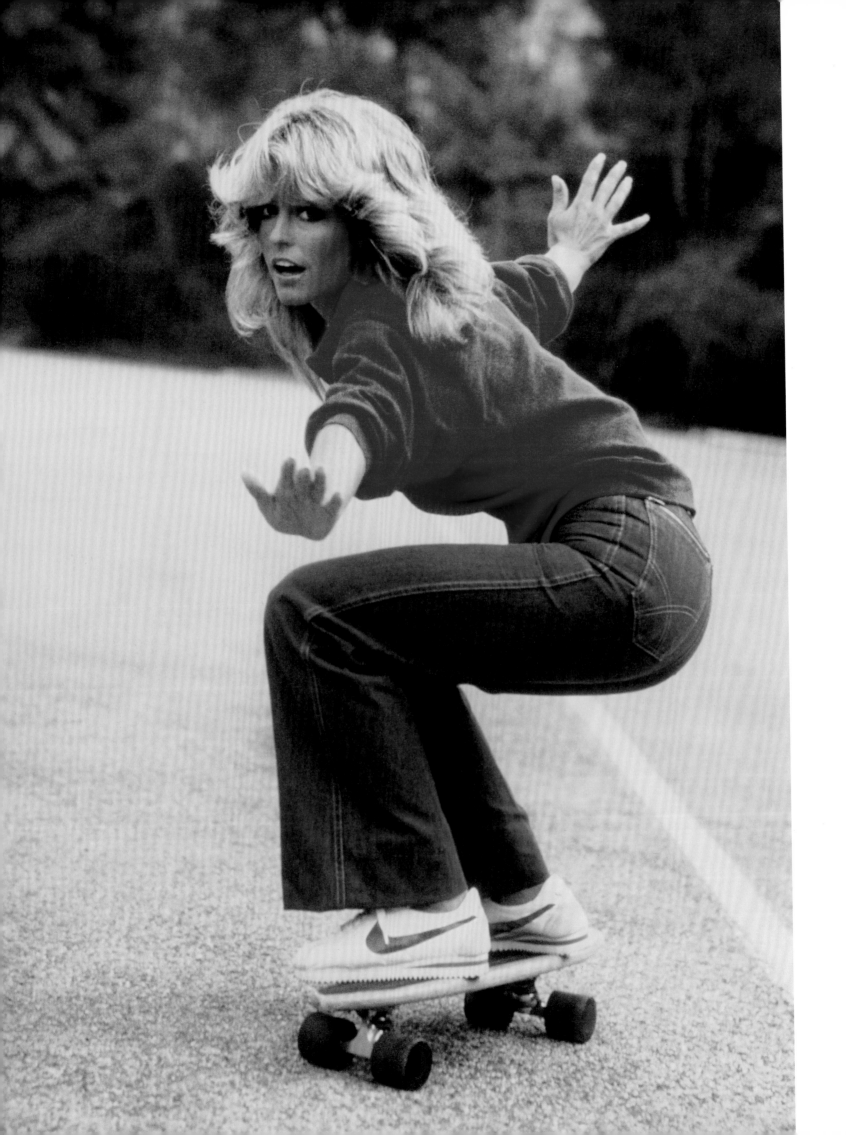

OPPOSITE
Angel on wheels;
Farrah Fawcett, 1976.
∎

ABOVE
Iggy Pop at the Rainbow, 1978.
Photograph by Jill Furmanovsky.
∎

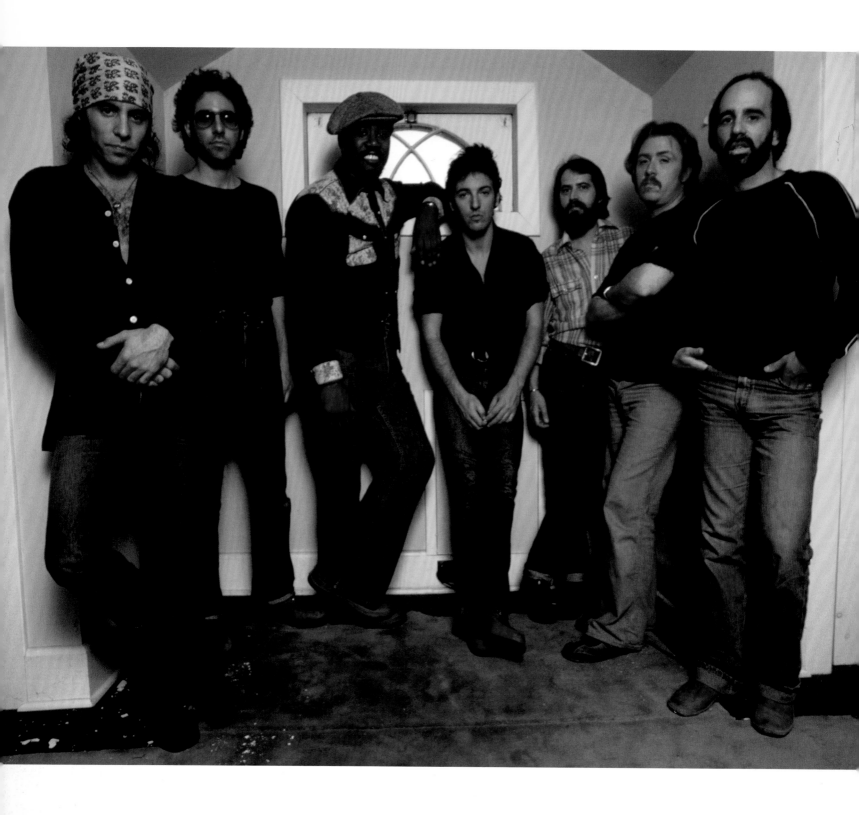

Worn in the USA; Bruce Springsteen
and the E Street Band, 1978.
Photograph by Lynn Goldsmith.

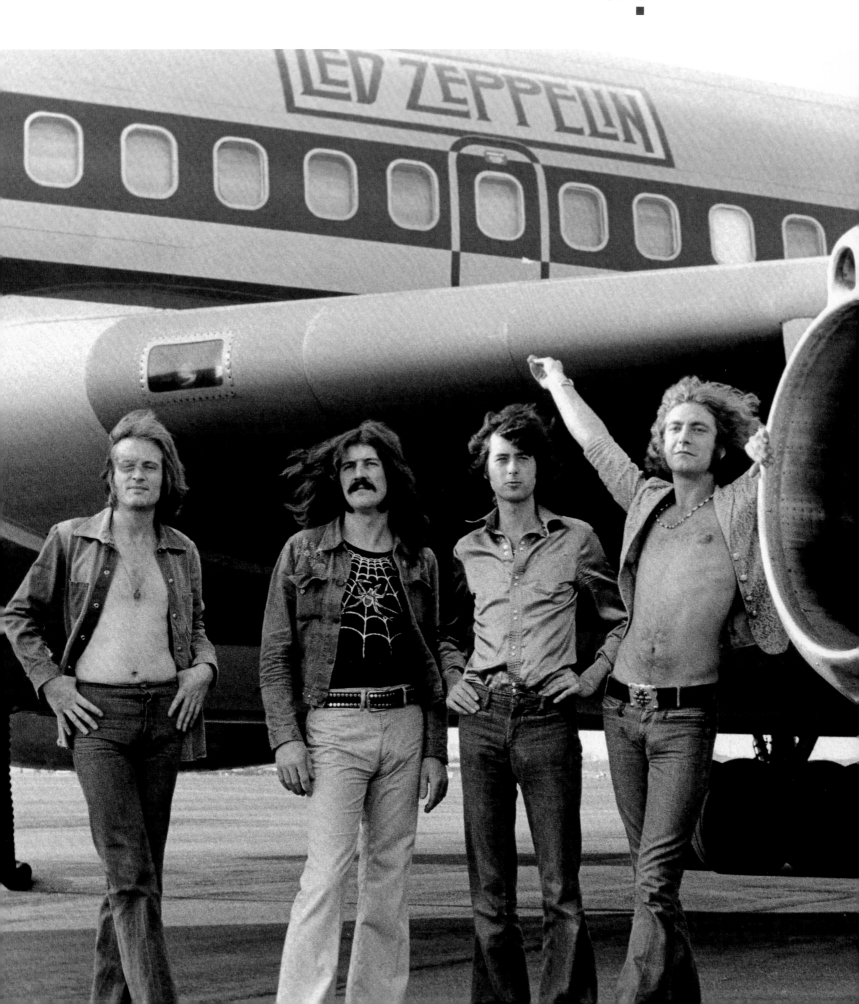

Tight harmony; Led Zeppelin (John Paul Jones, John Bonham, Jimmy Page, and Robert Plant), 1978. Photograph by Bob Gruen.

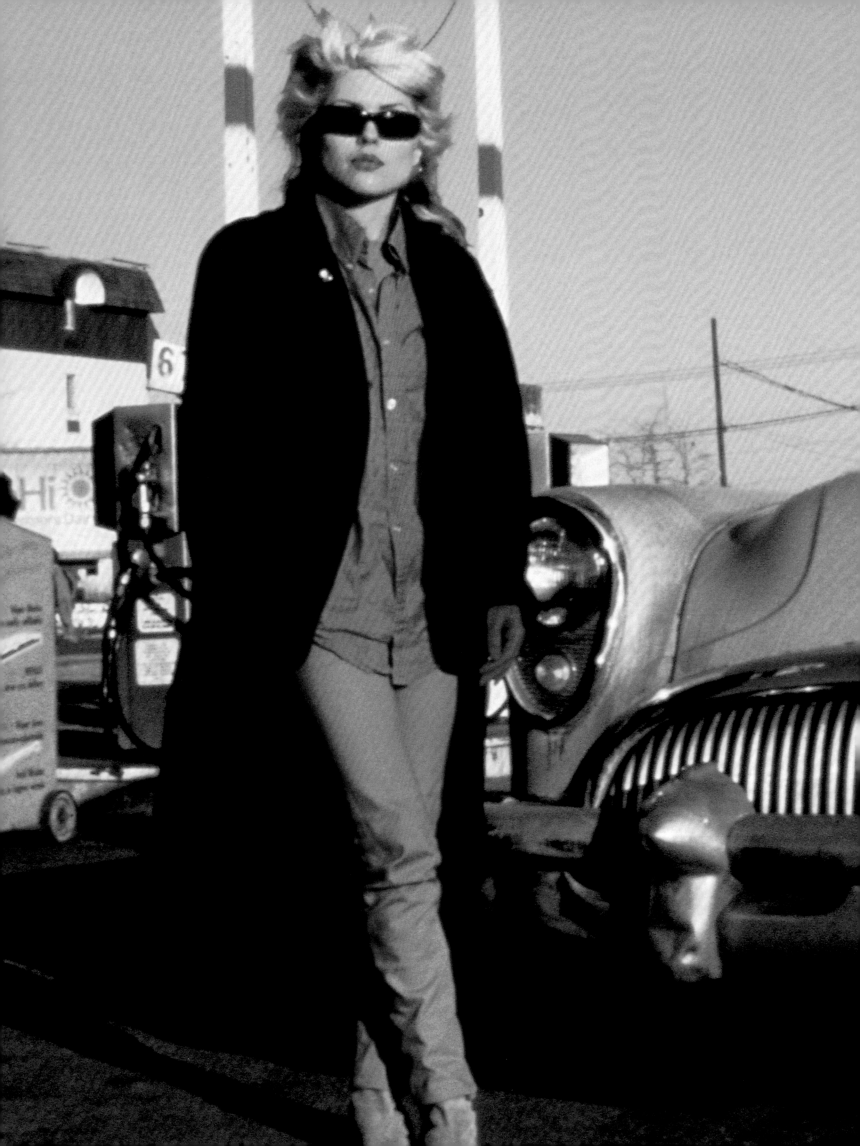

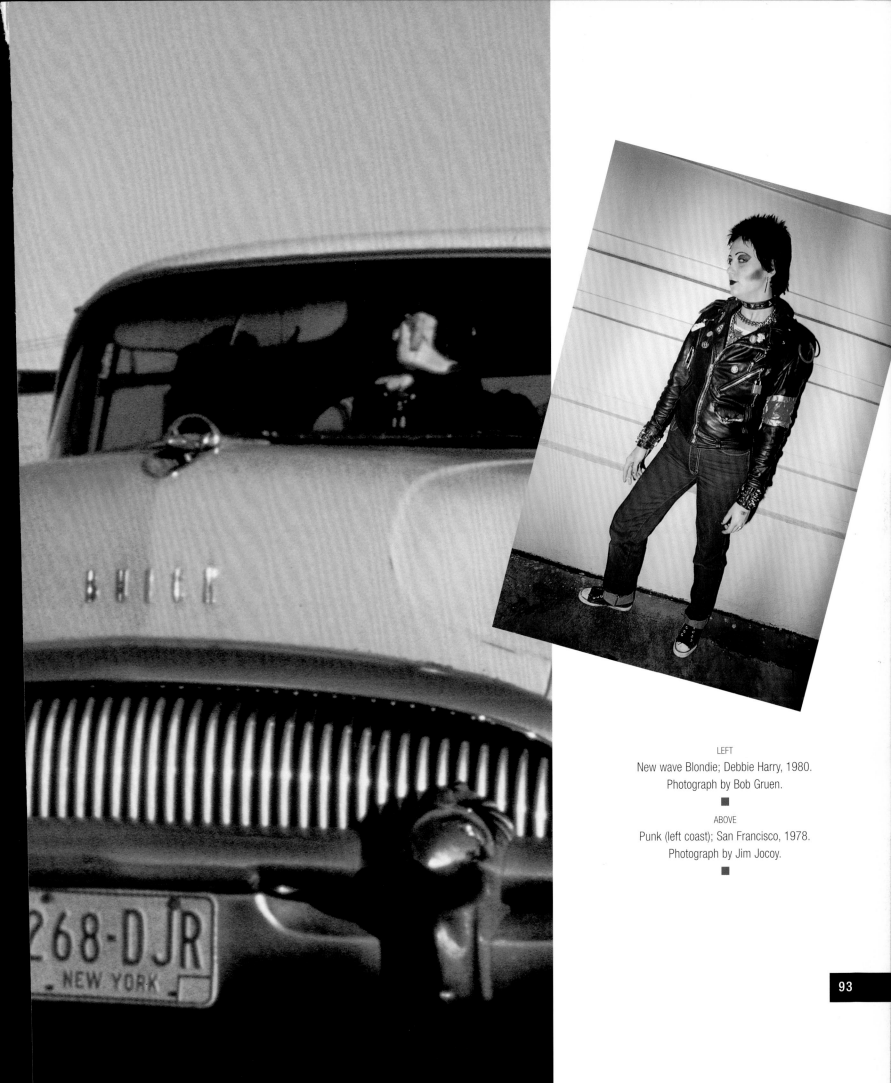

LEFT
New wave Blondie; Debbie Harry, 1980.
Photograph by Bob Gruen.

■

ABOVE
Punk (left coast); San Francisco, 1978.
Photograph by Jim Jocoy.

■

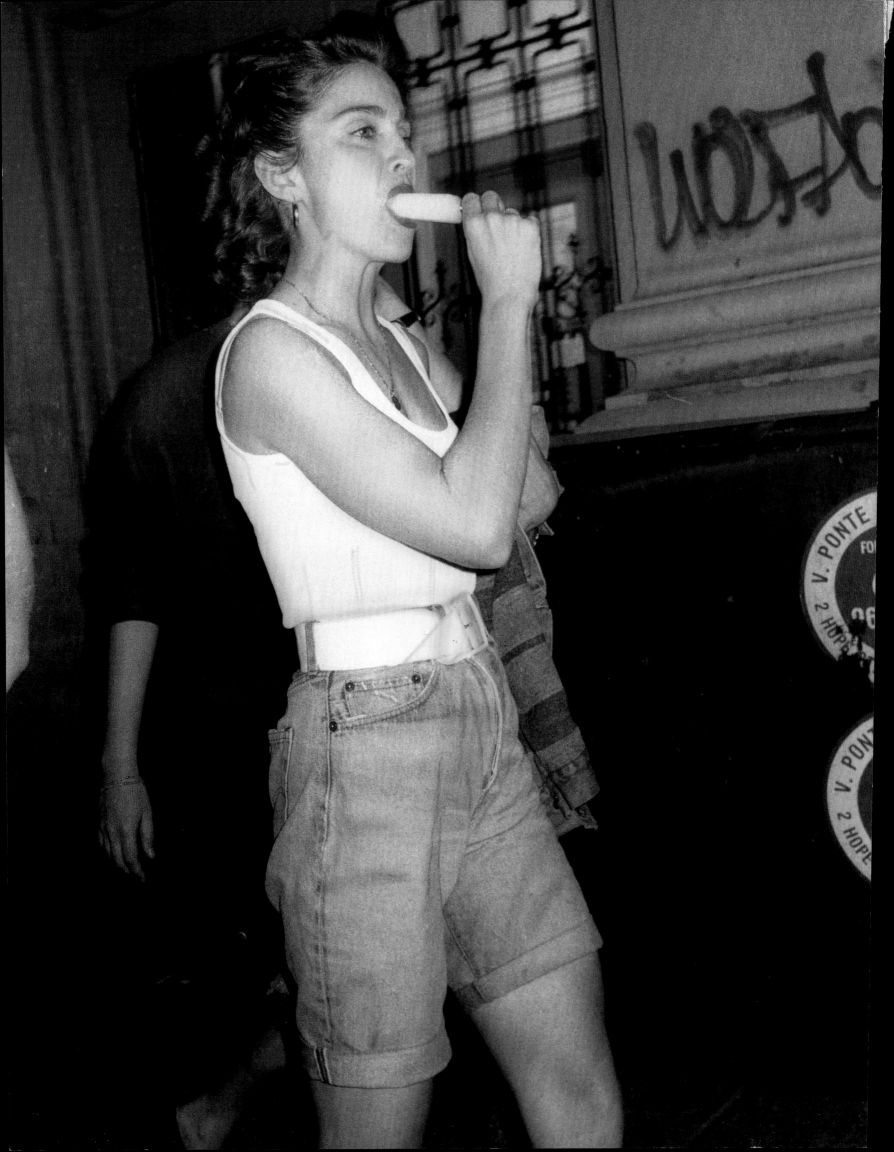

I

Lucky Star(sicle); Madonna, New York, 1988. Photograph by Gene Shaw.

■

n 1981, Americans bought more jeans than they ever had before. 502 million pairs were sold that year—2.2 for every man, woman, and child in the country.

Europe was fascinated with this American garment, and the market was flooded with brands like Sassoon, Jordache, Guess?, and Sergio Valente. In 1980, Andy Warhol adorned the cover of a jeans-themed issue of *L'Uomo Vogue*, and in 1982 Karl Lagerfeld designed a denim suit for Chanel. Even Yves Saint Laurent was moved by the phenomenon. "I wish I had invented blue jeans," he told *New York* magazine in 1983. "They have expression, modesty, sex appeal, simplicity—all I hope for in my clothes."

Thanks to the endless ingenuity of a capitalist culture, blue jeans—once a working man's garment to be hung in the shed before mealtime—had permeated every strata of American society. It was boom time on Wall Street, and the aggressive socialites parodied in prime-time dramas like *Dynasty*—the poof-dress-wearing Alexis Colby crossing manicures with the jeans-ily wholesome Crystal Carrington—were alive and air-kissing at "Denim 'n' Diamonds" charity fundraisers in New York. In the White House a jeans-wearing Jimmy Carter was ousted by a jeans-wearing Ronald Reagan. Bruce Springsteen reclaimed denim for the working class with his iconic 1984 album cover, *Born in the USA*—netting himself a ruling-class-sized paycheck in the process.

"A garment that squeezes the testicles," wrote the Italian intellectual Umberto Eco, "makes a man think differently." So does a culture that thrives on marketing. In the 1980s, designers kept coming up with different ways to sell more jeans. The entry of new brands into the denim arena forced producers to scramble for ways to differentiate their product in the marketplace. Suddenly, it was all about the finish, with stone-wash and acid-wash procedures finding favor with the country's latest crop of teenagers (Lee experimenting with everything "from golf balls and sneakers to tires and rocks" before later hitting on pumice stones to wear in their jeans).

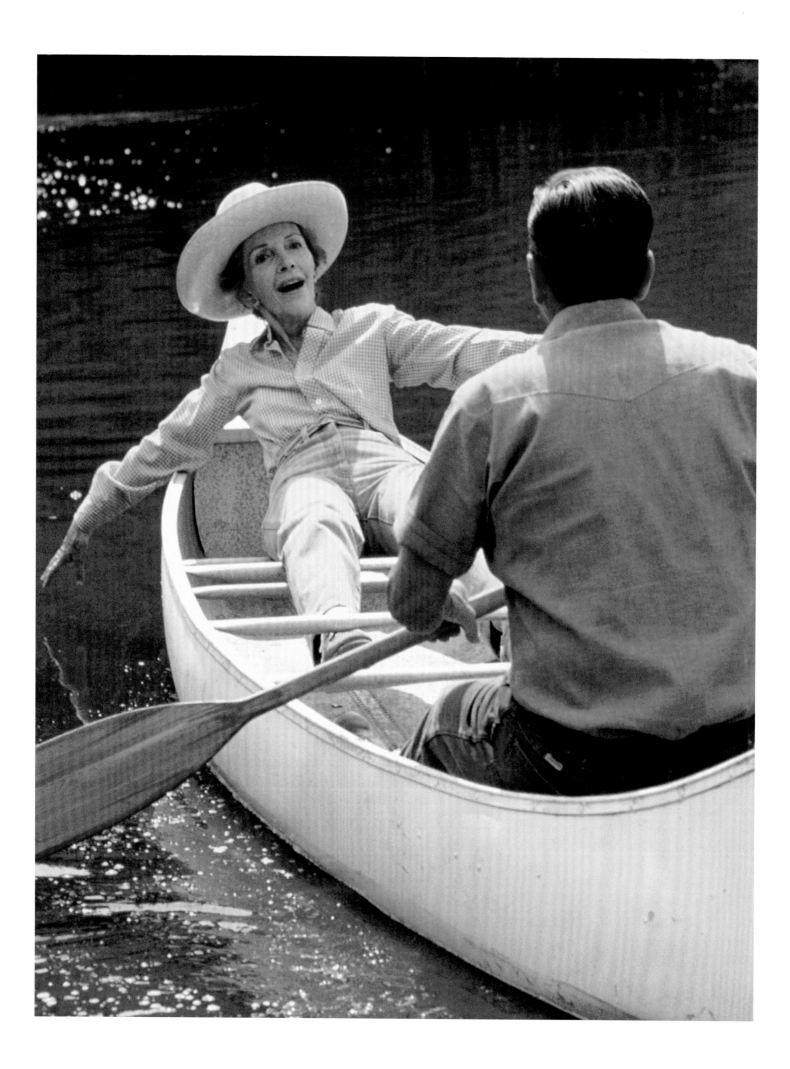

The punk movement that began with the Ramones in New York in the 1970s and hole-riddled straight legs, and refined in London with its own trend for torn and mended black denim, filtered down to the malls and suburbs of America as the craze for ripped jeans. In 1986, Lee began selling its popular "Storm Rider" label with holes and tears already in place. In the heartland, a pair of torn blue jeans was as much a part of the uniform of American youth as a black rock concert tee-shirt and a pair of Converse high-tops.

Meanwhile in New York, a rising star named Anna Wintour took over as editor-in-chief of *Vogue* magazine in November 1988. The first thing she put on the cover? Blue jeans. Wintour paired light blue Guess? stonewash jeans with a Christian Lacroix jewel-studded top, accelerating the nascent trend of teaming "high" and "low" fashion.

Important as the choice of jeans was for Wintour's first cover, four years later she did it again on another historic cover. For the magazine's 100th issue in April 1992, Wintour posed ten supermodels, all dressed identically in white shirts and white Gap denim jeans. The message from *Vogue* could not have been clearer: denim was once again defining a new cultural moment, if not of grunge, then at least of casual Fridays.

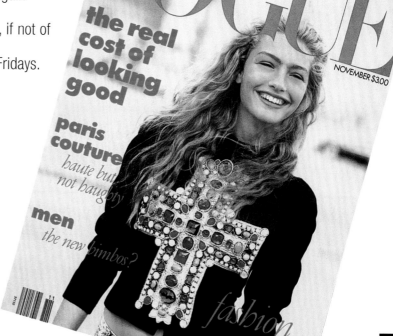

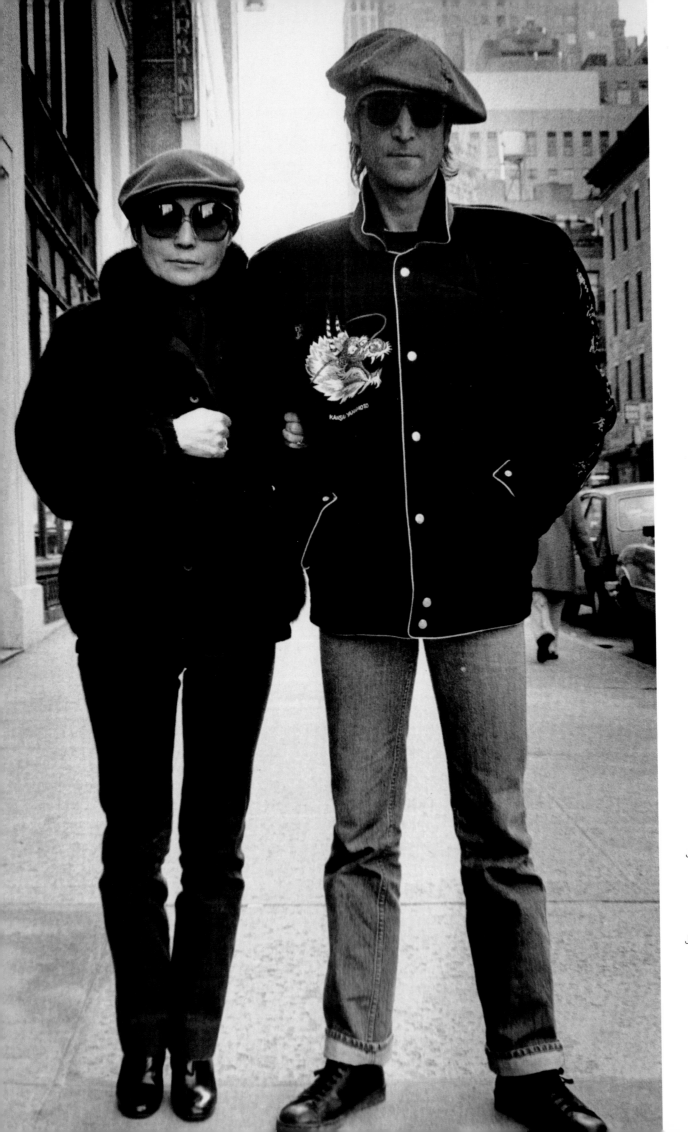

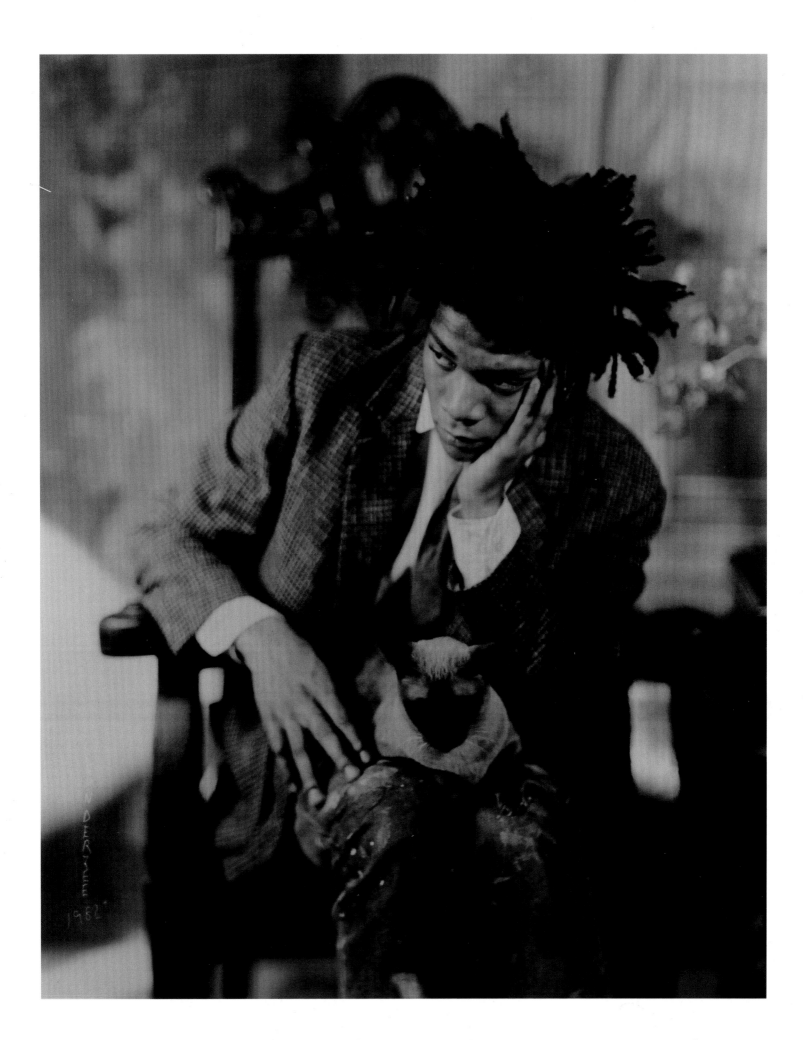

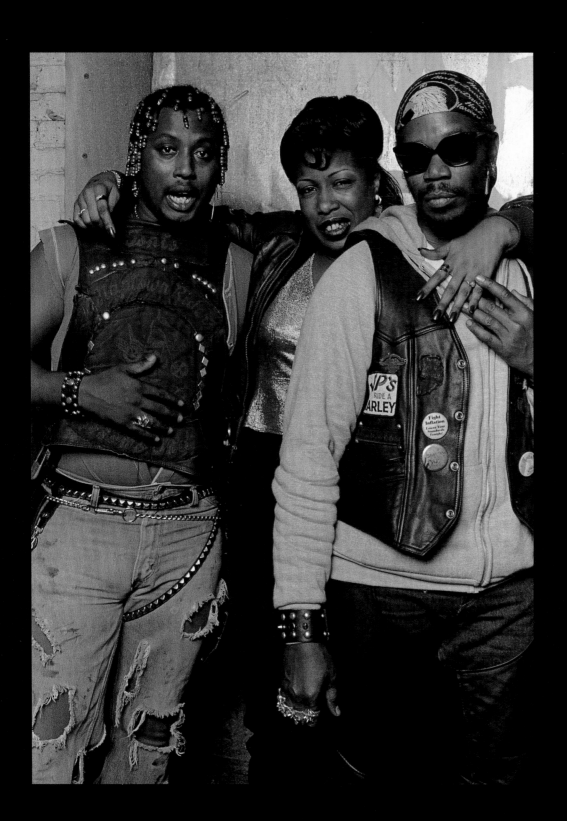

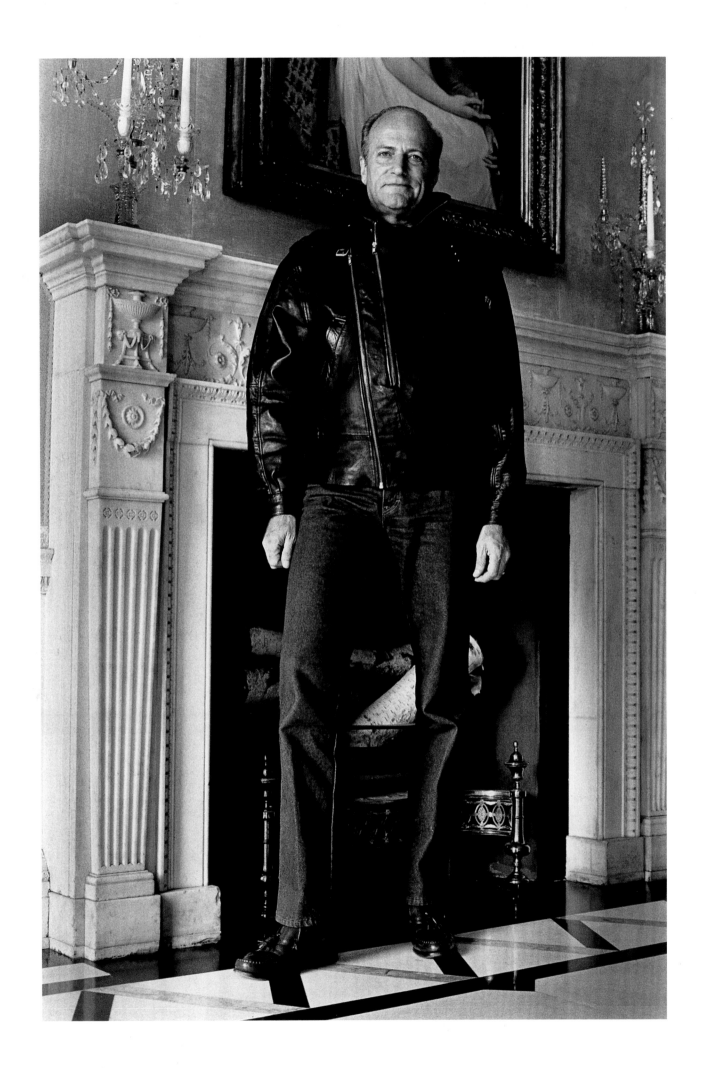

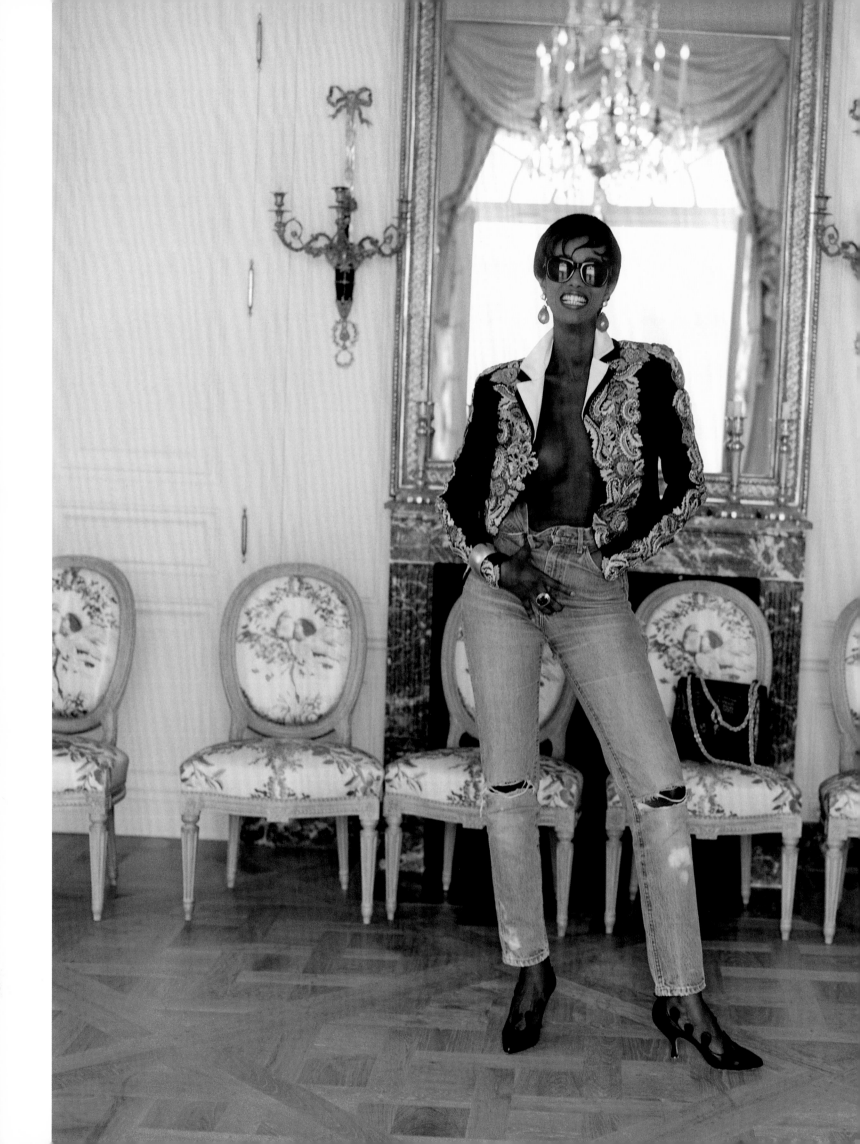

Born to be torn; Iman, 1989. Photograph by
Helmut Newton.

■

Bill Blass, Connecticut, 1983. Photograph by
Jeannette Montgomery Barron.

■

ABOVE
Southwestern chic takes hold, 1989.
Photograph by Judy Gantt Newton.

■

RIGHT
Holly Hunter and Nicholas Cage in
Raising Arizona, 1987.

■

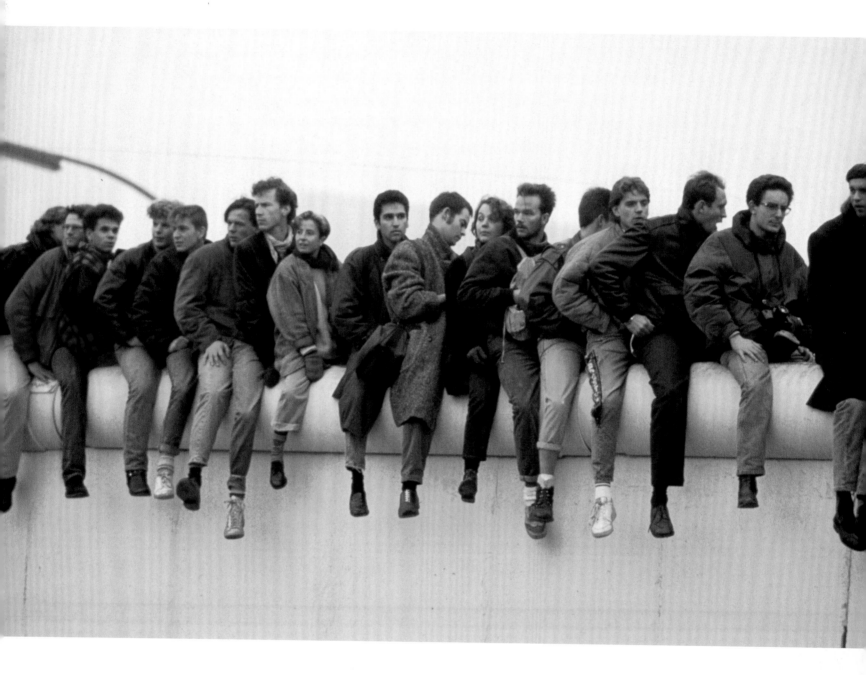

OPPOSITE
Blue jeans, über alles; a set with inscriptions (left leg): "fight for life/live and love/and always stay cool," (right leg): "refuse to march/activate for peace'" Nuremberg, Bavaria, 1980. Photograph by René Burri.

∎

ABOVE
Berlin Wall, November 1989. Photograph by Peter and David Turnley.

∎

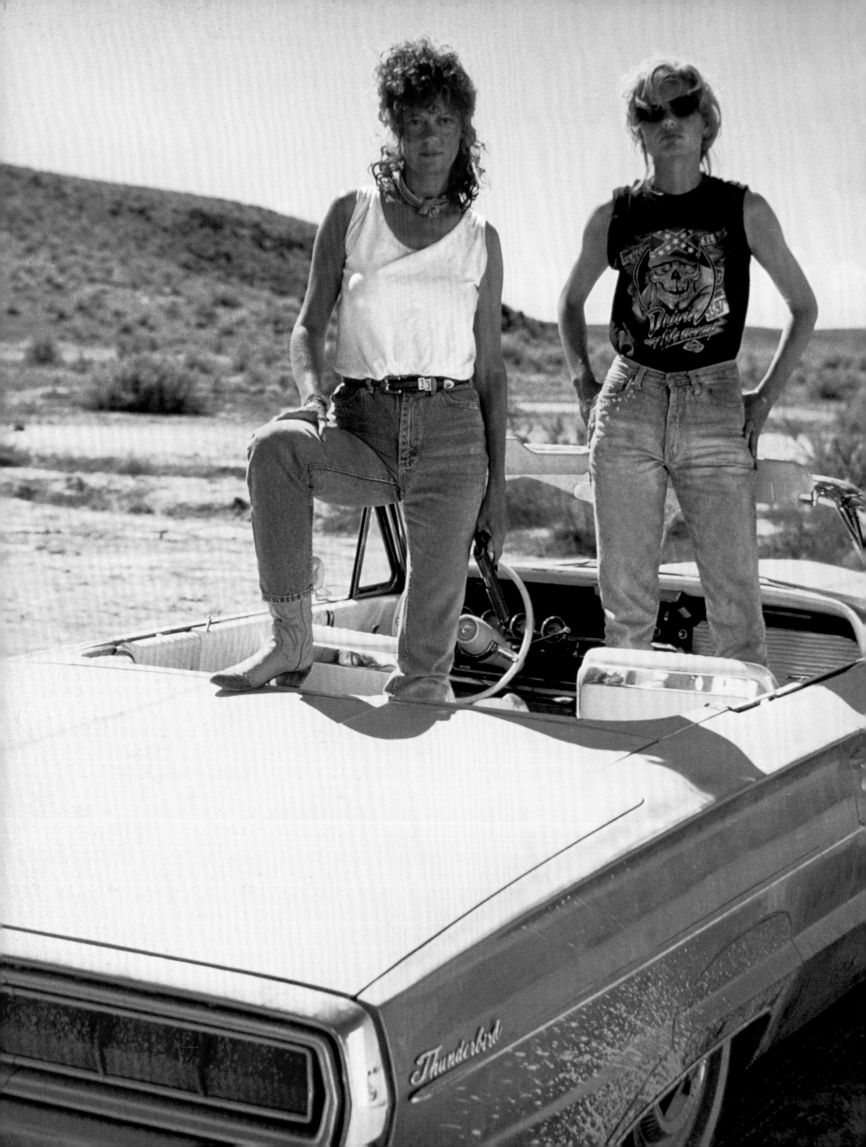

Can you have too much of a good thing? If blue jeans were to suffer at all in the 1990s, it was from ubiquity. Sales, which peaked in 1981, had trailed off for much of the previous decade. As the fashion writer Suzy Menkes observed, jeans were no longer the streetwear of radical youth, they were what the parents of radical youth wore on weekends.

It is a measure of how much denim had become part and parcel of American society that even Germaine Greer, herself a child of the Second World War, didn't have a kind word to say. In the 1991 foreword of the twentieth-anniversary edition of her feminist classic *The Female Eunuch*, she wrote: "You can now see the Female Eunuch the world over…spreading herself wherever blue jeans and Coca-Cola may go. Wherever you see nail varnish, lipstick, brassieres, and high heels, the Eunuch has set up her camp."

Was this how it was to end, with jeans being heaped upon the cultural bonfire as no more important than nail polish? Well, blue jeans had been called worse before—derided as laborer's togs, wrong for school, and the fatigues of street toughs. But youth culture wasn't finished with denim yet.

The history of American music in the twentieth century has been written by black performers, from jazz to blues to Motown to rock 'n' roll. And so, despite the early appearance of grunge—with its pale-skinned, flannel-shirt-and-ripped-jeans-wearing acolytes emerging from Seattle—the '90s were the decade of hip-hop. Before they got into Gucci and Prada, hyper-masculine rappers were adopting the signifier of beltless jeans, referencing the belt confiscation of young men entering prison. Though label-conscious as any Rodeo Drive princess, the emerging urban hip-hopracy highly prized sportswear brands, like Nike and Tommy Hilfiger. It wasn't long before successful rap music producers saw the opportunity to get into the fashion biz themselves. Def Jam founder Russell Simmons began the Phat Farm label in 1996, a hugely successful spin-off which, among other styles, rehabilitated the blue denim overall. Rap entrepreneur

Ready to rumble; Susan Sarandon and Geena Davis in *Thelma and Louise*, 1991.

■

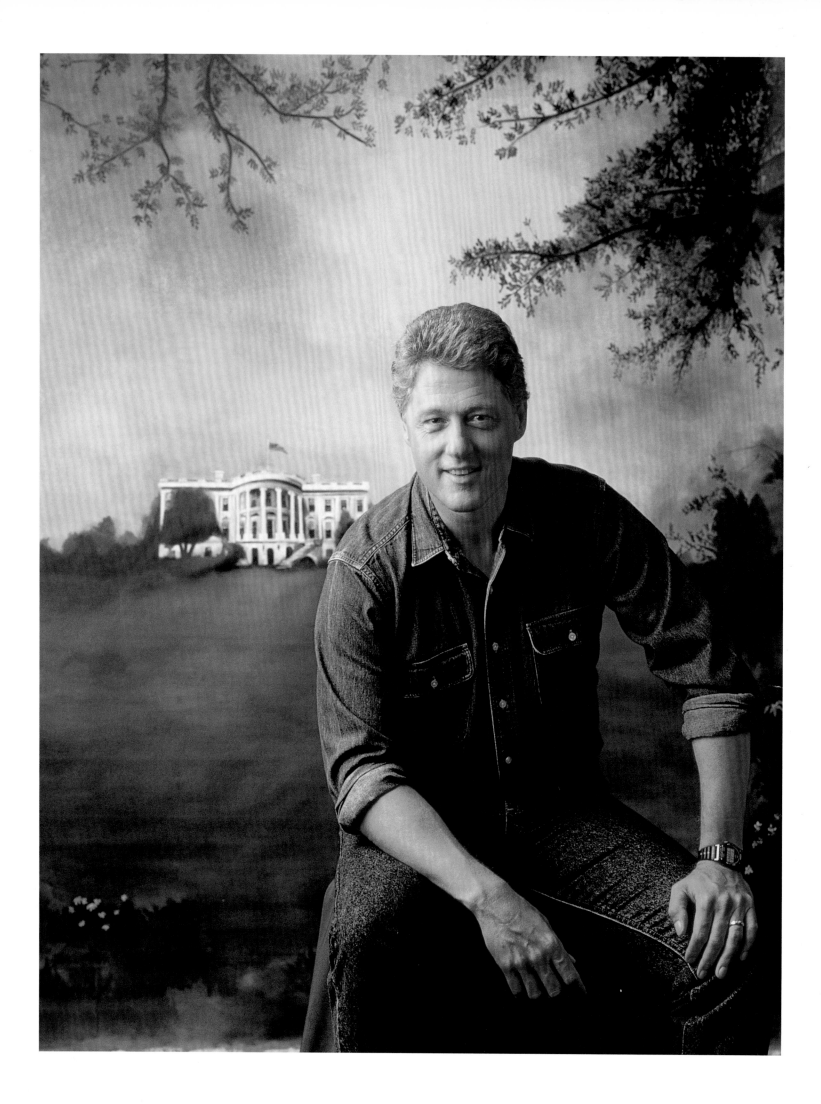

Sean Combs—a.k.a. Puff Daddy and or P. Diddy in his music—debuted his Sean John sportswear line at the New York 2001 fall fashion shows. The first collection paired denim with fur and loose, off-the-shoulder tops.

For neo-hippie kids on the street, both white and black, '90s denim "parachute pants" meant jeans so loose-fitting that they could almost lift you off the ground in a strong wind. The pockets were deep enough so you didn't lose your cell phone and cigs while skateboarding. It was a style that borrowed as much from international raver culture as much as it did hip-hop, and it mutated easily with the multicultural Asian and Latino communities growing throughout the United States.

Of course, while trendsetters on both coasts rhapsodized and editorialized about the merits of blue jeans, a good chunk of the country didn't need to be told. As avant-garde designer Helmut Lang was in New York coming up with paint-splattered and "dirty denim" jeans that only a very successful goldminer could afford, in the heartland jeans were as solid as a good friend. They were the one item of clothing just as likely to be found in the biggest mansion in town as in the most modest two-bedroom ranch.

Governor Bill Clinton, Little Rock, Arkansas, 1993. Photograph by Mark Seliger.

∎

If one woman epitomized this union of the American class system, it was Guess? jeans model Anna Nicole Smith, widow, at twenty-seven, of a nonagenarian wheelchair-bound billionaire. But it was in 1992, when Guess? chose the former *Playboy* model to replace Claudia Schiffer as its icon, that Smith gave jeans another moment in the lime-light and wowed America with a Marilyn Monroe-inspired campaign.

In 1999, Christie's New York held a sale of clothing owned by Monroe. Choice among the lots were three pairs of blue jeans originally worn by the actress in the 1954 classic *The River of No Return*. It was the middle of the dot-com boom—bidding was intense, and the three Foremost brand blue jeans offfered for sale (originally purchased for $2.29 each) sold for $37,000. The successful bidder, designer Tommy Hilfiger, later gave a pair to Britney Spears.

As the twentieth century came to a close, it was a fitting (very well fitting) tribute to a hundred-year-old tradition.

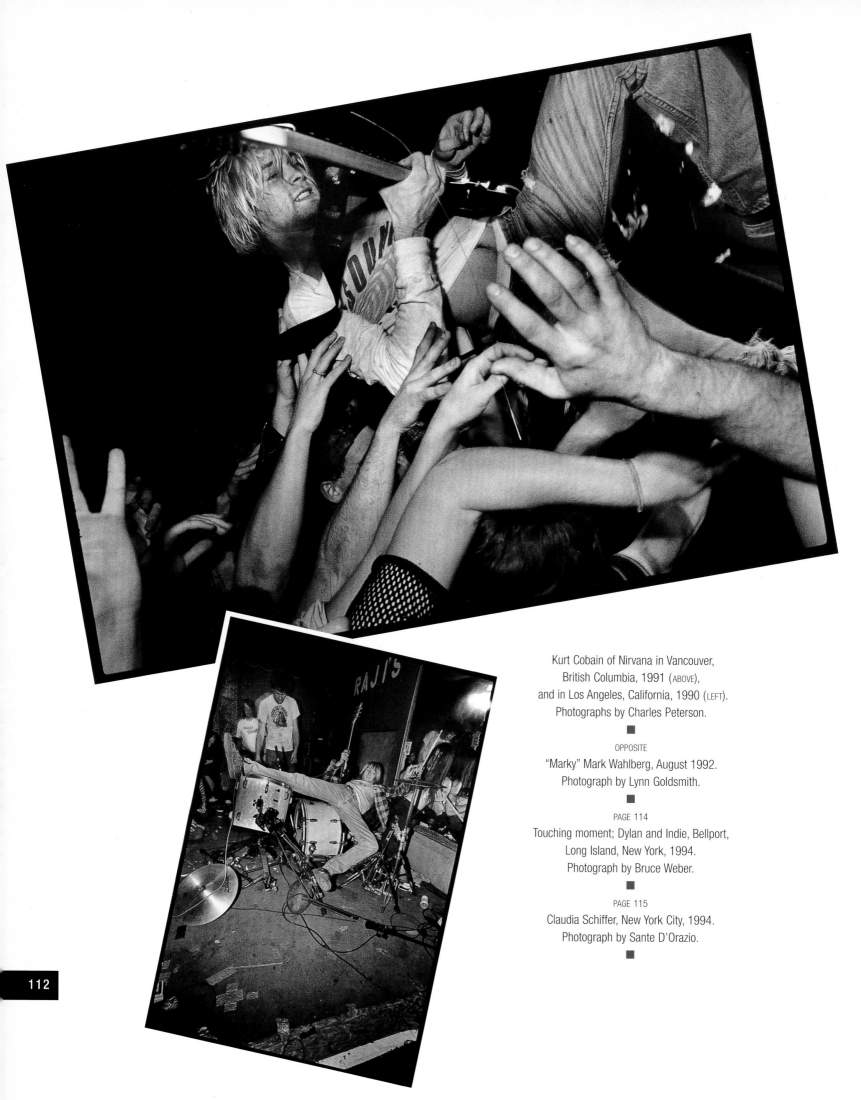

Kurt Cobain of Nirvana in Vancouver,
British Columbia, 1991 (ABOVE),
and in Los Angeles, California, 1990 (LEFT).
Photographs by Charles Peterson.

■

OPPOSITE
"Marky" Mark Wahlberg, August 1992.
Photograph by Lynn Goldsmith.

■

PAGE 114
Touching moment; Dylan and Indie, Bellport,
Long Island, New York, 1994.
Photograph by Bruce Weber.

■

PAGE 115
Claudia Schiffer, New York City, 1994.
Photograph by Sante D'Orazio.

■

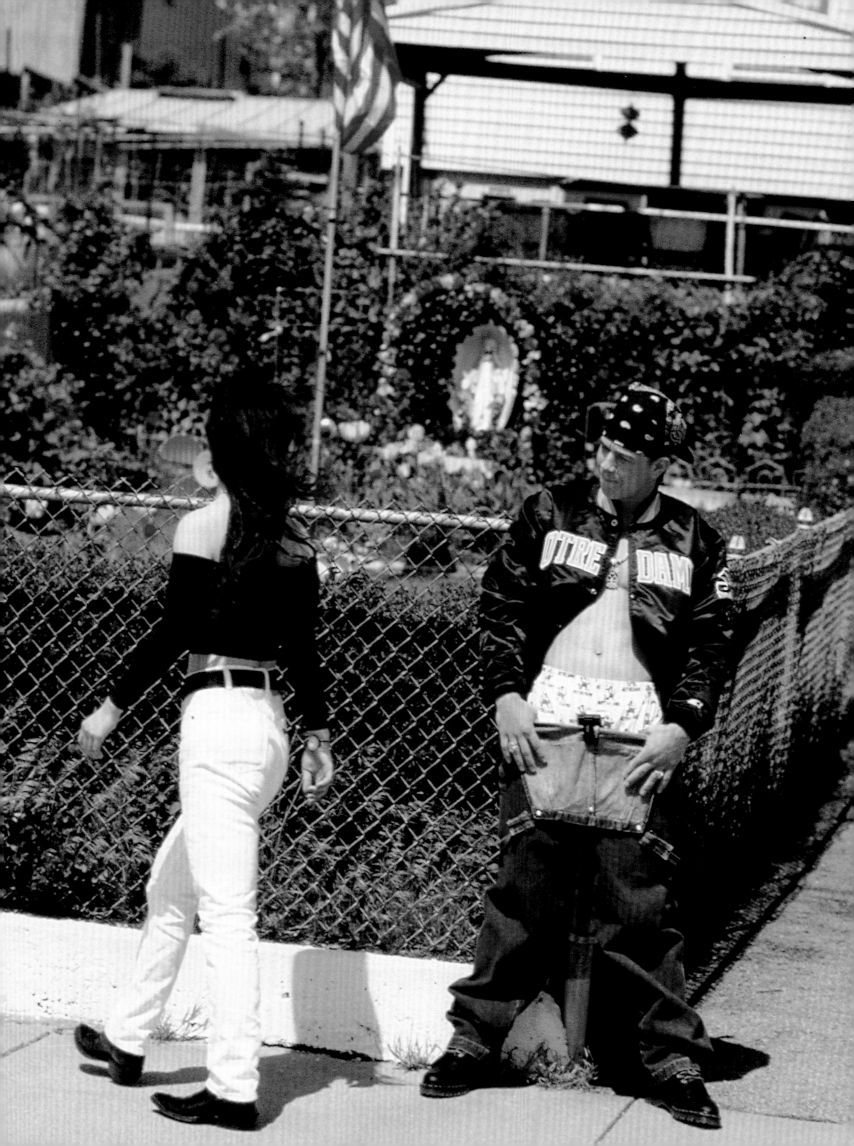

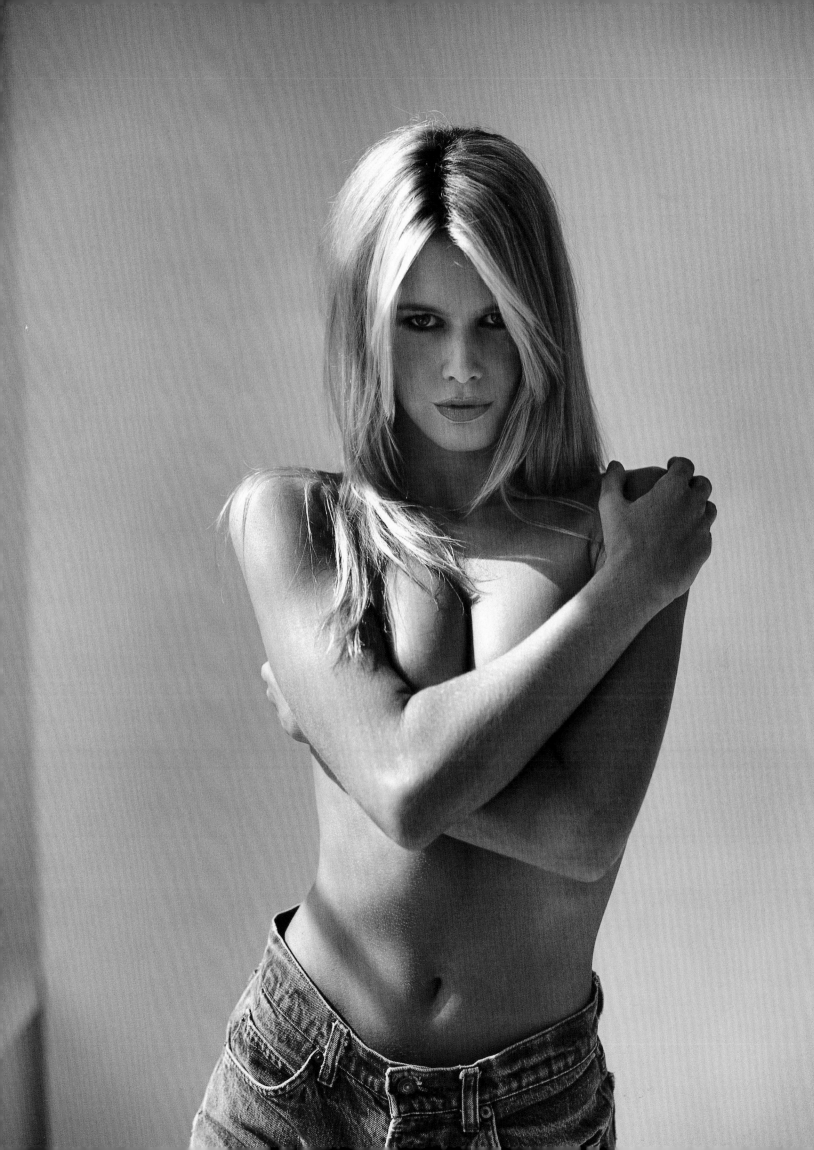

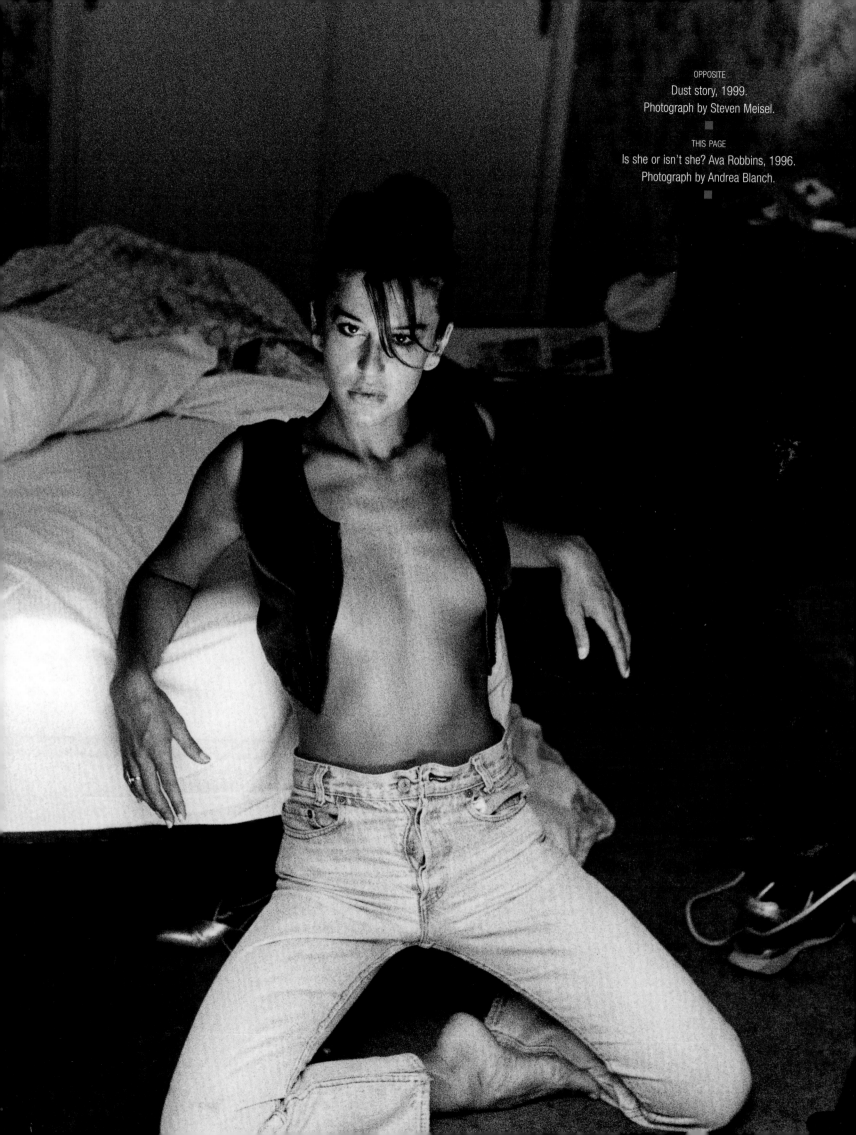

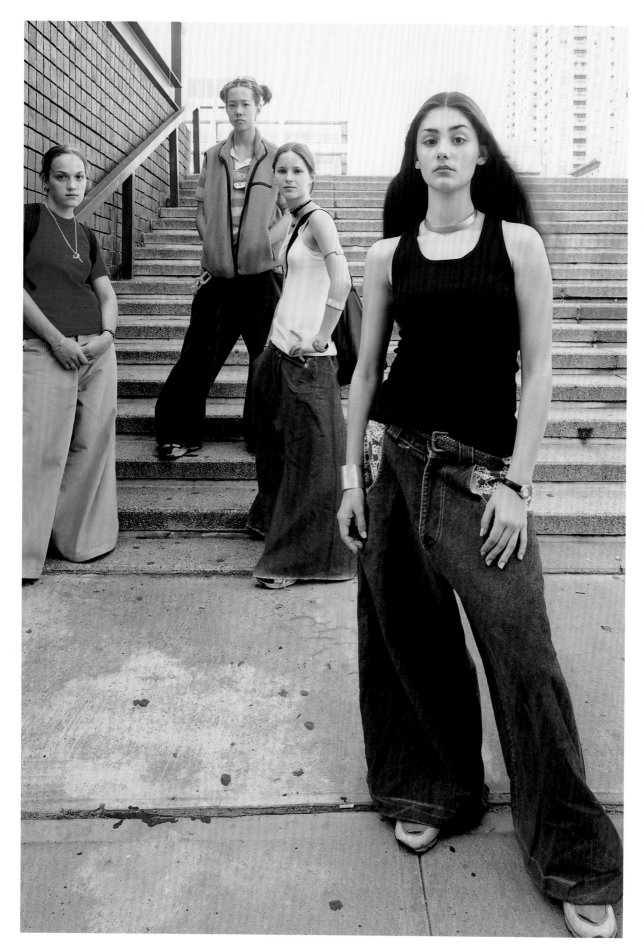

LEFT
High school students in parachute pants, *The New York Times Magazine*, October 19, 1997. Photograph by Christian Witkin.

◼

OPPOSITE
Clam-diggers, i.e.rolled up jeans—suddenly chic again, 1999. Photograph by Jack Pierson.

◼

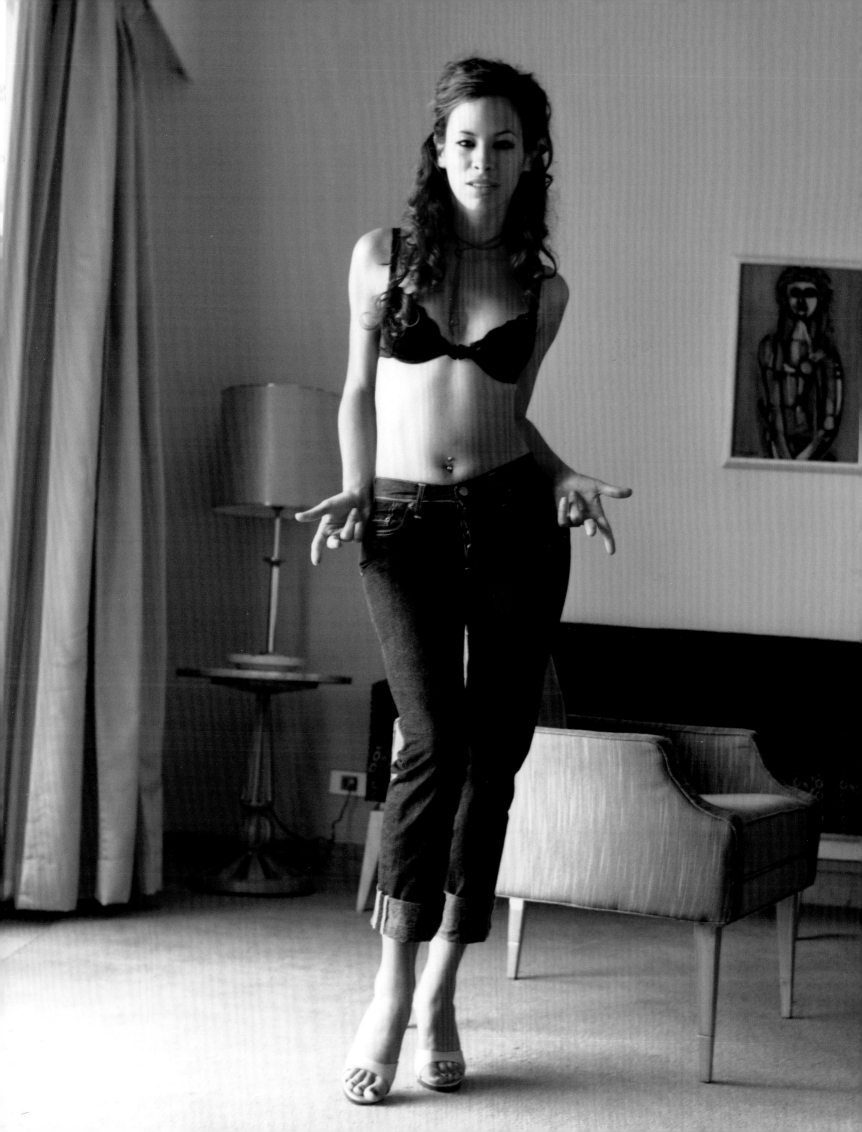

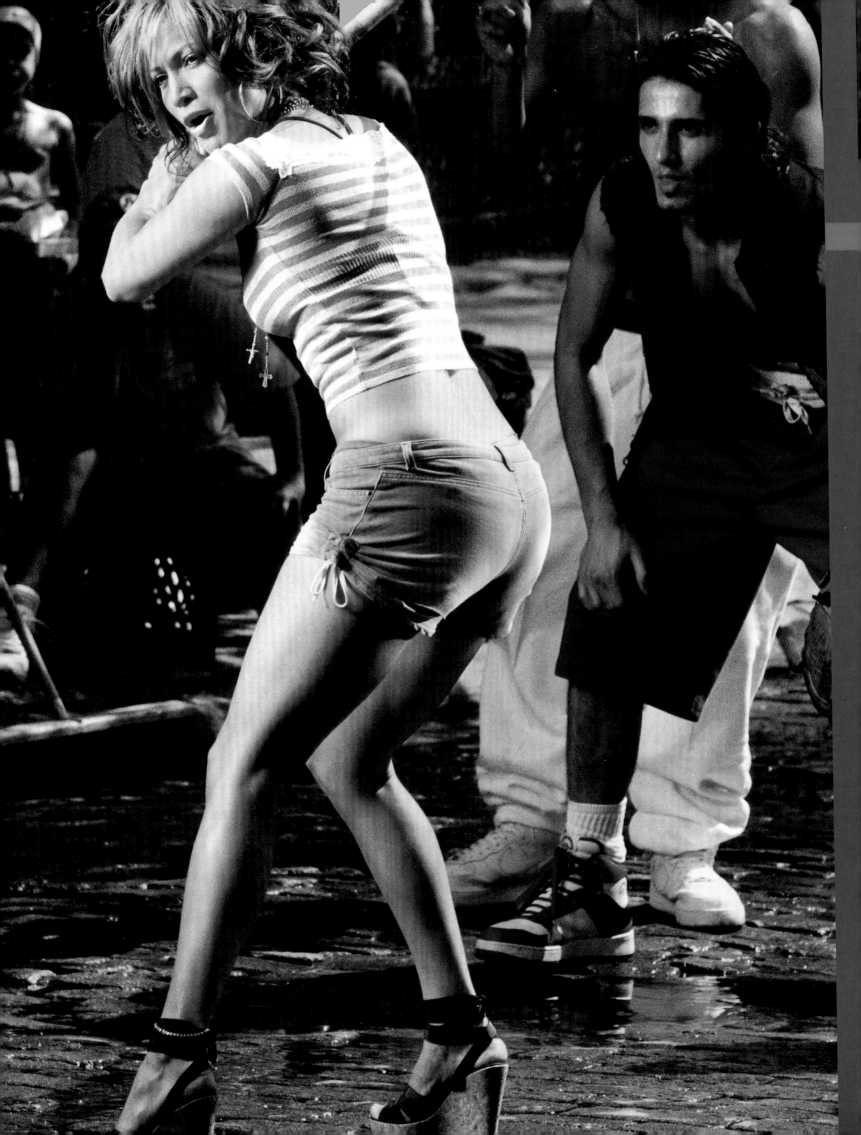

For almost all of this story, that $46,000 pair of Levi's waist overalls was sitting out there in a pile of muck in Nevada. Why they were kept so long after their purchase in a dry goods store in the 1880s we'll never know. Maybe they were on their original owner when he found a nugget of gold, and were saved as a lucky charm. Maybe they stayed useful long enough to ride in an automobile, or even to be taken to see a new-fangled moving picture show.

Although the design has changed over the years—this pair was intended to be worn with suspenders, so there are no belt loops, and a buckle in the back could be cinched for a tighter fit—they are fundamentally the same kind of Levi's sold today. As much a social document as a pair of denim pants, they make manifest the enduring popularity of blue jeans.

And they are still evolving. In 2002, Chanel's Karl Lagerfeld announced a new partnership with the fashion brand Diesel for a range of jeans and jackets. Levi's Silver Tab jeans—as deconstructed as anything by an avant-garde Japanese designer—started showing up on fashion-conscious men. Whiskered jeans by a New York company called Paper Denim and Cloth began making the worn-in look a precise science. And boutique denim labels, from Earl jeans to low-slung Seven and Frankie B. jeans (super trendy, but only as of this printing), staked new claims to midriff realty, taking jeans to new lows—literally.

These days, most denim is milled outside the United States, and in 2005, production quotas set by the World Trade Organization will expire, exposing domestic manufacturers to even more intense foreign competition. But it's unlikely that any kind of economic transition will dent the lasting popularity of this American icon. Over the years, they've been romanticized and valorized in popular music. Songs like "Venus in Blue Jeans," by Jimmy Clanton, "Oh Very Young," by Cat Stevens ("denim blue fading up to the sky"), and "Tiny Dancer," by Elton John ("blue jean baby"), have found poetry in these particularly prosaic pants. Perhaps the last word on the subject, however, was written in 1979, when Neil Diamond sang:

"…long as I can have you here with me,

I'd much rather be,

Forever in blue jeans."

Forever is right.

Bronx booty queen;
Jennifer Lopez, 2002.
Photograph by Frank Ross.

■

OVERLEAF
Karl Lagerfeld, Ben Stiller,
Hedi Slimane, and models,
Vogue, December 2001.
Photograph by Annie Leibovitz.

■

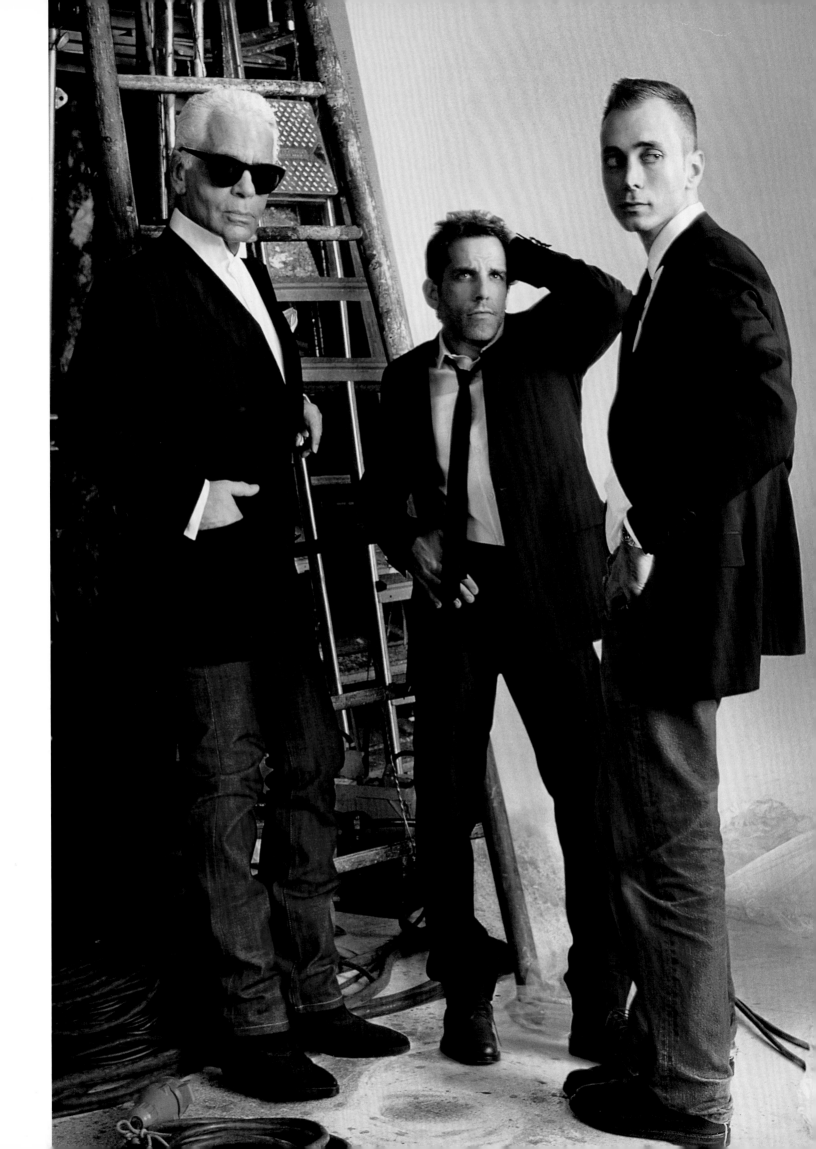

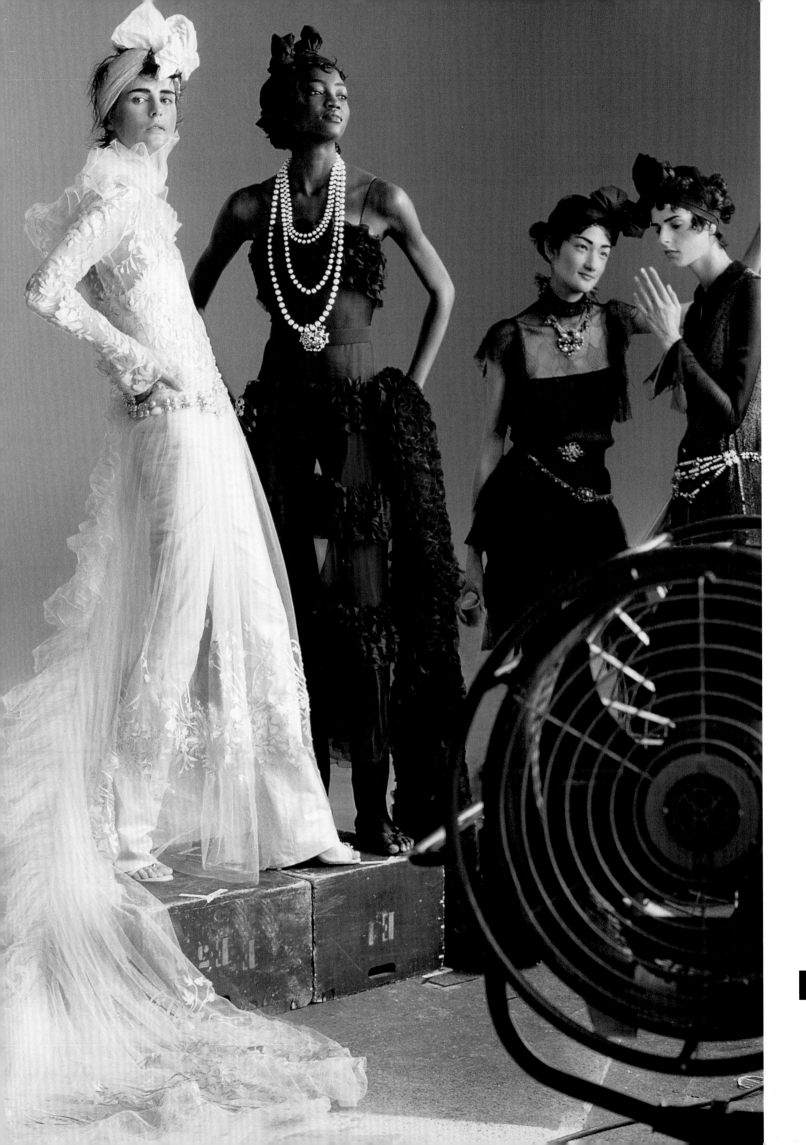

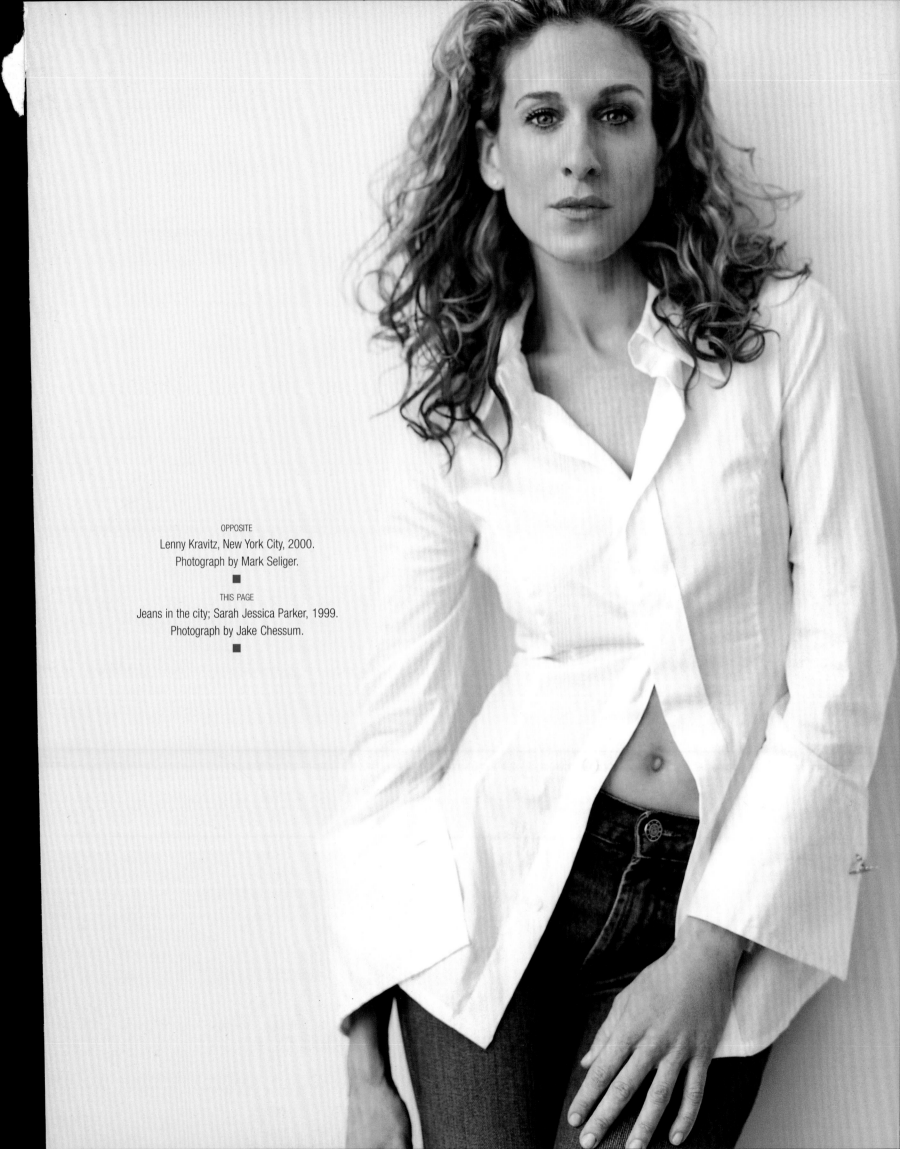

OPPOSITE
Lenny Kravitz, New York City, 2000.
Photograph by Mark Seliger.
■

THIS PAGE
Jeans in the city; Sarah Jessica Parker, 1999.
Photograph by Jake Chessum.
■

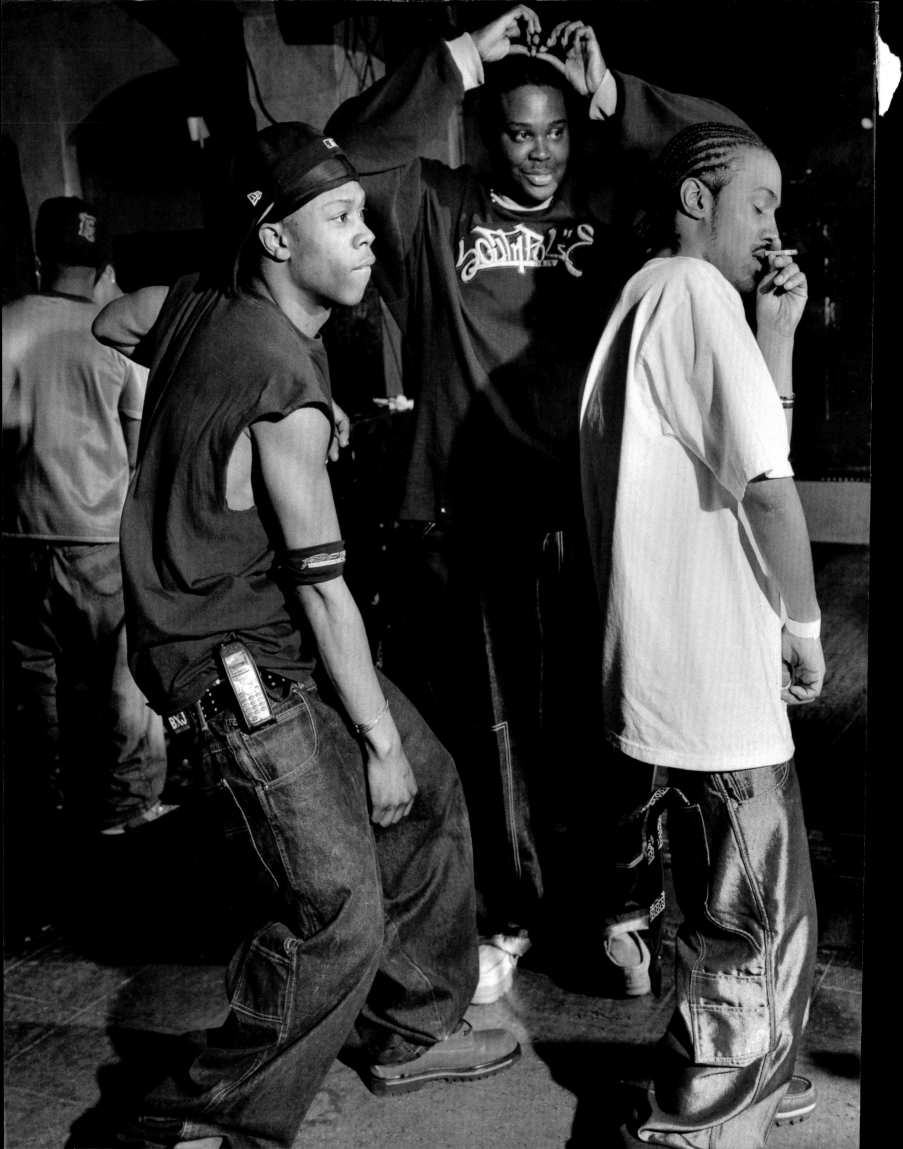

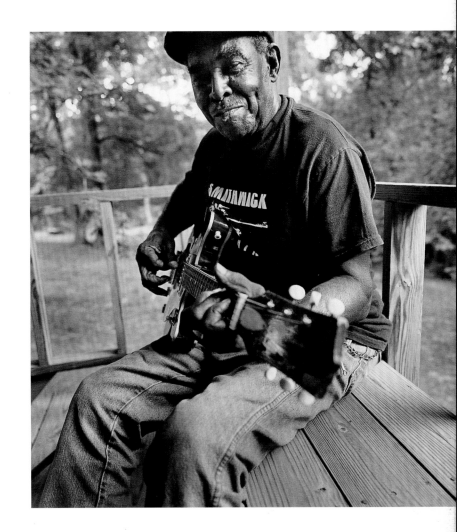

OPPOSITE
Club Speed, New York City, 2001.
Photograph by Larry Fink.
■
ABOVE
T-Model Ford, Oxford, Mississippi,
2001. Photograph by Larry Fink.
■

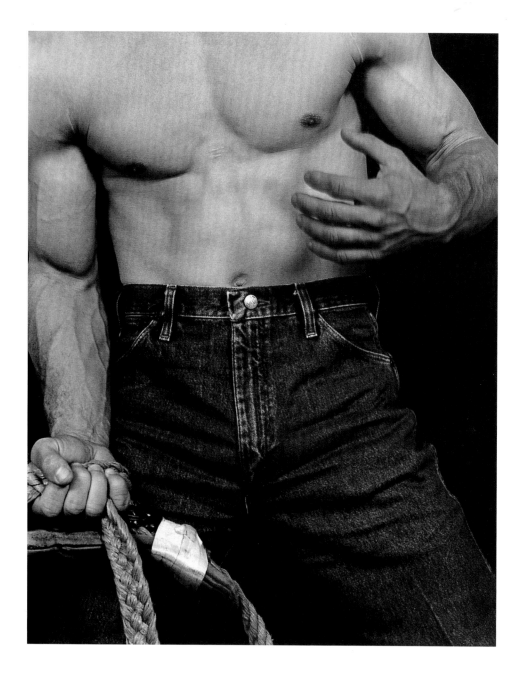

ABOVE
No weeny Wainwrights here: a real man in jeans;
rodeo champion Ty Murray, Oklahoma City, 1999.
Photograph by Kurt Markus.

■

RIGHT
L'il biz/big buzz; Lil' Kim, 2000.
Photograph by Larry Fink.

■

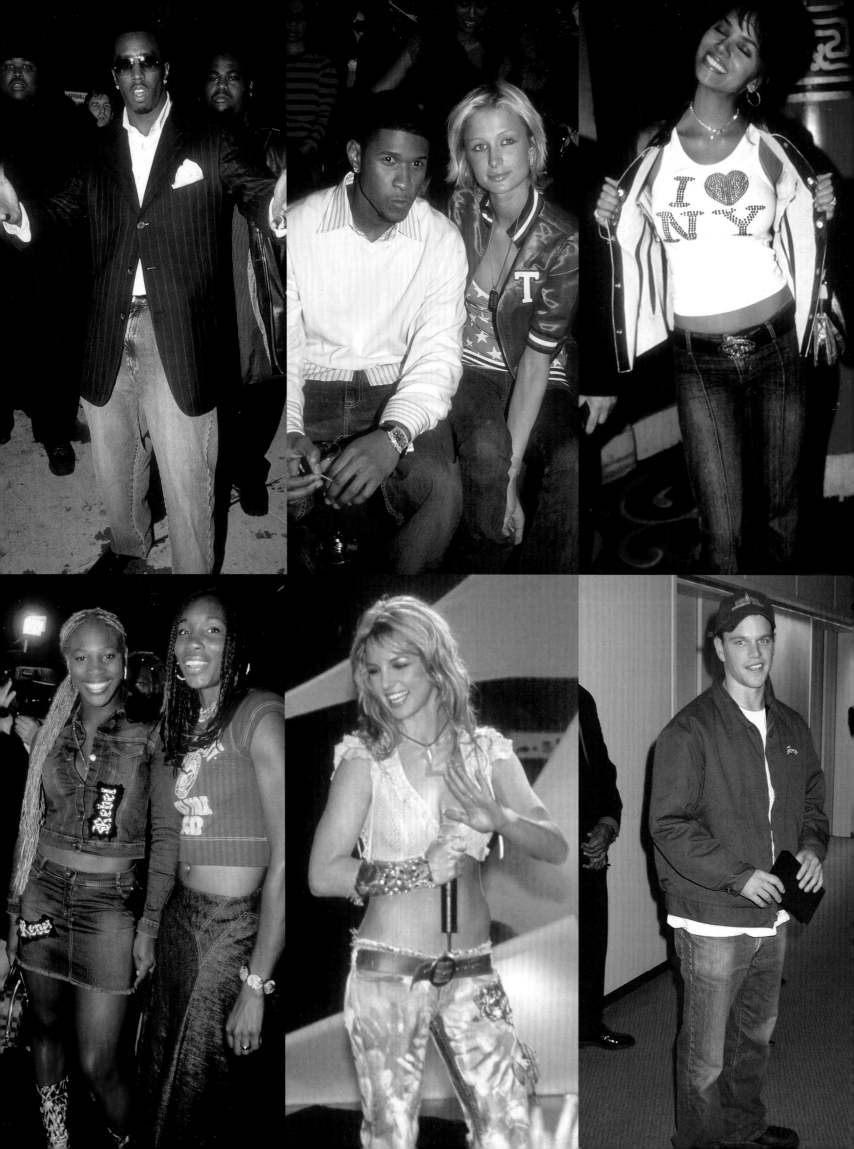

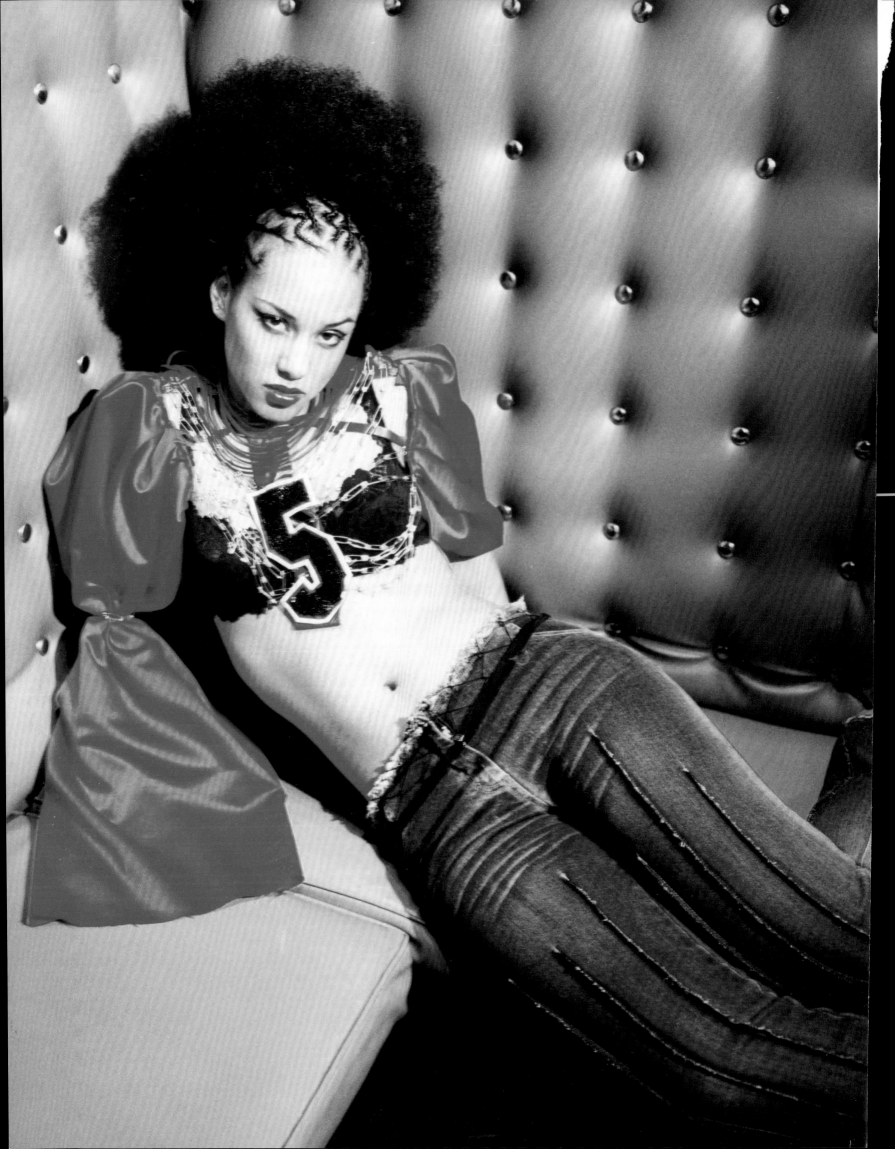

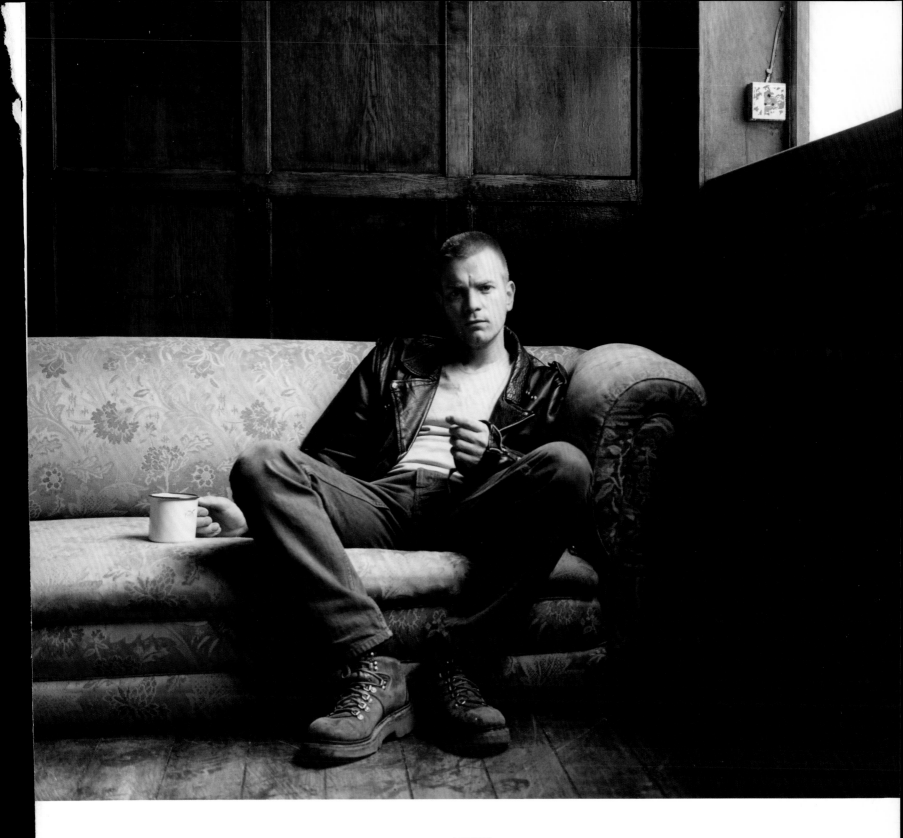

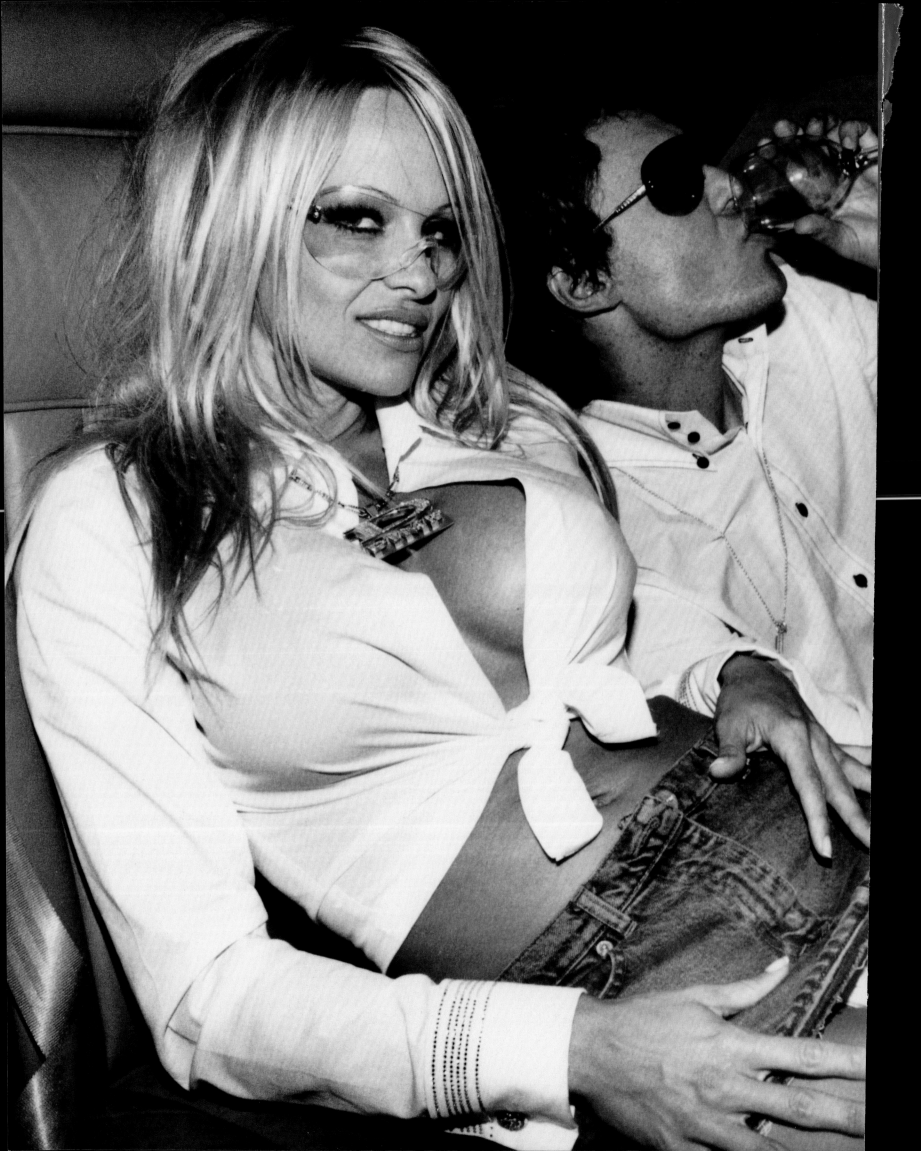

No, we're not going to touch this;
Pamela Anderson and David
LaChapelle, Los Angeles, 2001.
Photograph by Roxanne Lowit.

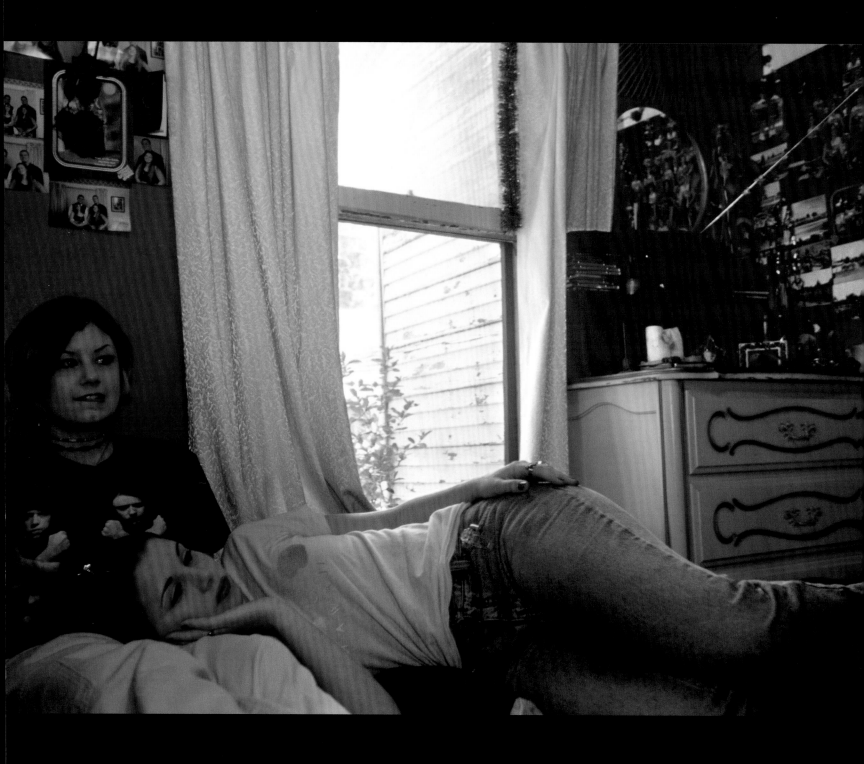

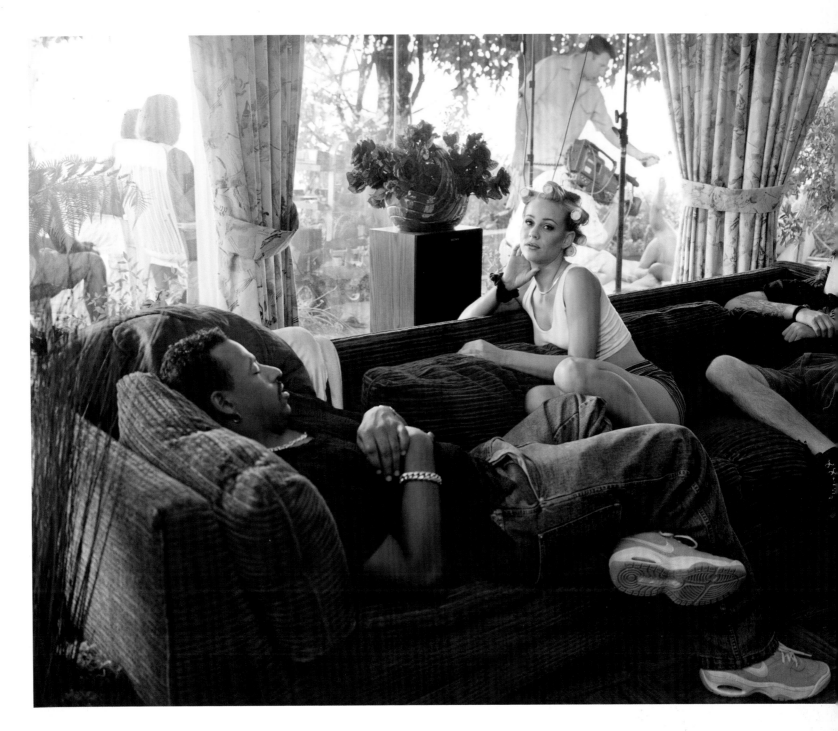

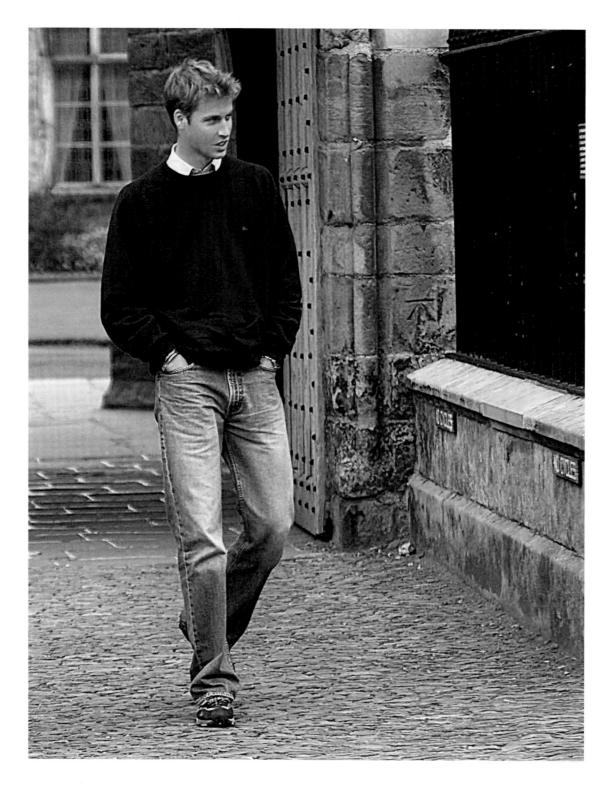

ABOVE
Royal blue; Prince William visits
St. Andrews University, Scotland, 2002.
Photograph by Ken Goff.
■

OPPOSITE
Captain No Beard; John Galliano, *W*, April 2002.
Photograph by Nick Knight.
■

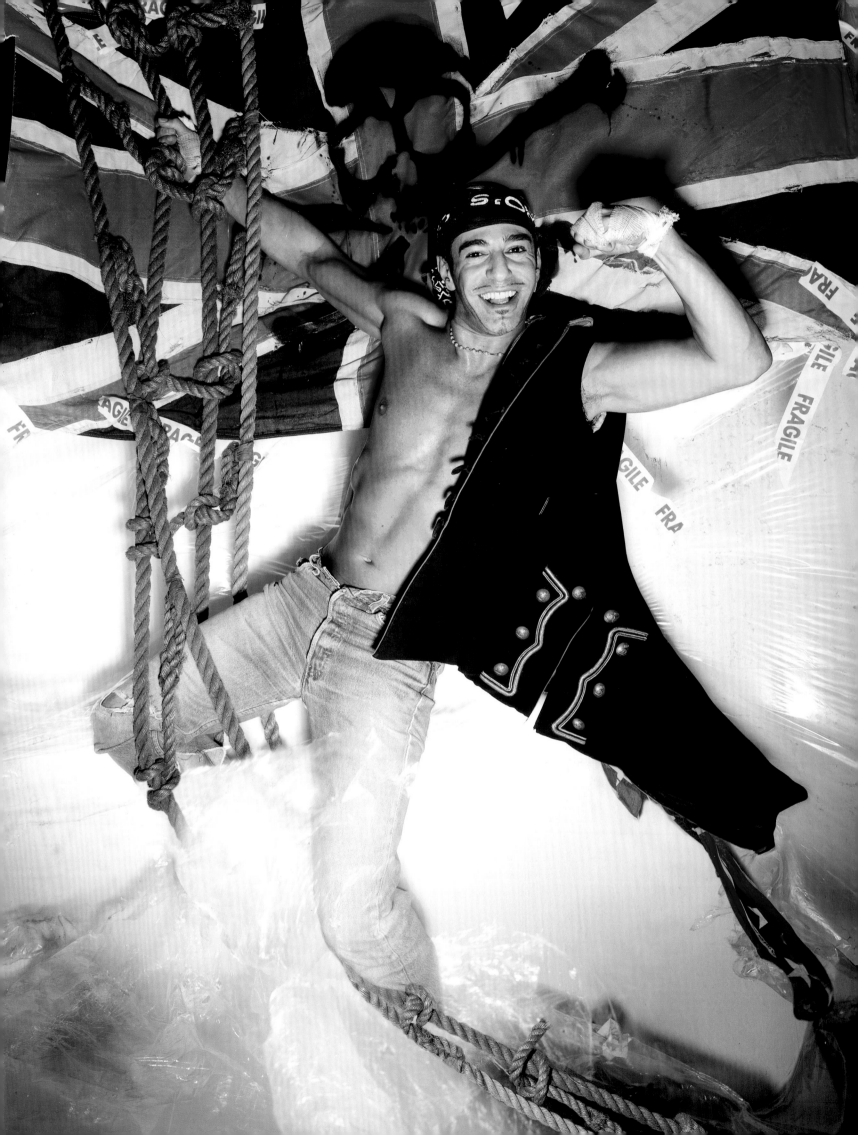

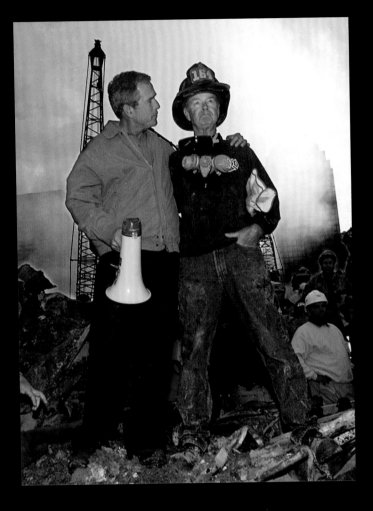

ABOVE
President George Bush with
firefighter Bob Beckwith,
World Trade Center site,
September 14, 2001.
Photograph by Doug Mills.

■

RIGHT
Midnight vigil at impromptu
Union Square memorial,
New York City, September
19, 2001. Photograph by
Chien-Chi Chang.

■

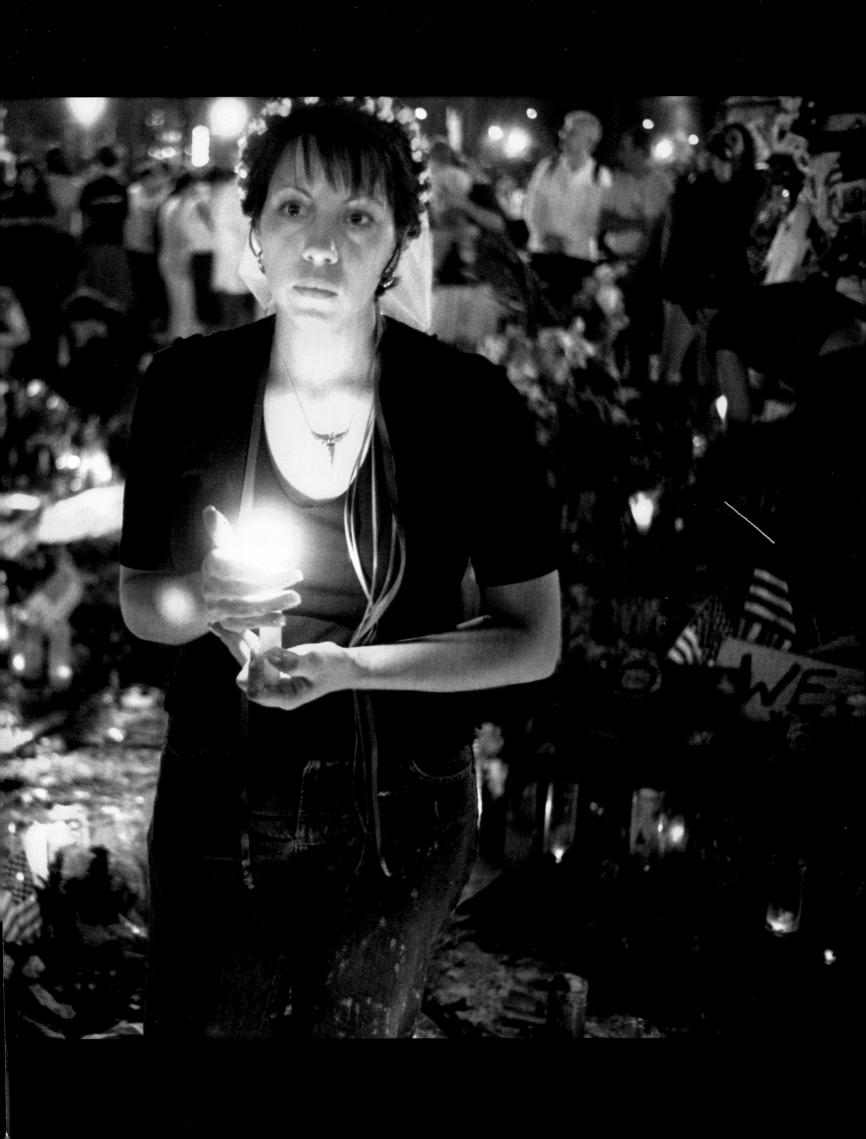

"...Forever in blue jeans."

Neil Diamond

Acknowledgments

Special thanks to Diana Edkins, you have brought greatness to an icon.

To Joel Avirom, Meghan Day Healey, and Jason Snyder, you have captured the icon and made it extraordinary.

To Bob Morris, from Sunday Styles to jean styles, thank you for your words of blue.

To Joseph Montebello, from *The White T* to *The Blue Jean*. Thank you for your encouragement and support.

To Daniel Power and Craig Cohen, thank you for not letting anything come between me and my jean book!

For the women in my life who have inspired me with their insights, individuality and style: Sue Barton, Marcie Bloom, Elizabeth Callender, Eileen Cassidy, Marcy Engelman, Denise Eppolito, Phyllis Goldstein, Samantha Harris, Carole Isenberg, Deneen King, Ginny Knott, Lauren Lavelle, Fern Mallis, Marilyn Marinaccio, Rosemary Peck, Danielle Petrulli, Paulette Resnick, Nan Richardson, Wendy Sarasohn, Elaine Sexton, Donna Summer Sudano, Janique Svedberg, Lorraine Toto…and especially my Mom, whose love and inspiration gave me the tenacity to endure.

—Alice Harris

Special thanks go to each of the photographers. Our grateful thanks go to the following for their generous assistance, advice, and information—for going that extra mile:

Gigi Benson; Bob Consenza, Kobal; Cynthia Cathcart, Condé Nast Publications; Rachel Connors, Michael Foster, ARG Talent; Norman Currie, Corbis Bettmann; Wim DeWitt, The John Paul Getty Research Institute; Rosa DiSalvo, Getty Images; Robbie Feldman; Craig Fruin; Heloise Goodman and Jennifer Palmer, Anthology, Art & Commerce; Arlu Gomez and Diane Prete, Sante D'Orazio; Barbara Gottleib, Black Star; Alana Hall, Lighthouse; Phillippa Oakley Hill; Geoff Katz and Hugo Reyes, CPi; Claudia Kishler and the Ansel Adams Trust; Dianne Nilsen and Denise Gose, Center for Creative Photography; Lissa Fesus, Fraenkel Gallery; John Galliano; Suzanne Goldstein, Pacific Press Service; Jim Johnson, Matthew Rolston Studio; Virginia Lohle, Star File; Ron and Howard Mandelbaum, Photofest; Karen Marks, Howard Greenberg Gallery; Ellen McQuire and Kim Pilson at Polo Ralph Lauren; Jessica Miranda; Neal Peters, David Smith and Greg Mann, The Neal Peters Collection; Bridie Picot, Z Photographic; James Price, Sipa Press; Shelby Reed, Tehabi Books; Yvette Reis, AP/Wide World Photos; Linda Ritter, Brown Brothers; Thomas Rockwell; Charlie Scheips, Ivan Shaw, and Michael Stier, Condé Nast Publications; Claudia Schiffer; Rose DiSalvo, Retna Ltd; Michael Schulman, David Strettell, and Ben Gillis, Magnum Photos; Shelter Serra; Jeffrey Smith, Contact Press Images; Nicholas Wissel; and Curtis Publishing.

—Diana Edkins

Credits

Pictures are courtesy of the following individuals and collections:

Front Endpaper: Courtesy of The Neal Peters Collection; Back Endpaper: Courtesy of the Keith de Lellis Gallery; Half Title Page: David LaChapelle. Courtesy of the photographer and Art + Commerce; Contents Page: Bob Deutsch/Neal Peters; 8: AP/Wide World Photos; 11: Library of Congress, Prints and Photographs; 12: Photofest; 14: © *Vogue*, The Condé Nast Publications, Inc.; 15: David Freund; 16: David Freund; 17: Library of Congress, Prints and Photographs; 18: Library of Congress, Prints and Photographs; 19: Library of Congress, Prints and Photographs; 20: Hulton Getty Picture Collection Limited; 21: David Freund; 22: Library of Congress, Prints and Photographs; 23: Photofest; 24: Photofest; 25: New York Public Library, Photography Collection; 26: Lester Glassner/ Neal Peters; 28-29: Brown Brothers; 31: Printed by permission of the Norman Rockwell Family Agency; 32-33: Center for Creative Photography, Tucson, Arizona; 34: Arizona Historical Society; 35: © *Mademoiselle*, The Condé Nast Publications, Inc.; 36: The Neal Peters Collection; 37: © Wayne Miller/Magnum Photos; 38: "Used by permission, Elvis Presley Enterprises, Inc."; 40: © Wayne Miller/Magnum Photos; 41: Courtesy Time Pix; 42: The Neal Peters Collection; 43: Photofest; 44-45: Movie Still Archives; 46: left: The Neal Peters Collection, right, Photofest; 47: Lester Glassner/Neal Peters; 48: The Neal Peters Collection; 49: The Neal Peters Collection; 50: The Kobal Collection; 51: The Neal Peters Collection; 52: Copyright © John Cohen/Courtesy Deborah Bell, New York; 53: Hans Namuth Estate, Hans Namuth Archive, Center for Creative Photography, Tucson, Arizona; 54: Courtesy of the Academy of Motion Picture Arts and Sciences; 55: TimePix; 56: © Eve Arnold/Magnum Photos; 58: © Danny Lyon/ Magnum Photos; 60: Black Star; 61: © Mark Shaw/Photo Researchers; 62-63: Movie Still Archives; 64: © Eve Arnold/Magnum Photos; 65: Photofest; 66: Courtesy of the photographer; 67: © Dennis Stock/Magnum Photos; 68: © Elliott Landy/Magnum Photos; 69. Barrie Wentzell/Star File; 70: Retna; 72-73: © Dennis Stock/Magnum Photos; 74: Bob Gruen/Star File; 77: AP/Wide World Photos; 78: © The Estate of

Garry Winogrand, Courtesy Fraenkel Gallery, San Francisco; 79: Photofest; 80: The Neal Peters Collection; 81: Photofest; 82: Max Waldman Archives; 83: ©Annie Leibovitz/Contact Press Images; 84: © Felice Quinto; 85: © Roxanne Lowit; 86: © left, Alexander Liberman, The John Paul Getty Research Institute; 87, left: ©*Vogue*, The Condé Nast Publications, Inc.; 87, right: Courtesy of the photographer and CPi; 88: The Neal Peters Collection; 89: Jill Furmanovsky/Star File; 90: © Lynn Goldsmith/LGI; 91: Bob Gruen/Star File; 92: Bob Gruen/Star File; 93: Courtesy of the photographer; 94: Courtesy of the photographer; 96: © Harry Benson; 97: Peter Lindbergh, Courtesy of *Vogue* and Lighthouse; 98: Bob Gruen/Star File; 99: © Donna Mussenden VanDerZee; 100: Courtesy of the photographer; 101: © Helmut Newton; 102: © Helmut Newton; 103: Courtesy of the photographer; 104: Courtesy of the photographer; 105: The Kobal Collection; 106: © René Burri/Magnum Photos; 107: Corbis/Bettmann; 108: Photofest; 110: Courtesy of the photographer; 112: Courtesy of the Photographer; 113: © Lynn Goldsmith/LGI; 114: Courtesy of the photographer; 115: Courtesy of the photographer; 116: Courtesy of the photographer/Art + Commerce; 117: Courtesy of the photographer; 118: Courtesy of the photographer; 119: Courtesy of the photographer and Art + Commerce; 120: Courtesy of the photographer; 122-123: © Annie Leibovitz/Contact Press Images; 124: Courtesy of the performer and the photographer; 125: Courtesy of the photographer; 126: Courtesy of the photographer; 127: Courtesy of the photographer; 128: Courtesy of the photographer 129: Courtesy of the photographer; 130: Courtesy of the photographer; 131: AP/Wide World Photos;132: Courtesy of the photographer/ Art+Commerce; 133: Courtesy of the photographer and CPi; 134-135: © Roxanne Lowit; 136: © Lauren Greenfield/V11; 137: Courtesy of the photographer/Z Photographic; 138: Sipa Press; 139: Courtesy of the photographer (Art Direction: Tom Hingston, Concept: John Galliano, Hair: Sam McKnight@ Premier, Makeup: Val Garland @ Untitled, Manicurist: Marian Newman @ Amalgamated Talent, shot at Bigsky Studios, scanning by Idea Digital Media, retouching by Metro Imaging); 140: AP/Wide World Photos; 141: © Chien-Chi Chang/Magnum Photos; 143: Courtesy of the author.

Special Thanks to Evan Gubernick, Steven David Bernstein, Greg Di Benedetto, Ben Harris, and Jonathan Rheingold

Footnotes

Page 9: "This is all…" Katherine Weiss "Vive Le Jeans," Jean-eology (*Women's Wear Daily* supplement), May 18, 2000; Page 10: "He was shown…" Daniel J. Hoisington, *Made In Beverly—A History of Beverly Industry,* 1989; Page 10: "In short, the whole…" Ibid; Page 30: "The buttons hold…" American History: Lee Jeans 101 (company publication); Page 75: "Jeans make me conscious…" Charles Reich, *The Greening of America,* Crown Publishers, 1971; Page 75: "Levi's are the best…" quoted by Barbara Fehr, "Yankee Denim Dandies," Piper, 1974; Page 76: "Sure enough…" Bob Colacello, *Holy Terror,* HarperCollins, 1990; Page 109: "You can now see …" Germaine Greer, *The Female Eunuch,* Farrar, Straus and Giroux, 1991; Page 121: "Forever in Blue Jeans" by Neil Diamond and Richard Bennett © 1979 Stoneridge Music and Sweet Sixteen Music, Inc. All rights reserved. Used by permission.

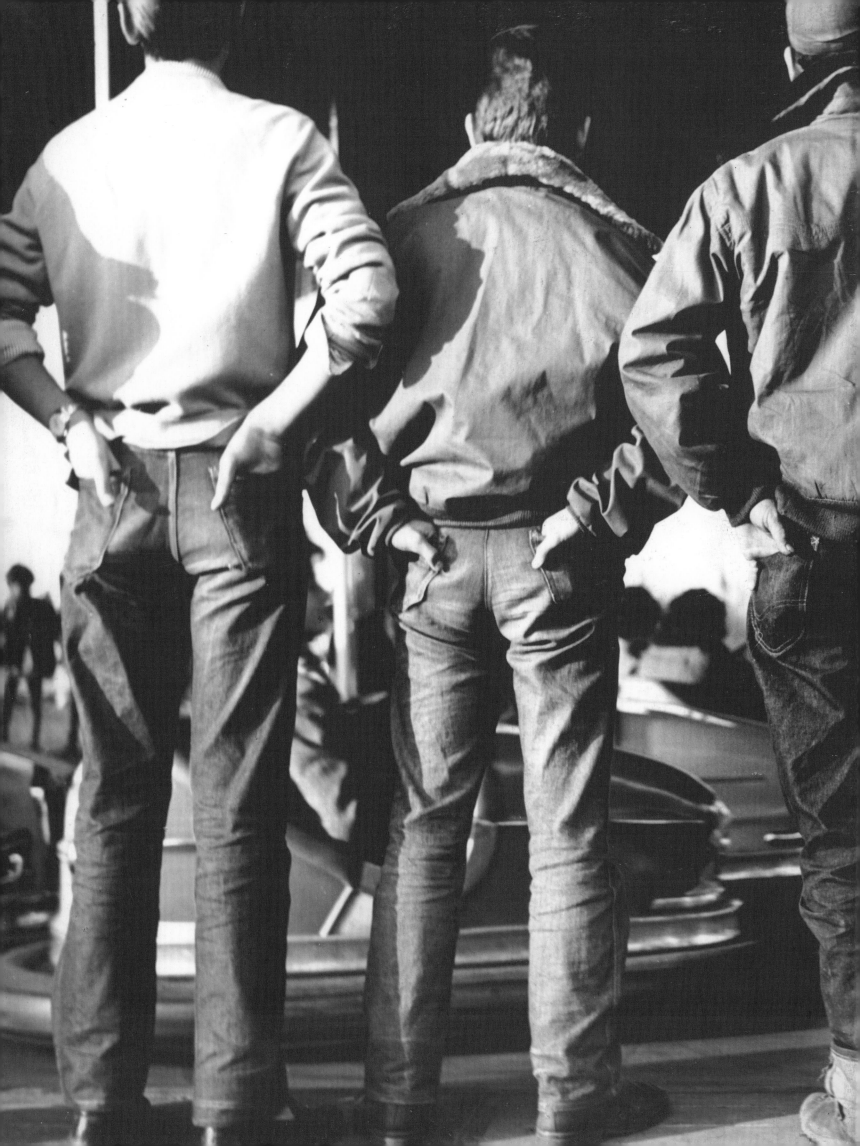